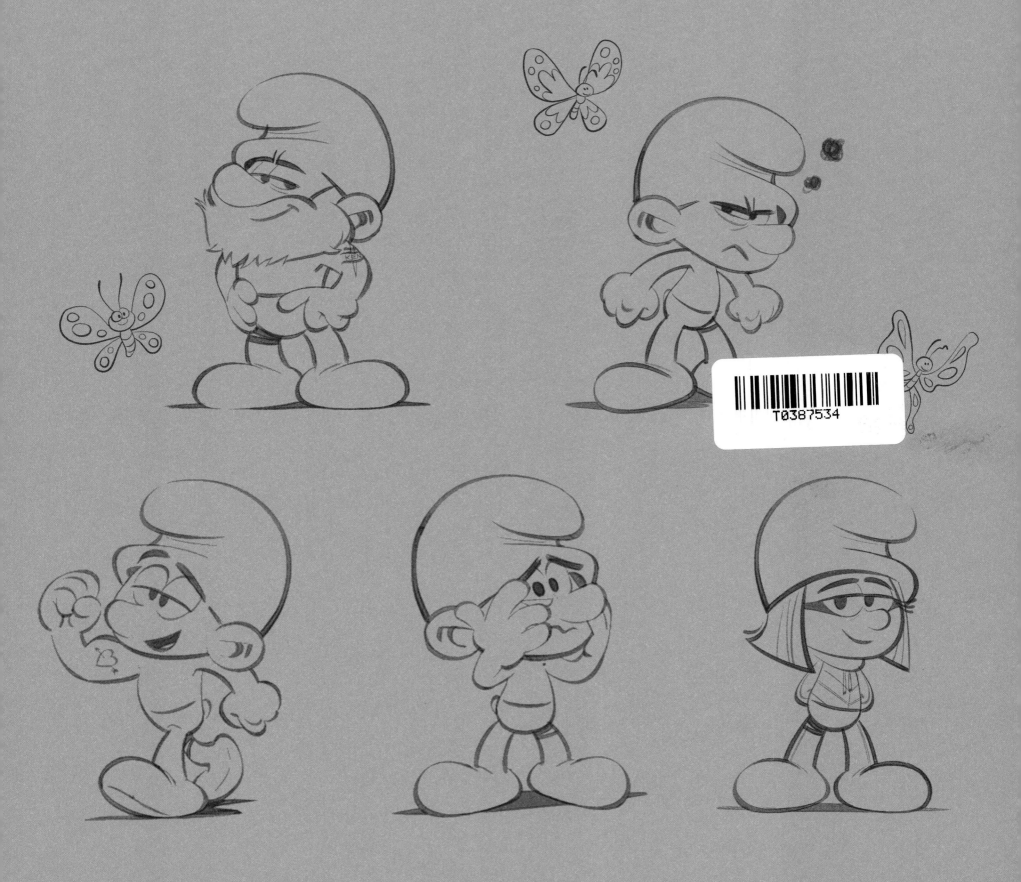

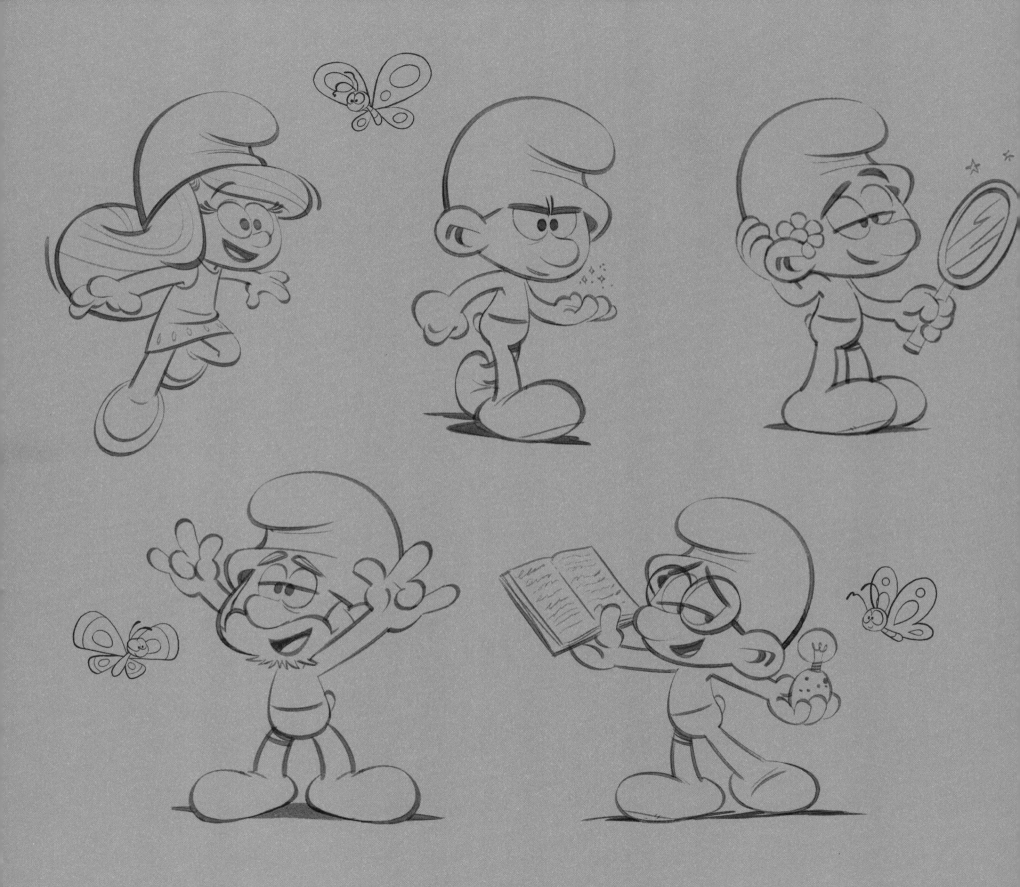

@IDWPUBLISHING
IDWPUBLISHING.COM

979-8-88724-369-6
28 27 26 25 1 2 3 4

COVER ARTIST: Smurfs™ & © Peyo - 2025 - Licensed through Lafig Belgium/IMPS.
Margaret Wuller Smurfs, The Movie © 2025 - Paramount Pictures. All Rights Reserved.

EDITOR: THE ART OF SMURFS. JULY 2025. FIRST PRINTING. The IDW logo is
Alonzo Simon registered in the U.S. Patent and Trademark Office. IDW Publishing, a division
of Idea and Design Works, LLC. Editorial offices: 14144 Ventura Blvd, Suite 210,
COLLECTION Sherman Oaks, CA 91423. Any similarities to persons living or dead are purely
DESIGNER: coincidental. With the exception of artwork used for review purposes, none of
Darran Robinson the contents of this publication may be reprinted without permission from Idea
and Design Works, LLC. IDW Publishing does not read or accept unsolicited
submissions of ideas, stories, or artwork. Printed in Canada.

Davidi Jonas, CEO
Andrew DeBaker, CFO
Gregg Katz, General Counsel
Tara McCrillis, President Publishing Operations
Bobby Curnow, Editor in Chief
Aub Driver, VP Marketing
Gregg Katzman, Sr. Manager Public Relations
Warren Buchanan, Licensing Manager
Lauren LePera, Sr. Managing Editor
Shauna Monteforte, Sr. Director of Manufacturing Operations
Jamie Miller, Director Publishing Operations
Jasmine Gonzalez, Director Ecommerce Operations
Alison Quin, Sr Director IT
Ryan Balkam, Specialty Market Sales Manager
Nathan Widick, Director of Design
Neil Uyetake, Sr. Art Director, Design & Production

Ted Adams and Robbie Robbins, IDW Founders

Special thanks to Risa Kessler, Benjamin Harper, and everyone at Paramount for
their invaluable assistance.

For international rights, contact licensing@idwpublishing.com

EU RP (for authorities only)
eucomply OÜ
Pärnu mnt. 139b – 14
11317 Tallinn, Estonia
hello@eucompliancepartner.com
+33757690241

Contracting Partner:
Tara McCrillis, IDW Publishing | EU RP Partner: Marko Novkovic, CEO

Color key by Margaret Wuller

CONTENTS

6 - Foreword by Véronique Culliford
9 - Introduction by Chris Miller
10 - Smurf It Up
12 - Once Upon a Peyo
16 - Get This Search Party Started
26 - Welcome (Back) To The Village
72 - Some Things Wicked...
124 - Far Out Spaces, Places, and Faces
162 - The Greatest Smurf(s) Ever
192 - All's Smurf That Ends Smurf

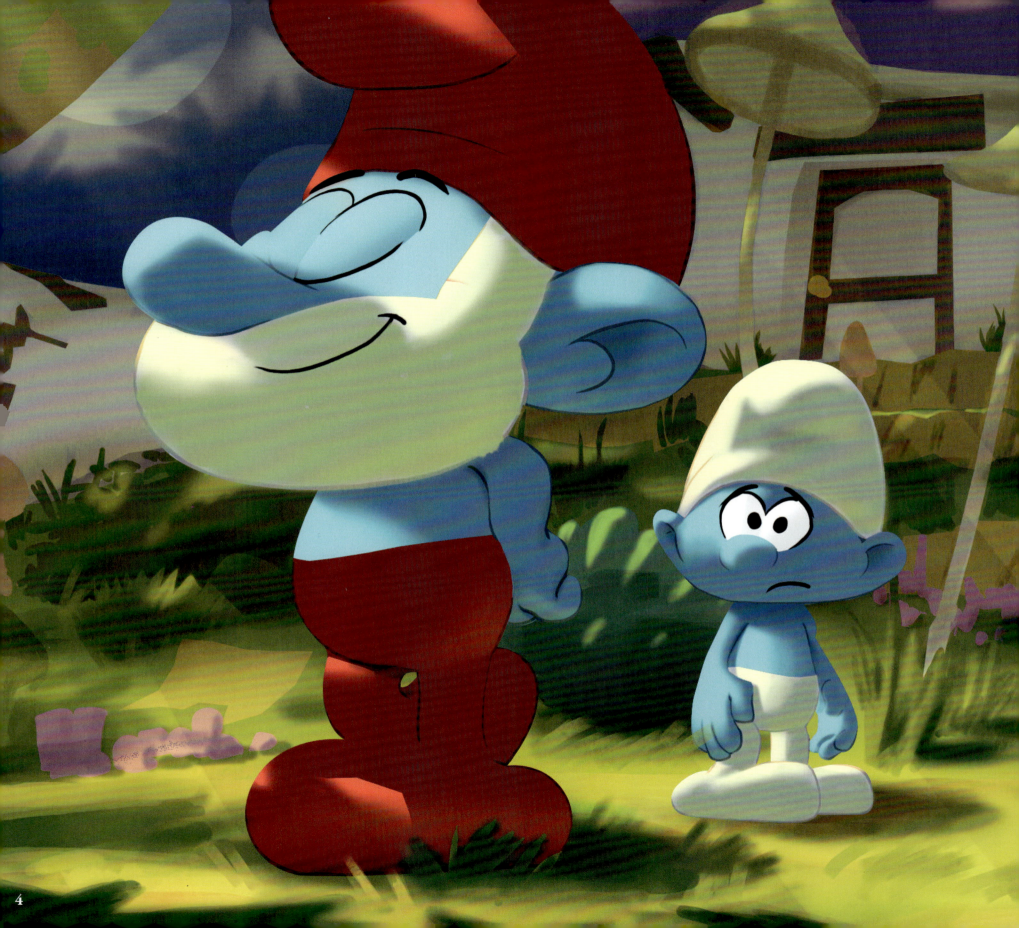

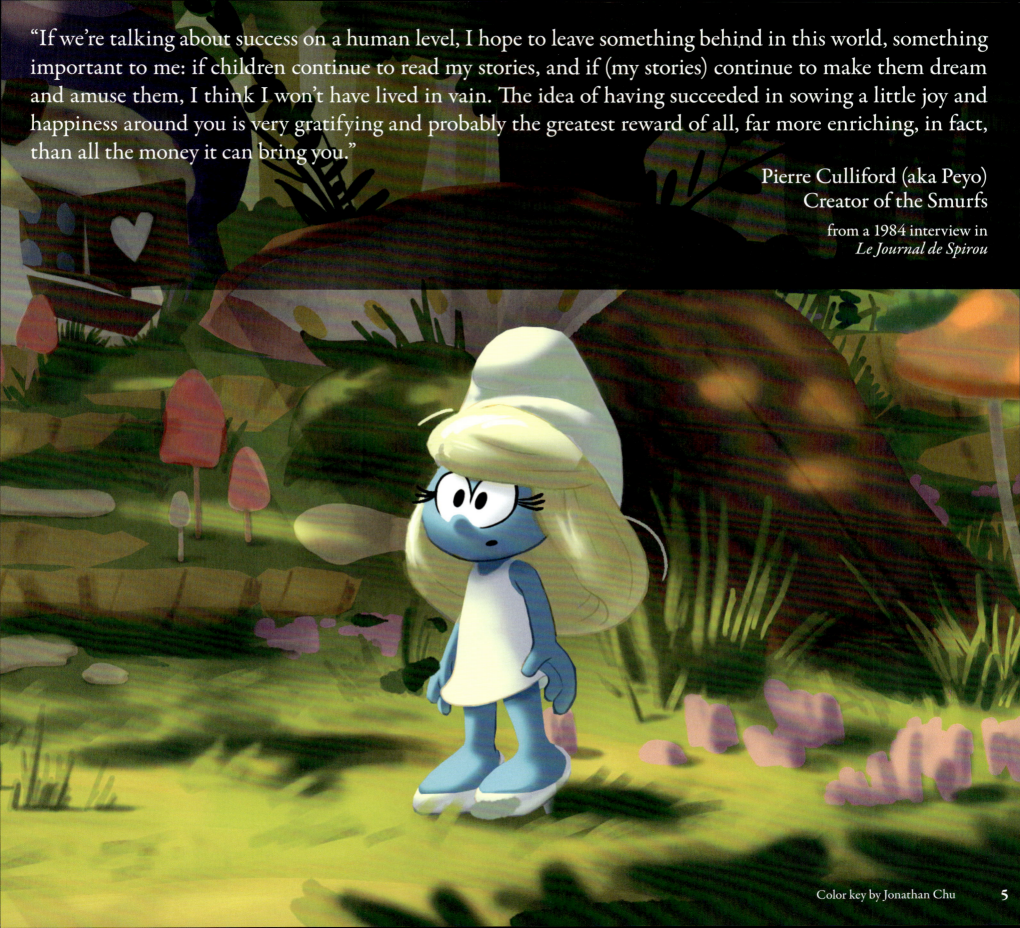

"If we're talking about success on a human level, I hope to leave something behind in this world, something important to me: if children continue to read my stories, and if (my stories) continue to make them dream and amuse them, I think I won't have lived in vain. The idea of having succeeded in sowing a little joy and happiness around you is very gratifying and probably the greatest reward of all, far more enriching, in fact, than all the money it can bring you."

<div style="text-align: right;">
Pierre Culliford (aka Peyo)

Creator of the Smurfs

from a 1984 interview in

Le Journal de Spirou
</div>

Color key by Jonathan Chu

FOREWORD

The world of the Smurfs has enchanted generations with its charm, humor, and timeless adventures. From their humble beginnings in comic books to becoming beloved icons of animated television and cinema, these little blue characters have captured the hearts of audiences worldwide. Now, as we embark on an exciting new chapter, we are thrilled to present the next Smurfs movie—a film that promises to bring even more magic, laughter, and unforgettable moments.

This cinematic adventure is made even more special through an incredible collaboration with Paramount, a studio renowned for its storytelling, excellence, and ability to bring animated worlds to life in spectacular fashion. With its expertise, creative vision, and dedication, Paramount has helped elevate this new Smurfs movie to unprecedented heights, ensuring that both longtime fans and new audiences will be spellbound by the journey ahead.

In this film, we delve deeper into the enchanting Smurf universe, exploring new lands, facing exciting challenges, and meeting fresh characters (including new villains) that will surely become favorites. The animation is more dazzling than ever, the humor is as sharp as always, and the heartwarming essence of the Smurfs remains at the core of this tale. And, of course, there are the new songs written and performed by superstar Rihanna, who plays the voice of Smurfette to perfection.

We cannot wait for you to experience this extraordinary adventure. Whether you have loved the Smurfs since childhood or are just discovering their world, this movie is a celebration of friendship, courage, and the joy of imagination.

So, get ready to smurf your way into an unforgettable journey—because the Smurfs are back, and their next adventure is bigger and bluer than ever!

I wish you all a smurfy reading moment!

Véronique Culliford
Founder and president of IMPS/Peyo Company & daughter of Peyo

Art by Margaret Wuller

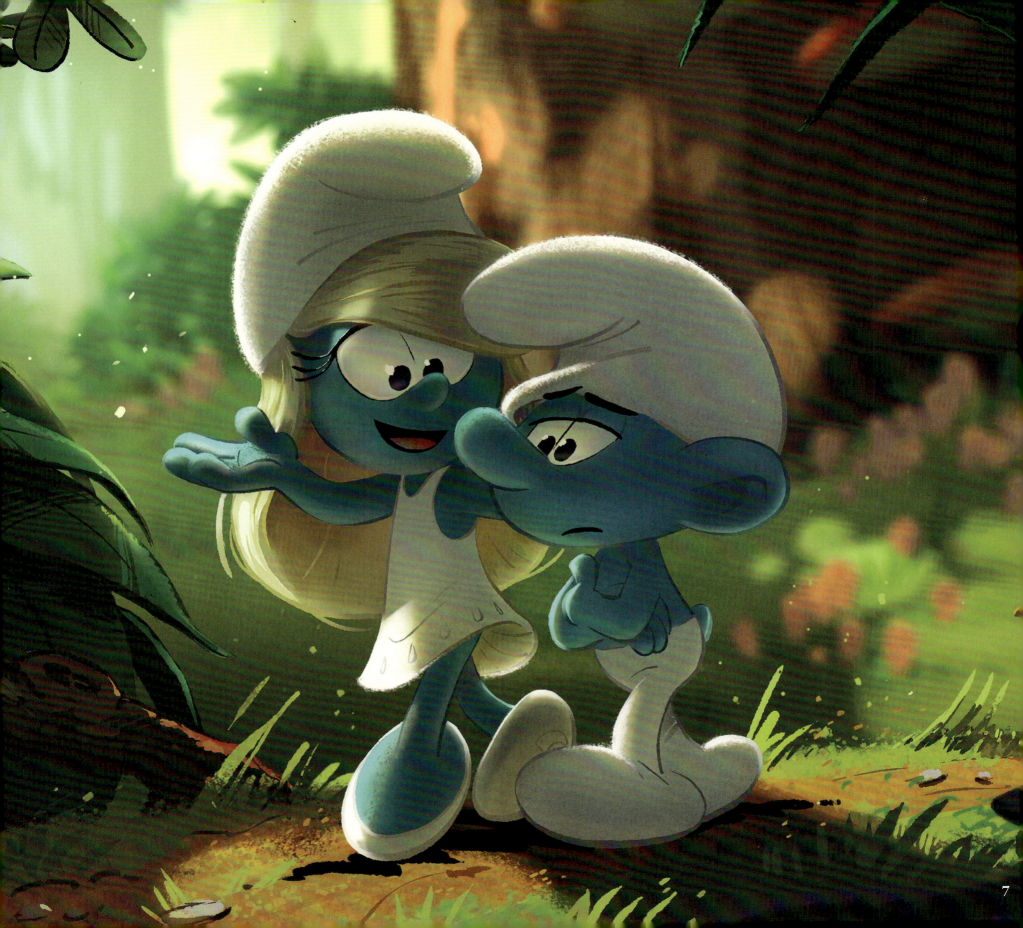

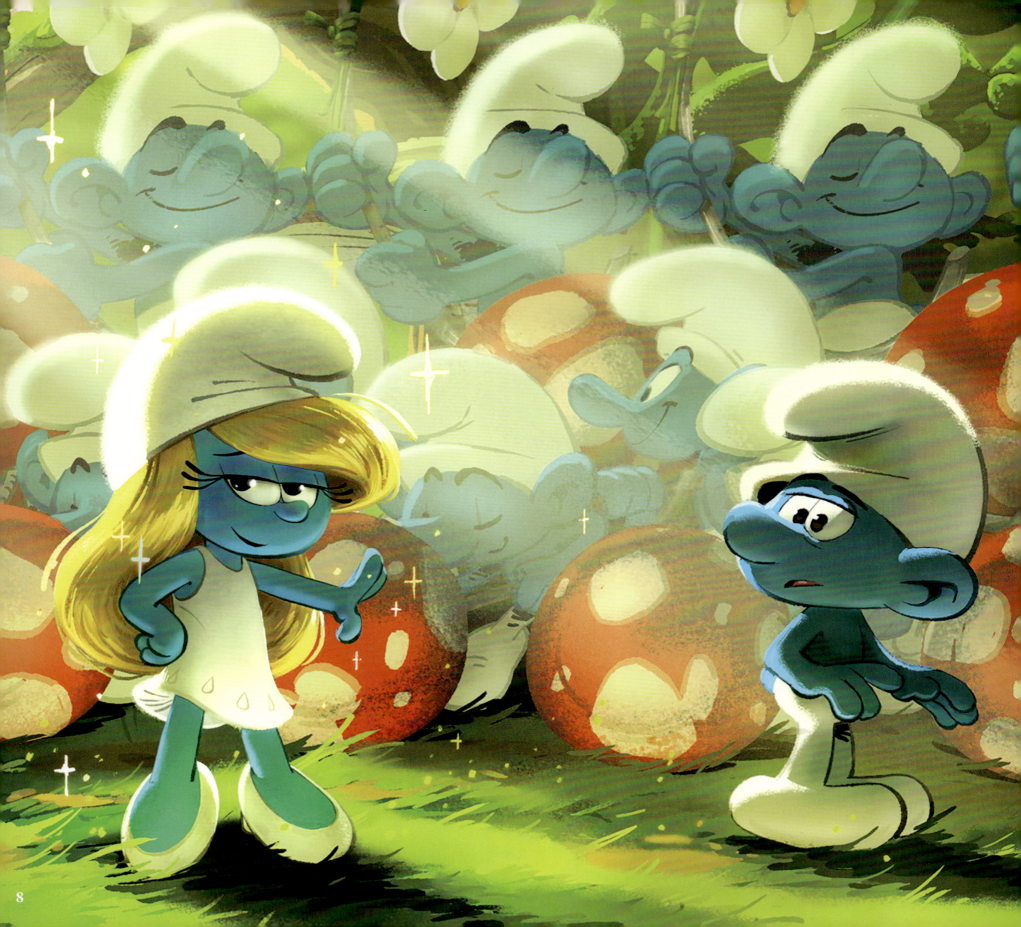

Art by Grace Kum

INTRODUCTION

From day one, we set out to create something unexpected and irreverent. Something memorable. When I read Pam Brady's first draft I instantly knew we were on the right path. Her sharp, whip-smart wit never sacrificed what makes a Smurf pure at heart. They are always sincere, without a whiff of cynicism.

And so the journey began with a clear mission to honor Peyo's original Smurf designs. This was our essential visual blueprint, and a stylized path for the film quickly took shape. The look demanded something expressive and bold, complete with thought bubbles and action lines that would leap off the comic book page and onto the big screen. For this to work, the world we created had to be a character in the film—an active vehicle for comedy and storytelling.

My incredible team included a deep bench of designers, painters, and story artists who immediately tapped into the cheeky tone of the *Smurfs* movie. Under the vigilant eyes of production designer Max Boas and art director Margaret Wuller, they created a lush, immersive world that embraces the balance of harmony with nature while delivering a stylized, handcrafted feel.

From the stylish charm of Smurf Village to the exotic fauna that thrives in that Belgium forest, every frame of *Smurfs* is a testament to their artistry and vision. Every brushstroke, every set piece, and every prop is a piece of the puzzle that helps bring these characters and this world to life.

What can I say? The art department nailed it.

I'm so thankful to Rihanna and her little blue badass contributions. She brought a new point of view that makes *Smurfs* modern and fresh.

Among the themes of our movie is togetherness. The Smurfs can't take on the world alone—it's the power of community that gives them strength. The movie, too, was a team effort. And everyone's contributions are on the screen and in these pages.

All of their incredible work is in your hands now. Enjoy the journey...

Chris Miller
Director, *Smurfs*

SMURF IT UP

On February 6, 2025, Paramount Pictures in partnership with Peyo Company debuted the first trailer for *Smurfs*, a new animated feature film starring the community of magical blue gnomes that has been capturing imaginations since 1958 with comics, television, music, film, and sought-after collectibles.

The two-minute-and-twenty-five-second clip offered the world a look at a new vision for the globally beloved property. Under the direction of seasoned filmmaker Chris Miller it would star English media personality James Corden as the film's central Smurf, American character actors John Goodman, Natasha Lyonne, and Nick Offerman in supporting roles, and international pop music sensation Rihanna as the iconic Smurfette.

While peppered with a comedic sensibility and music catering to a 2025 audience, the trailer revealed that the heart of the film beats to a rhythm that

Art by Max Boas

celebrates the heritage of the property and its creator, Peyo—not only in the story's themes of family, camaraderie, and identity, but especially through the movie's exquisite design and animation.

Producer Ryan Harris notes, "We studied all aspects of the brand, all of it. It was such a wonderful process to hear each person's connection to these blue little ones."

The following pages examine this amalgamation of spirit and craftsmanship, as well as the attention to history, and explore what makes the 2025 feature a celebration of every aspect of the art of the Smurfs.

ONCE UPON A PEYO

BRANDED

The term "brand" is one that's often used in the early 21st century when discussing the subject of a major motion picture property, and it's one that certainly can apply to the Smurfs.

Defined by Merriam Webster as both "a public image, reputation, or identity conceived of as something to be marketed or promoted" and the "class of goods identified by name as the product of a single firm or manufacturer." For nearly eight decades (as of this writing) the Smurfs have been used to promote toys, records, apparel, home décor, theme parks, and breakfast cereals, while also being their own creative identity with original stories being told in every possible medium including film, television, videogames, and "graphic novels."

In fact, what some fans may not realize is that before the live ice shows and app games, the Smurfs first appeared in October 1958 as side characters in the (then) popular Belgian comic strip *Johan et Pirlouit*. Although they were only planned for a single appearance in the story *"La flûte à six trous"* ("The Flute with Six Holes"), the small woodland sprites who spoke in a strange language became breakout stars and soon were not only making other appearances in *Johan* but were given their own series which would eclipse the original series in both popularity and sales.

The Smurfs became such a sensation that overseeing the small media empire that formed around them eventually became the full-time job of their original cartoonist, Pierre Culliford, who signed his work and was better known in his lifetime as Peyo.

In the modern media landscape, the original comics—which continue to be published in multiple languages today—are often overlooked by the larger public, who may simply think of the blue gnomes as just little rubber dolls on their shelves or the stars of a Saturday morning cartoon show from another era.

The filmmakers behind 2025's *Smurfs*, however, chose to celebrate those comics first and foremost, especially where the production art and visual storytelling were concerned.

According to art director Margaret Wuller: "We were so attached to the source material of the comic[s]. I can really say, in all honesty, [they were] absolutely our 'bible.' I have four [comics collections] on my desk at home. I probably have five more on the lot [at] Paramount with tabs in [them]."

"Peyo was our blueprint," said Chris Miller, perhaps offering a hidden pun. "My [initial] exposure to Smurfs would be the '80s TV series. Then I discovered Peyo, which blew my mind esthetically. I'm like: 'Wow, this. This is an artist. These designs are brilliant.'"

SMURFING ACROSS EUROPE

Since their early days, the Smurfs expanded beyond their comics' panels having been almost immediately marketed as a line of latex figurines available wherever *bandes dessinées* (BD) were sold, and quickly used spokes-elves for a French cookies company, not to mention the face of Kelloggs breakfast cereals in Belgium.

Additionally, the Smurfs' first stories were adapted for television in 1961, via a series of black and white cartoons animated with paper cutouts (similar in style to the original *South Park* cartoons of the 1990s), which were produced by *Spirou's* publisher Éditions Dupuis.

For the next decade, the Smurfs would dominate the pop culture landscape of French speaking countries, while enjoying a boost in the German and Dutch language markets on account of being published in all three languages in their tri-lingual homeland. Because of Belgium's multi-cultural history, the Smurfs ascendancy across Europe was near complete and culminated in the 1975 release of the feature film adaptation of *"La Flûte à six trous"*—which had been re-titled *La Flute a Six Schtroumpfs* (and eventually translated as *The Smurfs and the Magic Flute*).

Despite their near inescapable presence throughout the continent as comics, books, record albums, and toys, the Smurfs had difficulty breaking into one European region—the United Kingdom.

Success in the English-speaking world eluded them until 1977, when "The Smurf Song," a Dutch tune by children's entertainer Father Abraham, sold over half-a-million copies worldwide in promotion of the *Magic Flute* feature. While there was no English dub of the film at the time, the song itself was translated into English and released in conjunction with a Smurf figurine give-away at gas stations in Great Britain. Translations of other Smurfs media flooded into additional specialty stores and Smurfs-mania finally took hold of England.

The 1979 UK release of *Magic Flute* came with additional toys, books, music, and ephemera created for and aimed at an English-speaking audience. This breaking of the language barrier opened the door to a land the Smurfs had perhaps never dreamed of—the United States of America.

PEYO AND COMPANY

In 1979, Fred Silverman, then President and CEO of the National Broadcasting Company, returned from a business trip with a plush Smurf that his child went crazy for.

He was able to ply the doll away from his child long enough to take it to a meeting with Joseph Barbera, co-founder of the legendary animation house, Hanna-Barbera Productions, at which Barbera was essentially told to get the rights at any cost.

After a protracted period of negotiations which ensured a then unheard-of level of creative control by Peyo and his studio, an animated Smurfs series was commissioned and went into production for the 1981 television season.

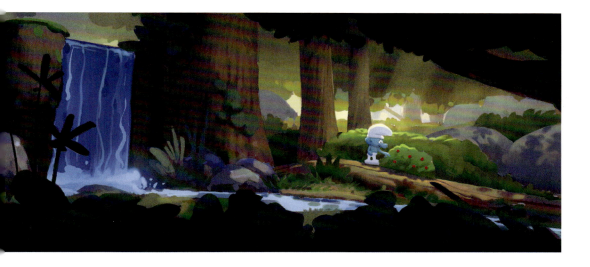

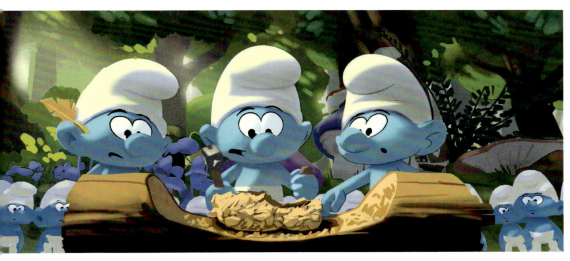

color keys by Jonathan Chu

Airing on Saturday mornings, when much of that era's children's programming was scheduled, *The Smurfs* began an impressive nine-season run on NBC, starting as a half-hour show, but expanding to 90 minutes at the height of its popularity as it brought in ratings which rivaled and sometimes exceeded those of live-action, primetime television shows.

The earlier excitement and marketing frenzy that happened in Europe during the '60s paled in comparison to the 1980s Smurfs explosion that was set off by the Saturday morning cartoon show. The Smurfs went truly global with touring live shows, theme park lands, and retail sales in the hundreds of millions per year.

The level of success was massive, if only for a relatively short while, as the show's cancellation prior to the 1990 season marked a period of perceived dormancy for the property, at least in America.

However, the Smurfs continued to enjoy success in Europe, having become cultural icons at the level of Mickey Mouse in their Belgian homeland—where new comics continued to be published, still under the direct supervision of Peyo, and the art studio which shared his pen name.

Following Pierre Culliford's death in 1992, his legacy was carried on by his son Thierry, who under his father's tutelage had become a cartoonist in his own right, and daughter Veronique, who had worked directly with Pierre in a different capacity, handling the business end of his empire.

While in the late '90s and early 2000s the Smurfs was wrongly understood as an artifact of the 1980s, the property launched a large-scale comeback in the 2010s when it was adapted into two CG/live-action hybrid films produced by Sony Pictures Entertainment.

New rollouts of the original comics, the Hanna-Barbera cartoons, and contemporary merchandise categories like app games and high-end adult collectibles stoked the love of longtime fans and new ones alike.

A third film from Sony, this time exclusively animated, was released in 2017, and was followed in 2021 by a computer-generated series using the characters from that film, this time produced by Dupuis and Peyo's company which had been calling itself IMPS since 1984, before adding an additional company, Lafig Belgium SA in 2005.

However, to dispel any confusion about who the organization was, and further honor their eternal guiding presence, IMPS president Veronique Culliford renamed it Peyo Company in 2024.

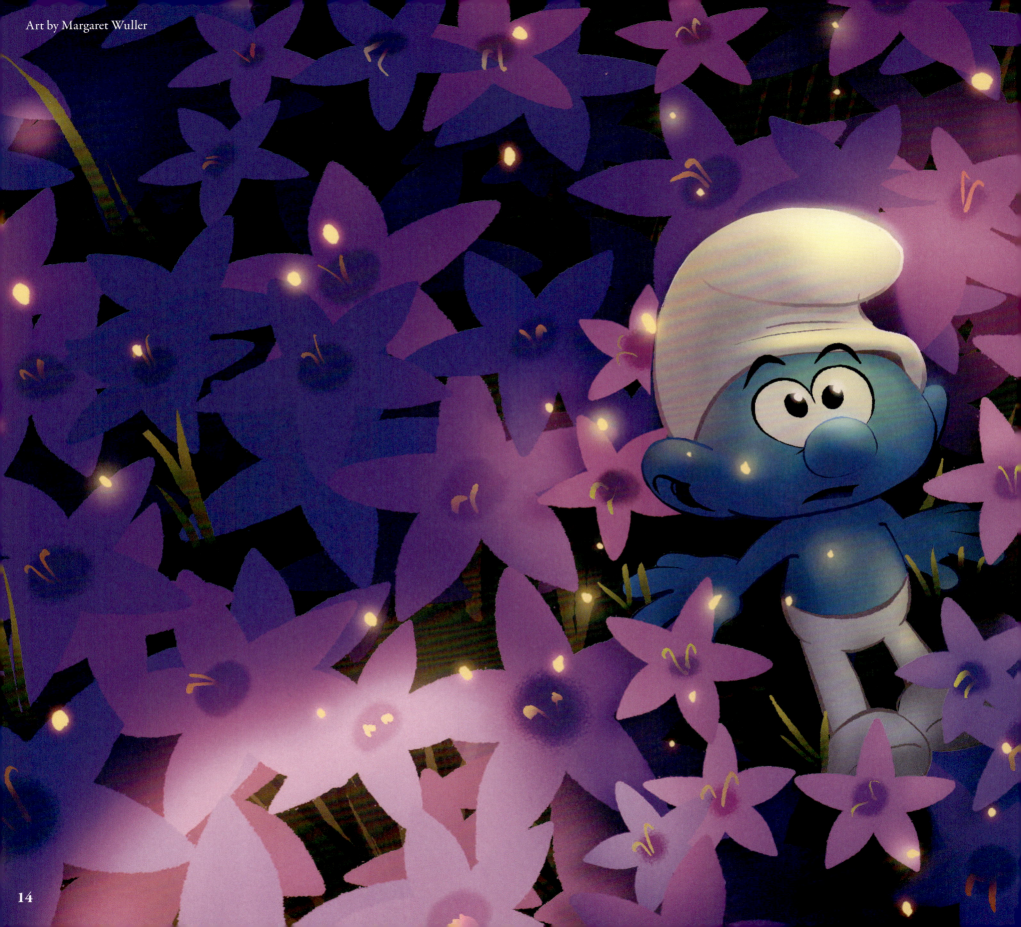

GET THIS SEARCH PARTY STARTED

MOUNT UP

 In a statement commemorating the partnership between Peyo Company and Paramount, and announcing the movie, Ramsey Naito, president of Paramount Animation, asserted that the company was "the home to some of the world's most popular family franchises" and "honored to add the Smurfs to that roster." She added, "We're excited to tell a story that stays true to its origins, but with a Smurf-tastic musical twist that excites new audiences and builds on the Smurfs franchise and universe of wonderful characters and stories."

 While the search began for a production team to usher the film to the silver screen, the announcement came with one key player already attached to the project: writer Pam Brady.

 Brady had extensive experience in animation as a writer and producer on over ninety episodes of *South Park*, but she might have seemed a strange choice, considering the stark disparity between the two properties. "Ramsey Naito, she worked back at *South Park*—she hired me, so she knew what I'd do," Brady said on the subject in an April 2025 interview. "I take the Smurfs super seriously. I love Smurfs. I'm psyched to be writing [this movie]."

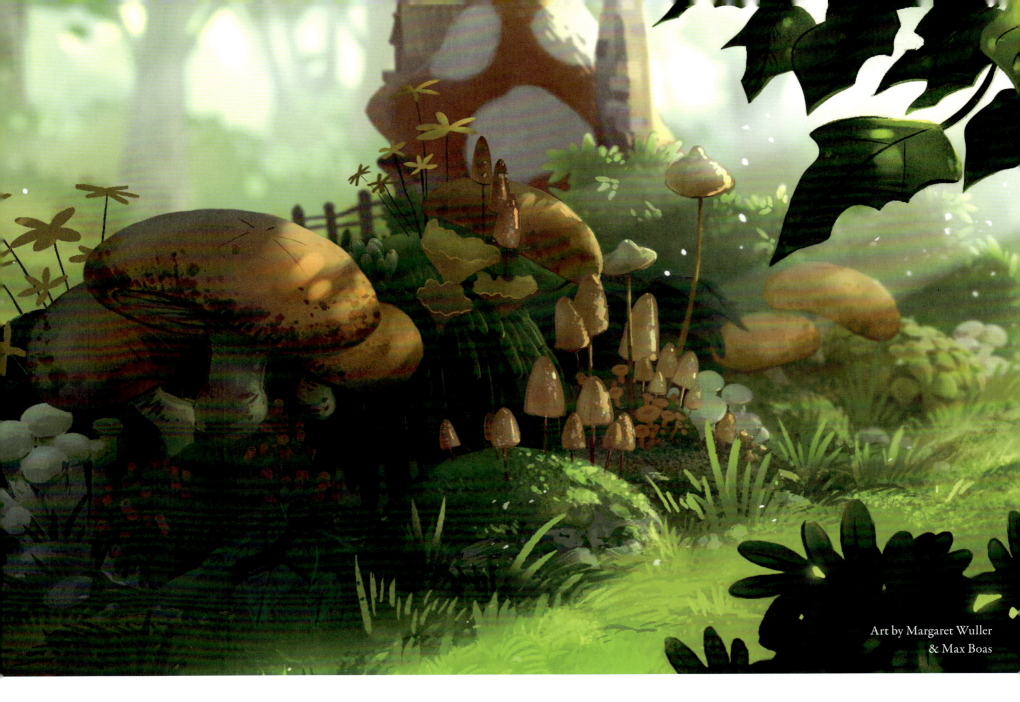

Art by Margaret Wuller & Max Boas

In the same interview, Brady confessed, "My first draft of the script was pretty weird." She elaborated, "We're trying to answer the question 'What is a Smurf? Where did they come from?' And the answer is kind of trippy. That's just as satisfying to me as it is to be satirical or politically relevant—being able to take an iconic franchise and be like, 'We're going to play with the canon a little bit.' I don't think it's subversive—to me, it's fun."

One of the people brought on board to oversee the behind-the-scenes process was producer Ryan Harris, who says about working with Brady, "Pam has this brilliant ability to bring a fresh perspective, offering an extremely unique voice and comedy."

To balance Brady's new takes, Harris, as producer, also reached out extensively to IMPS/La Fig to maintain the integrity of the property. "We worked very closely with the Peyo estate to ensure we were aligned on making this movie for new audiences while cherishing and respecting the brand," he says. "We had calls, Zooms, in-person meetings, and a very collaborative process from development through postproduction. It was a very positive experience."

TAKING DIRECTION

Meanwhile, the hunt for a director ended at the drawing desk of Chris Miller, who had studied at the prestigious California Institute of the Arts before building a successful career in the story departments of celebrated films such as *Antz, Shrek,* and *Madagascar*. He directed *Shrek the Third* and returned to that franchise to helm *Puss in Boots,* which earned him a nomination for the Best Animated Film award from the Academy of Motion Picture Arts and Sciences.

As for what drew him to what was then being called *The Smurfs Movie*, the answer was simple: "The script, the first draft, is one of the things that attracted me to this [movie]," Miller says. "I initially heard that Pam Brady was working on it and I instantly went, 'Man, I love her work.' She's hilarious. I thought it was great. Totally spot-on."

He adds, "What I was feeling [from audiences] was this sort of general attitude towards Smurfs that 'Oh, this is really built for toddlers' and I wanted to make sure and change that. That's not to say three-year-olds aren't invited to the party, but that [should be] 3 to 103-year-olds. I wanted to make sure that the film was going to play to a larger audience. I guess you could say I wanted to make a movie that's gonna make me laugh, as much as I want to serve the audience."

Beyond the chance to entertain, Miller was also drawn to the idea of adapting the look of the Belgian *bandes dessinées* (BDs) that he had become a fan of at CalArts as a means of fulfilling himself creatively: "The thing that struck me immediately was that there was an opportunity here to use the original Peyo comics as a way of something that was classic to me and making it contemporary, taking it from the comic page to a computer-generated world that was immersive. Something that you could feel like you could reach into, that you could touch, that you could smell. I felt like that was long overdue."

Once in place, Miller got to work on building his team. "My initial job as a director is working with people I love, that I have shared sensibilities with," he says. "I had an idea for what I wanted out of the picture. But as a director, I have to surround myself with the best people that I know, that I work well with."

"Our mission in crewing this film was very simple," says Ryan Harris. "We hired the best [at] their craft while leaning into those who had a love and appreciation for the Smurfs brand."

Two key pillars of support for Miller's overall vision were put in place with the hiring of production designer Max Boas *(Kung Fu Panda)* and art director Margaret Wuller *(How to Train Your Dragon)*.

"I've had the pleasure of knowing Max Boas and Margaret Wuller for ages," says Miller. "I've known their insane talent forever but never had the chance to partner with them before *Smurfs*. They complement each other's skill sets seamlessly. They're both brilliant with color and design, with a vigilant eye towards detail."

In addition to a mastery of their respective crafts, both Boas and Wuller also fulfilled the second requirement of Harris' employment mandate: a familiarity with the Smurfs.

"I was a fan as a kid," Boas told an interviewer, referring to his love of the Hanna-Barbera animated television series. "I used to watch *The Smurfs* when I was like ten years old, Saturday mornings, waking up and watching the TV show in the '80s."

Wuller was equally enthusiastic, while offering a more vivid memory: "I'm a child of the '80s, so I grew up with the Hanna-Barbera cartoons, and I loved them," she says. "I also grew up in Southern California, so I didn't really wear shoes until I had to in grade school. And I had Smurfette flip-flops, which I wore all the time and really loved them. So, getting the opportunity to work on a movie like this, such a well-known and well-loved franchise, one that I adored as a kid, is just really a huge privilege."

Of the initial production meetings, Wuller says, "Early on, we had the privilege to meet the Peyo estate, which is run by Peyo's daughter. And just hearing their stories and really understanding the scope of how many people love this franchise is amazing, especially in Europe—it's even bigger than it is in the United States."

"We studied all aspects of the brand—the comics, the TV show, all of it," says Harris. "Some of our crew connected with the comics and others the 1980s TV series. It was such a wonderful process to hear each person's connection to these blue little ones. I think the 1980s TV show was thought of often."

Art by Kaitlyn Nguyen

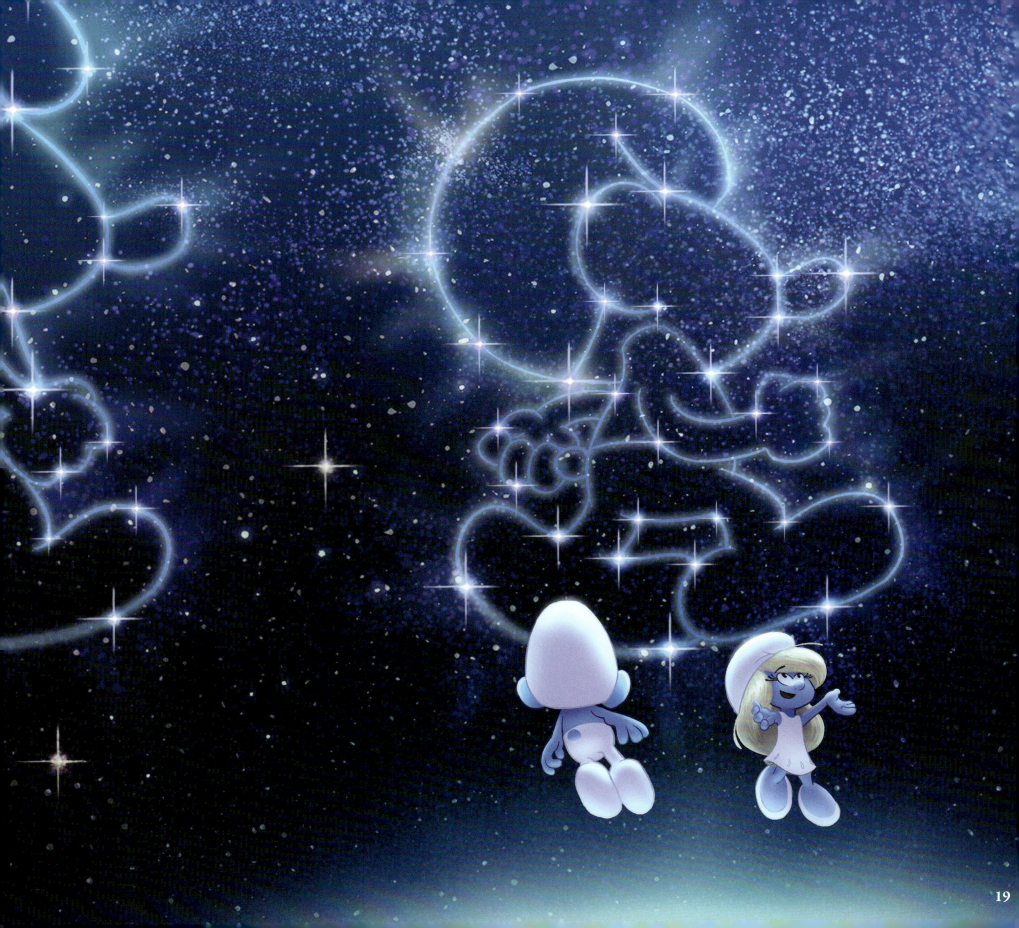

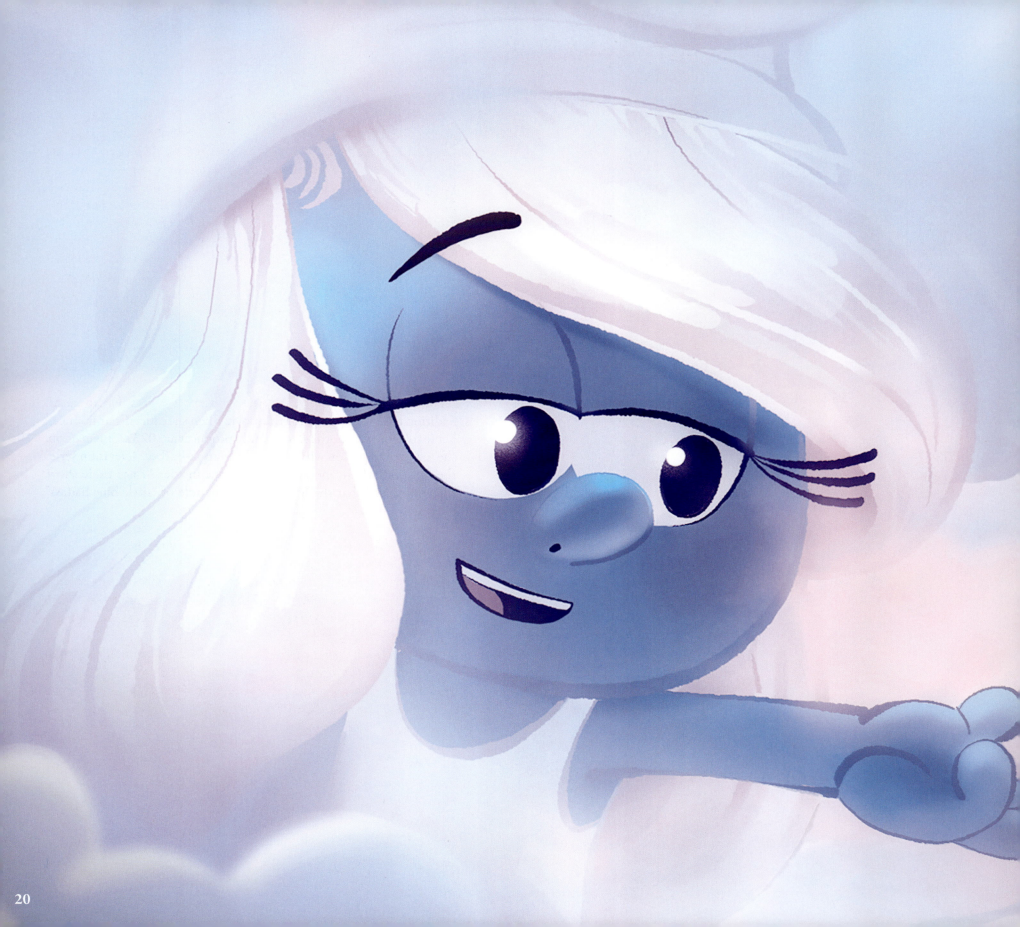

ENTER RIHANNA

Although a draft was the first thing in place for the growing team working on *Smurfs*, it's worth noting here that the screenplay of an animated film is never truly "finished" until the final prints of the movie have been shipped to theaters for screening. At the first-draft stage, Chris Miller explains, the team is working to develop the look of the film with both the story artists and the writer—"working two fronts simultaneously," as he puts it. "And really, I think the animation process in its entirety, it's all one big writing process."

Luckily for Miller and company, Pam Brady stayed involved throughout the process as other voices joined the proverbial party.

"You know, she's, of course, a pro," Miller says of his screenwriter. "She was on it, writing pages, but we also had story artists that would contribute, or I'd contribute. You get lots of contributions from everyone. But she [didn't] tire of the process or this project in particular." Brady was an "endless well of ideas," he says. "So yeah, very grateful for her."

Another contributor Miller was grateful for was Rihanna. In addition to building buzz for the movie when she officially announced her involvement as both an actor and a producer at 2023's CinemaCon, she may be the person who adores the Hanna-Barbera television series the most out of anyone involved with the movie. At the trade show, she announced that she had taken on the role of "little blue badass" Smurfette and would be providing original songs.

Her presence in the movie pre-dated that announcement, however, and was influential in moving along not only the promotional machine, but the production machine as well.

Miller remembers, "Coming on the movie and finding out that she was interested in being in it, I was like, 'Oh, all right, this is real, you got a really great script. Rihanna's interested. She wants to do something different.'"

He discovered not only a performer who was more than interested in putting a new line on her résumé but another partner who could contribute to the story—and not just musically.

"I don't know that there's a Smurf movie without her, period," he says. "She came in with an open heart, open mind, and also a history with the Smurfs. She knows more about Smurfs than anyone I will ever know."

He elaborates, "She knew [the lore] inside and out. She could quote stuff. I [would] sit there and pretend, like, 'Yeah, I remember that episode.' [I'd] have no idea what she was talking about. She's taught me more about Smurf things. It's very meaningful to her past. She made a huge difference."

Art by Margaret Wuller

SUBSTANCE AND STYLE

The story was laid out and an "all-hands-on-deck" approach was evolving.

"The narrative drive of the movie is: it's a rescue film," Chris Miller explains. "That's the short version of it, but the journey takes them around the world. There's a dimensional quality aspect to it, it's across dimensions and along the way, the Smurfs tap into this family secret: They find out that their place in the universe is much bigger than that utopian world that they've lived in. Sort of a higher calling."

But, according to co-director Matt Landon, "the relatively big challenge was trying to synthesize a version of the Smurfs that could exist in this big, giant world and then a movie that would create a whole new backstory, that could be a musical, that could introduce new characters, maintain some nostalgia factor, but also allow them to go on massive adventures and still have a viable musical thread to it."

Part of the answer came from the predetermination that the film would be a hybrid of animation and live-action—a conceit at first daunting to a production crew that had, for all their respective careers worked exclusively in animation, but they came to welcome the task of combining the two elements.

Production designer Max Boas believes that ultimately the breakdown was 80 percent animation and 20 percent live action, and in that 80 percent they would find their way through the story with a unique style. "We were in early discussions, talking to Chris about how much we loved the original comics from the '50s and '60s," Boas remembers. "Like, 'Oh man, the beautiful shape language, the character designs, the line weight, the thin, thick, the layouts of the background.' So all that was like 'Yes, let's embrace this look and try to capture that in the film.'"

He adds, "We have a lot of graphic elements in the film. There were thought bubbles, action lines directly inspired by the legacy comics." But he also opened himself up to inspiration from sources other than the Smurfs. "I guess another influence for me, personally, [was] some illustrators from back in my skateboarding days in the '80s and I randomly discovered these fantasy paintings from the 1970s and '80s."

A feeling came on that *Smurfs* would take on the look and scope of a fantasy adventure film from the 1980s, much like the movies many of the senior staff had loved and grown up on.

"I feel like with design and pop culture, everything is cyclical," acknowledges Margaret Wuller. "Like a bunch of the artists, Max and I are the same generation." Namely, Generation X, the group of children who were born anywhere from the mid-1960s to 1980. "You know, the '80s have come back several times over the course of my adult life. Everything really kind of cycles. And so part of this is just great things cycle back."

Character art by Tristan Poulain

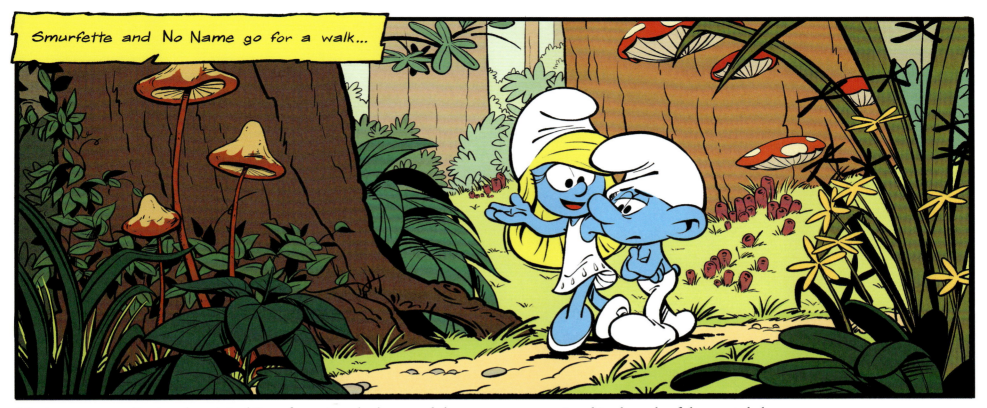

Movie moment replicating the original Smurfs comic style above, and the same moment painted in the style of the movie below.
Top: Art by Kaitlyn Nguyen. Bottom: Art by Margaret Wuller.

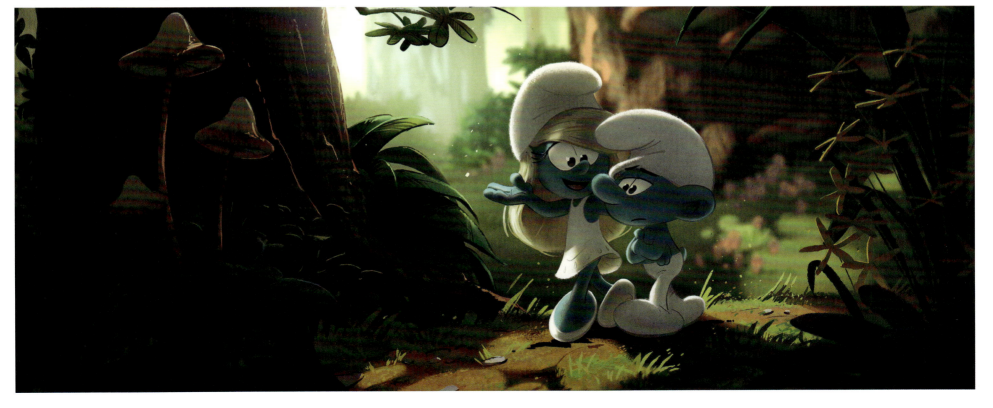

THE ART OF COLOR SCRIPT

In animation, a "color script" or "color key" is a linear sequence of illustrations that represent key scenes and establish the color palette for a movie, allowing for the filmmakers to map out the lighting and emotional beats. It enables the team to maintain visual and narrative consistency throughout the course of the project, linking specific colors to certain characters and moods at particular points in the story.

It's normally one of the earliest pieces of production art created and is the purview of the production designer, who is responsible for updating it over the course of the film's assembly.

When discussing his process during an interview for this book, Max Boas took the time to review some key points of a Smurfs color script draft dated July 12, 2024. "It's a thinking process early on. We're using a full range of color palettes," he explained, starting with the first act of the film. "You know, we're staying very warm green with our Smurf Village at the beginning as a concept."

He then moved through the timeline of each scene, with a focus on how the artists envisioned the different elements and users of magic. "We have different color palettes for different characters. So, that magenta is our evil color, it's Razamel's rise to power. No Name's magic is violet. The wizards' is colored hot pink and then when the Smurfs are powered up, it's our Smurfy blue color at the end."

When he reached the third act, he remembered wondering, "What is the actual color that we're going to be working with?" He used the map to explain the answer: "You can see there's that hint of magenta. So, Razamel's gaining power, he's trying to get the magic grimoire [for the wizards], so that pink shows up and then in the big action scene, there's a really dominant swirling vortex that has that pink color [before the blue]."

After the battle, the film returns to the Village, "which is very warm and green and happy again, that's kind of the feeling there." He mentioned reenforcing the bookending emotions as cued to the audience in their dominant colors.

He concluded, "There are multiple versions of this as I was working, making sure the whole movie is going to come together." However, this draft strongly resembles what made it to the final cut.

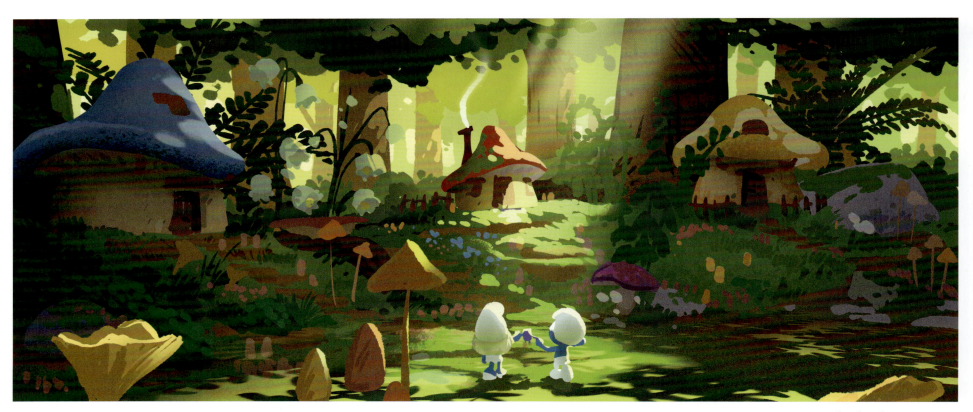

Color key by Max Boas

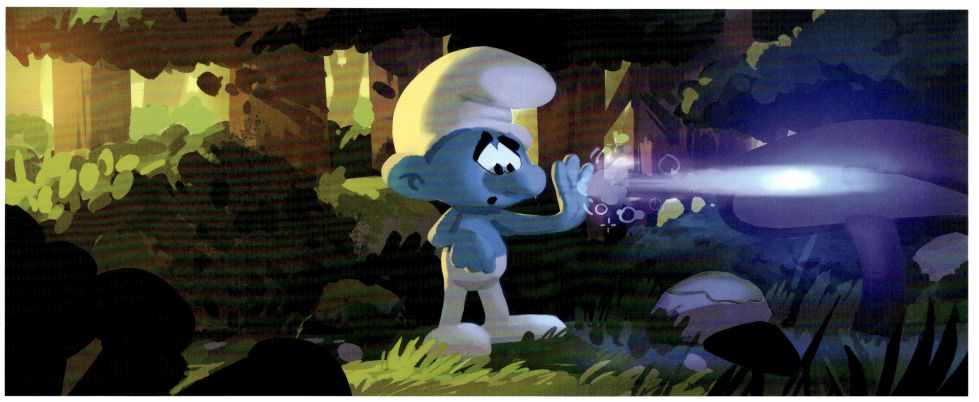

Color key by Jonathan Chu

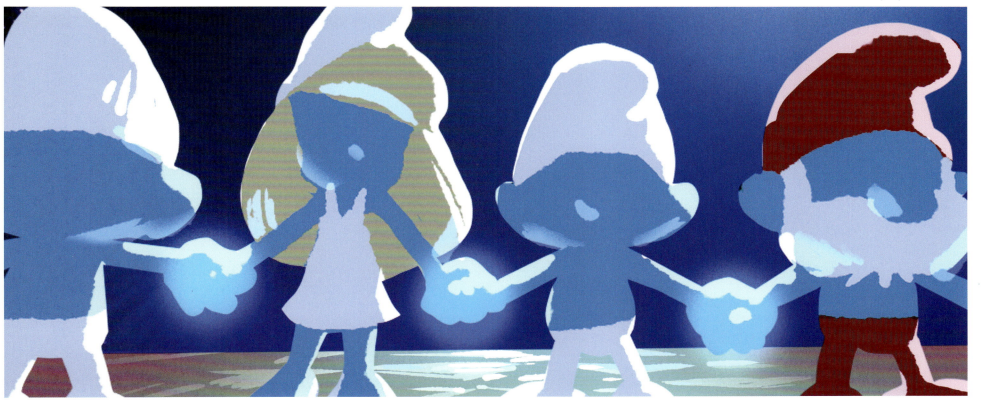

Color key by Max Boas

WELCOME (BACK) TO THE VILLAGE

Smurfs opens with a reintroduction to the Smurfs and their village before taking the audience on one of the biggest rescue missions ever: to save Papa Smurf! On their journey, the Smurfs discover a long-kept secret that defines their destiny, not only in their world but in ours.

Leading the quest is No Name, the only Smurf without a "thing," along with his biggest cheerleader, Smurfette—who encourages her friend to find his identity. The story opens on a day that's as nondescript as our hero, until the little Smurf without a name makes a wish to finally find his "thing."

His wish is granted. He's given magic powers he has barely been able to conceive of until this moment. He uses them to open a portal from Smurf Village into another dimension to take his newfound skills for a joy ride, only for Papa Smurf to be sucked into the vortex. Before disappearing, Papa yells a mysterious phrase: "Find Ken!"

Art by Margaret Wuller

SMURF VILLAGE

In the early comics, Smurf Village is historically located in what humans call the Cursed Land (*"Le Pays maudit"* in French) nestled in the wooded valley between the mountains and the Smurf River. For as long as anyone can remember, the enclave of mushroom houses has never been found by any human explorer without the help of a Smurf guide or a magic spell to lead them there.

"Life is good in Smurf Village, right?" Chris Miller asks rhetorically. "Every day is a gift. It's utopian. It's beautiful. You start your day with, maybe, some calisthenics and a song. Everyone has their thing. You're very safe and protected in this world—somewhere in the woods in Belgium."

"I would want to go into one of those little Smurf houses. They look really cute. I don't know where there are mushrooms this big, but if there are mushrooms this big somewhere, I would definitely want to check it out and go inside," imagines Margaret Wuller.

"The Smurf houses were very 'legacy,'" Max Boas says, cutting directly to the business of the 2025 film's design element. "Embracing what's so iconic in the comics."

"The source material, the original concepts, the early designs, the gestural comic book form was our visual blueprint," Miller states a little more soberly, offering again the mantra of the comics as a base plan. "As we developed the look of the world, we constantly referenced the early material."

Also coming around to the business end, Wuller expands that sentiment in her discussion of the influence the comics had on the design of the settings: "Initially you think, 'It's a 2D comic, such a different medium. Why would you have to go back so much?' But we really tried to integrate as much as possible to make it feel like the comic book, just with an amplified feeling of space. Computers can render reality really well now, like, hyper[real]. You see it in video games. We didn't want to go this route of 'Let's make everything feel really real' because that takes things away, maybe. We wanted to have this balance of everything feeling tactile but true to the [drawings]."

Art by Margaret Wuller

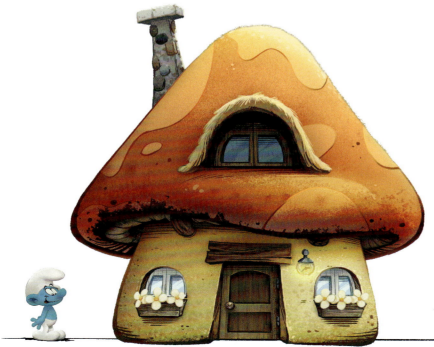

Art by Kaitlyn Nguyen

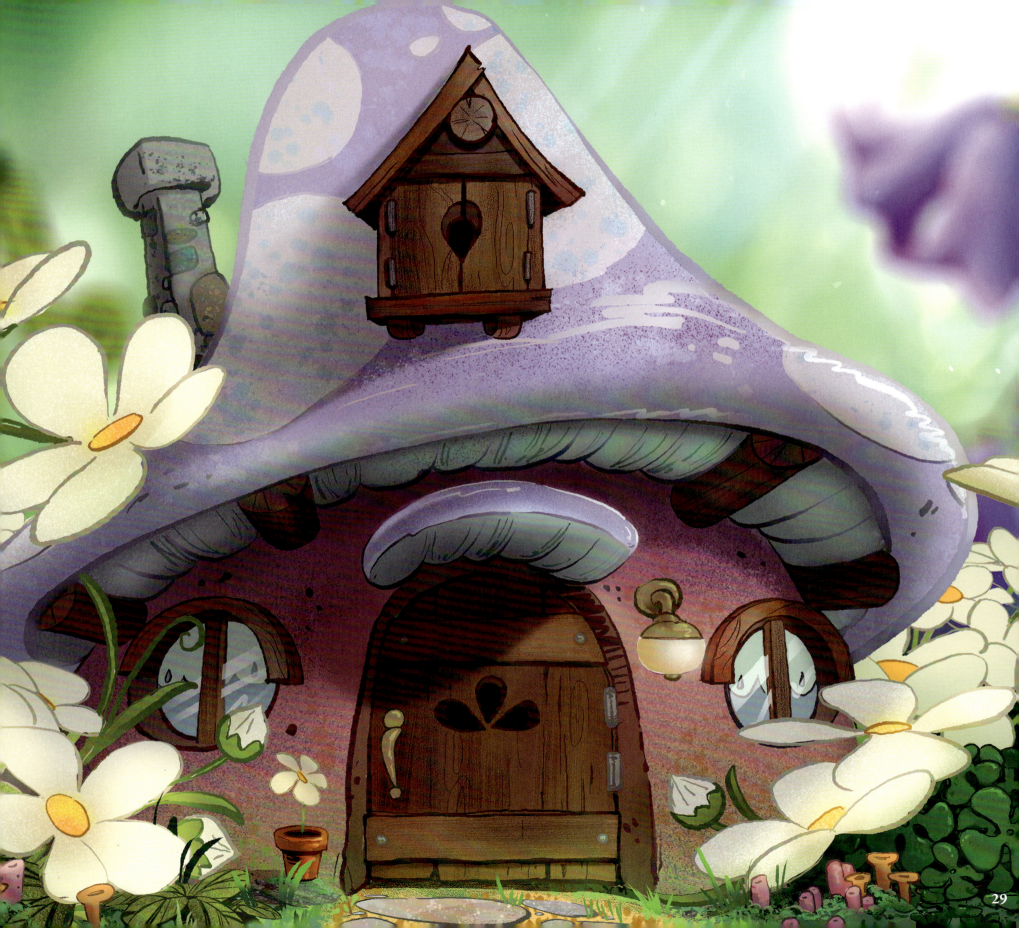

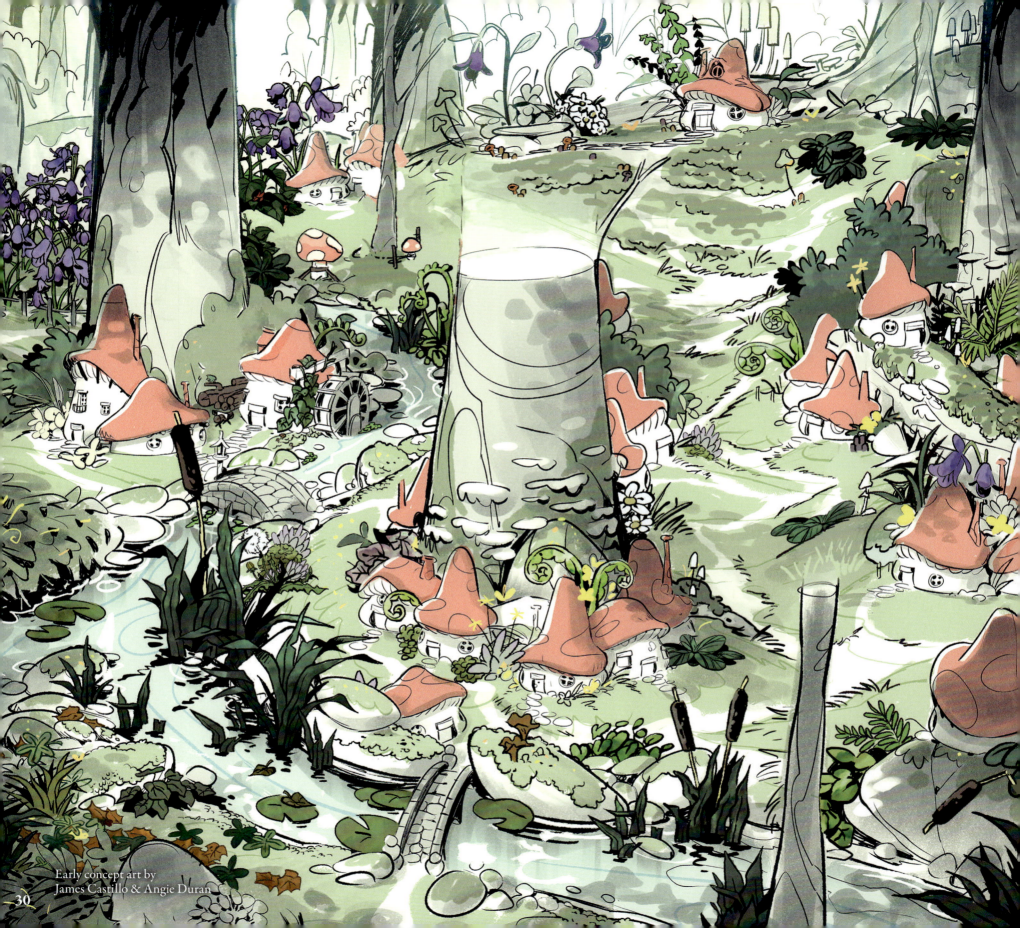

Early concept art by
James Castillo & Angie Duran

"I think early on Chris really wanted to push the magical quality," Boas recollects. "That's when I started looking at some of the '80s Smurfs, the Hanna-Barbera work. [They get] down low with these characters. Traveling through the forest, there'd be odd-shaped plants, leaning into more of a surreal quality—succulents and fungi, different shapes and how [the Smurfs live] with them."

"We took a little bit of liberty to change the topography of the village to allow for just more cinematic shots," admits Wuller. "You know—camera moves over the bridge, kind of going up into a hill, seeing different levels of houses. As far as the vegetation, some of the mushroom designs are directly pulled from comics, and then others, we took inspiration from succulents, even though those aren't found in the Belgian forest. But because their shape is so Smurfy, we incorporated some of those. We learned really quickly that things [with] a nice rounded shape looked the best. Spiky plants or really pointy grass just doesn't work with the whole look of the Smurfs."

"Something that was a little bit harder was the sarsaparilla," Wuller says of the plant that is the staple of the Smurfs' diet, "because the shapes are too complicated. We had to use that very sparingly."

Concept art by James Castillo

There is, it turns out, a scientific reason for that plant feeling somewhat incongruous in the film's environment—it's a very real plant that's native not to the magical woods of Central Europe but to rockier, more rain-drenched climes across the Atlantic in North and Central America. More commonly known as the flavoring agent of root beer, Peyo's writing partner Yvan Delporte had an affinity for the word and decided to make the herb the staple of the Smurfs ovo-lacto vegetarian diet. Its overall presence does lend an enchanting, pastiche element to the world both onscreen and off.

Another key to unlocking that magical quality was discovered in how the artists would express not just the shapes but the surfaces in the surroundings. Boas says: "The way [to] depict texture was something that we were analyzing, kind of distilling what's just enough line work, or mark making, that 'says' the texture with line, but still has a subtle handmade quality. Almost like an airbrush would back in the analog days of the '80s or '90s cartoons [with their] hand-painted backgrounds."

"One of the first thoughts that Max and I went through," according to Wuller, "was: 'What if we reduce our material properties, and by material properties, I mean computers render water well, they render metal well, and they render fur well, but we don't really need all of that stuff. That takes us it into [that] very hyper realistic realm [and] by reducing our materials to just a few, we have some highly reflective stuff, we have some soft things, but we don't really have a lot in the middle," like most metal or water.

She elaborates, that water as depicted in the Peyo comics "is very different than what real water looks like. It's very stylized. We wanted to get that stylization and then put an extra little 'plus,' in order to make it feel like it's a tactile thing, still maintain those very 2D graphic swirls and shapes."

A further "discovery" was the use of lighting. Per Boas, the goal of the film was to achieve "a comic inspired look in a volumetric space." He and Wuller found the "Peyo style" to be "flat and graphic, but everyone, the studio, the director, really wanted it to feel immersive and dimensional. How do we create dimension out of 'flat' and 'graphic'? Those are two contrasting ideas!"

The answer would be "flattening out the fill light, [emphasizing] a shadow side and key side of lighting, embracing the 'Peyo.'" They also noticed in the comics "there were floating leaves and grass blades that are separate—which doesn't make [natural] sense. There's a breakdown of physical volumetric light beams in that graphic space. So, using camera language, depth of field, we played with how the light would 'bloom out' with photography. We placed stuff in the air, like little dust [particles] flying around, but in our film, they're dots," again going back to the "hand-drawn" element. "We would call them 'Peyo dots.'"

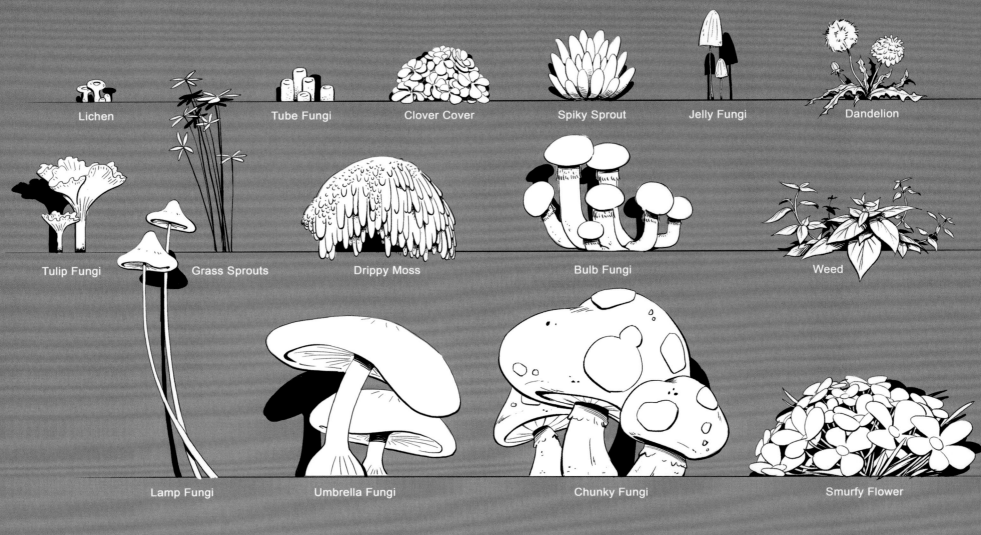
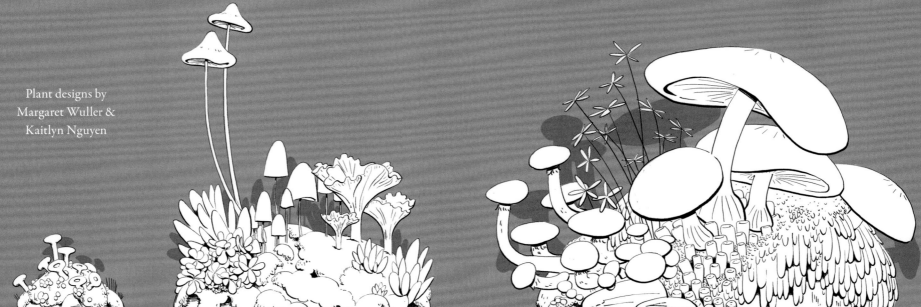

Plant designs by Margaret Wuller & Kaitlyn Nguyen

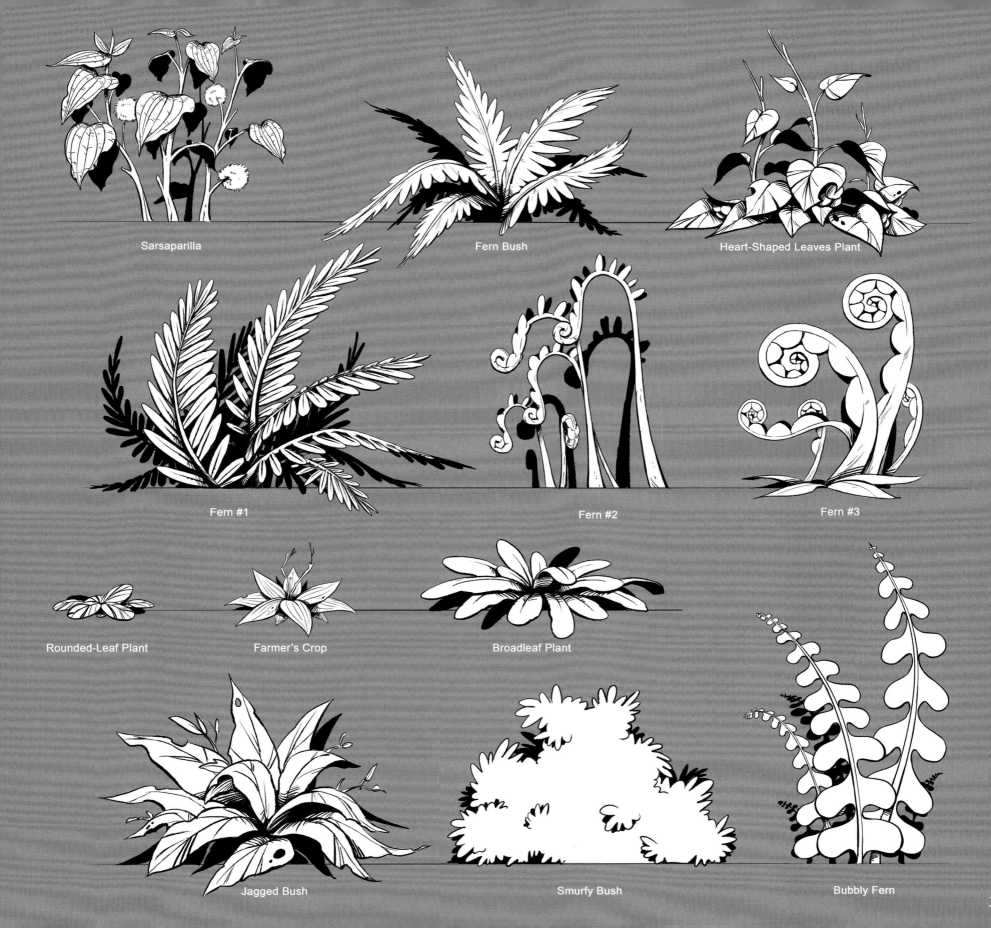

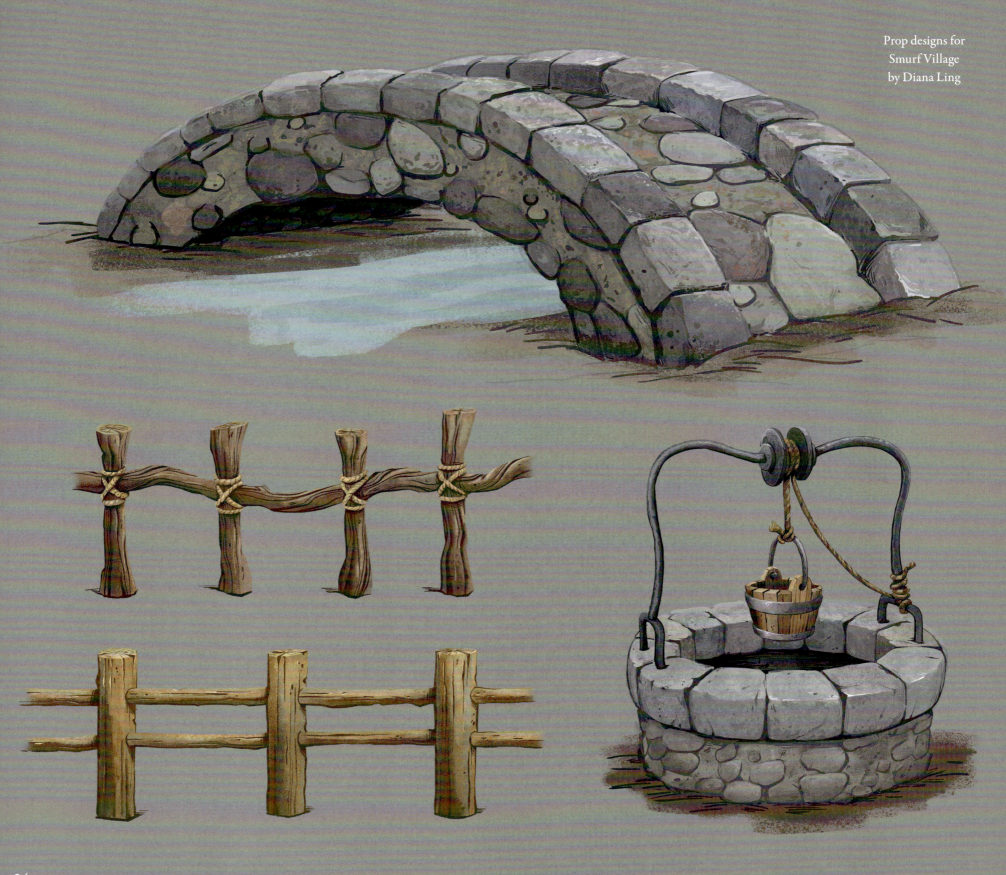

Prop designs for Smurf Village by Diana Ling

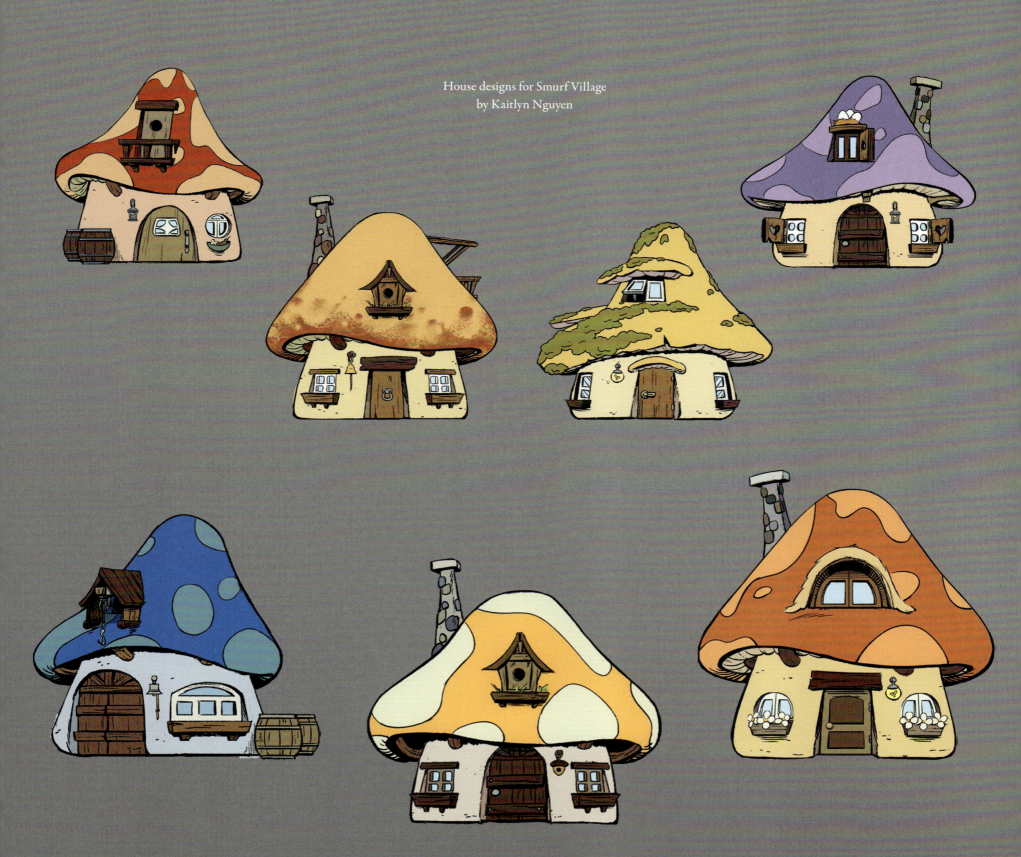

House designs for Smurf Village by Kaitlyn Nguyen

Color key by Max Boas

SMURFS SO BASIC

In moving on to discuss the movie Smurfs themselves, it's perhaps best to define what a Smurf is in form and function. The "generic" Smurf follows a basic model that is still used today no matter who is drawing them, or where, or in what media. Height-wise the Smurfs have often been identified as being "three apples high." In short, they're small. Six inches to be precise.

They're blue in color, a defining feature which was decided upon by Peyo's wife, Nine. As Peyo's colorist she designed the palette of his comic strips, and it was she who happened upon the shade that would best suit the Smurfs. Knowing that red would make them look angry and yellow would be too strange, she played with a particular blue that would make them pop from the forest greens of their surroundings.

The "generic" Smurf wears a somewhat floppy white bonnet that is based on the Phrygian caps traditionally worn by "magical folk" in some European fairy tales. To Peyo, the Smurfs were chiefly about community, first and foremost. The individual identities they exhibited over time were always in service of the greater whole of Smurf-kind. Their ensemble is made complete by a pair of footed white pants that have a hole cut out to accommodate their nubby little tails.

The actual look of the Smurfs can vary depending on the medium or even from individual artist to artist, but Peyo put in place a standardized "model," including a specific hat shape and a guide to line weights, around 1963. It has been adhered to in almost every interpretation of the characters since.

Smurfs production designer Max Boas offers a technical explanation for how he approached translating the model of the "generic" Smurf with his team: "As

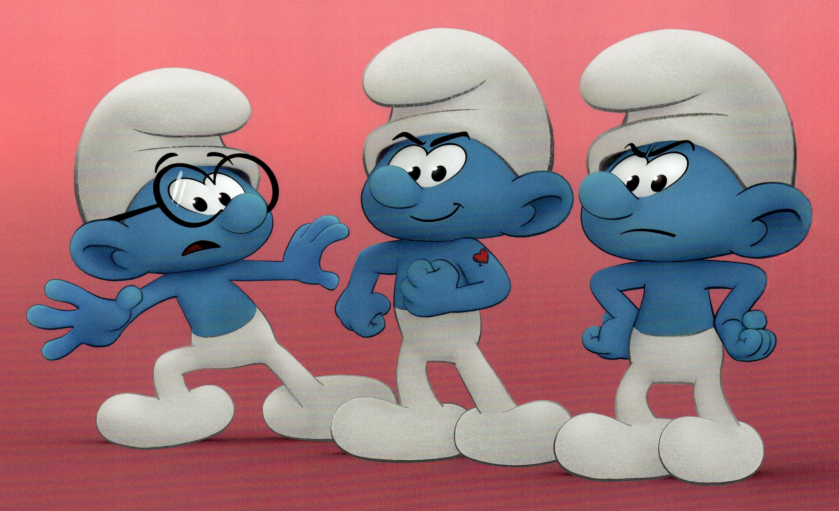

Character models by Cinesite; Paint touch-up by Margaret Wuller

far as our character breakdown, there was a lot of analyzing the Peyo comics. So, really graphic eyes, the eyebrows are floating, [just] pupils instead of irises, eye whites that are nice and bright. I really wanted to embrace the appeal the legacy comics have, which makes this all a challenge, but very Smurfy. I wanted to have that nose break the silhouette, have the hat break the silhouette. There's almost a hierarchy with the values of our whites. Eye spec [reflective quality] would be the brightest, then eye whites, then hats and pants or shoes. It's almost like three values of white that we were playing with.

"What is our Smurf skin color? We talked early on. We had to find our target—not too dark, not too purple, somewhere in that cyan blue range. How do we make it feel tangible but graphic? We thought of food as a fun, playful insight in the art department: 'Maybe their skin is almost like gummy vitamins?' It has that spongy gummy-bear kind of feeling, a little translucency to it, a little bit of toothiness, but just enough. Not too detailed, not too real. Definitely wanted to stay away from realism in that way."

"I mean, I can't take blue away from them," Margaret Wuller says of the iconic Smurf shade. "They own it at this point. They own it. Just maintaining their blue color so it always read perfectly and their hats always read as white, because white is a color that can really take on the environment. If you wear a white hat into a room with a red light, it'll turn ruddy pink. But we couldn't do that, the hat is the icon. So, keeping that always crisp was also something very intentional. That's the good thing about animation. We can always adjust it to make sure that it's nice and crisp and white."

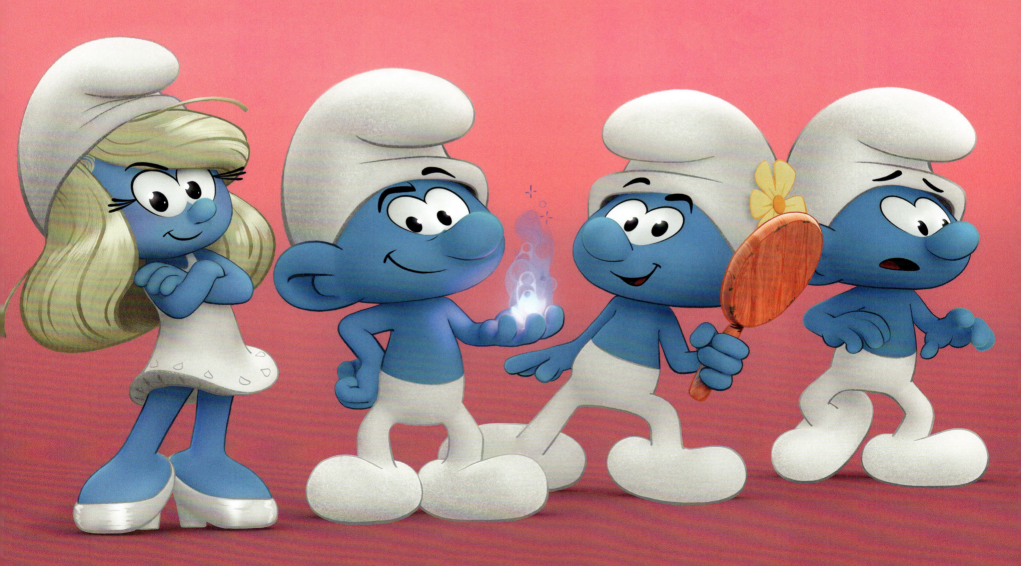

Smurf poses
by Tristan Poulain

Hand turnaround
by Tristan Poulain

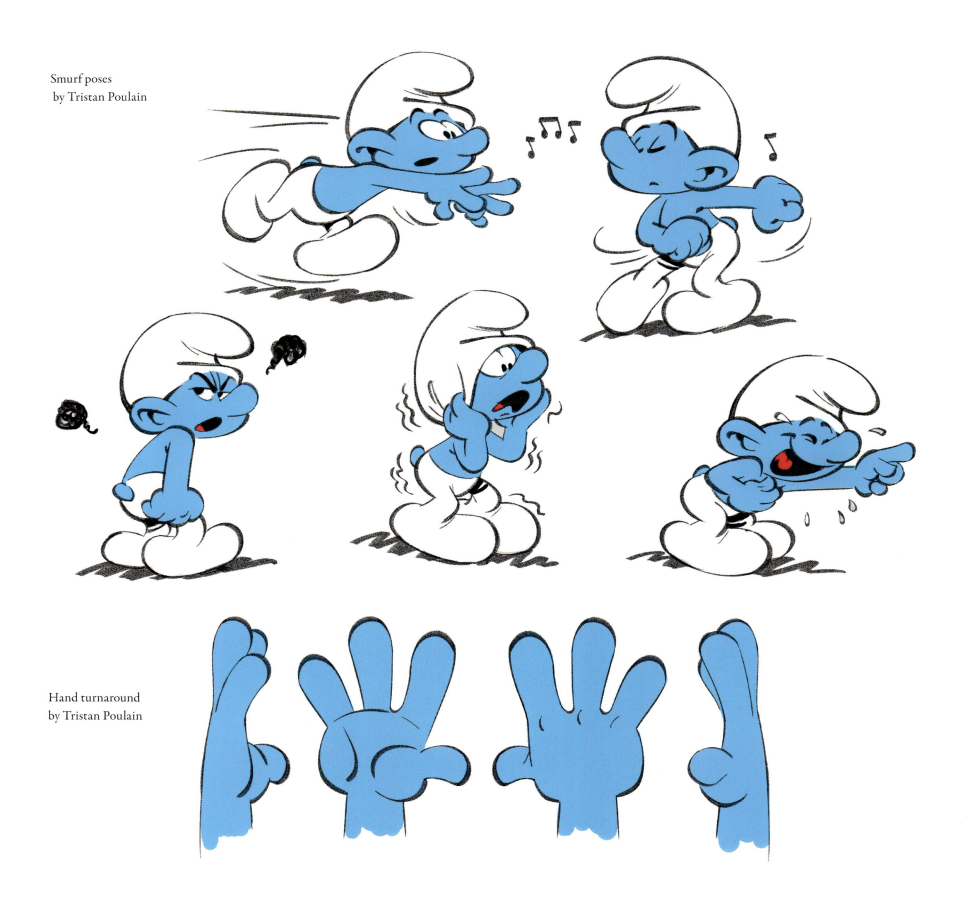

Once the design was agreed upon, the artists sent their model to the Canadian company Cinesite, Paramount's animation partner on *Smurfs*, to perform some animation tests. The Cinesite team built a rig—meaning the motion controls—into the design. "If the character turned its head, that hat silhouette would pop to the next side. So, if it rotated, they would have the controls to break the silhouette, to break physics, really, to go 'freeform.'"

"There were tricks in order to work with their head shape and their expressions," adds Wuller. "We could slide the mouth around. Because, yeah, in the drawings, it looks great—but then when we [translated] these characters into 3D, and we were [working] a turnaround"—spinning the character 360 degrees in virtual space—"and their 'side mouth,' all of a sudden, looked really weird. Even the eyes, the joining of the eyes, looked weird. So, there was a lot of attention taken to making sure that the compositions of shots, especially where we're really hanging on a character, weren't front-on because that wouldn't translate quite as well."

"As soon as the model was shot from front view, it would break apart," Boas bemoans. "It came down to the camera. So, there was an early discussion of camera work: 'Let's not have the camera move around a character.' But that was a limitation [director Chris Miller] didn't want to have."

Boas continues, "So, we would push the eyebrows above the hat, playing with the hat silhouette and having it be based on 'appeal,' always trying to think about, 'What's an appealing look for them?'"

Once the results of those in-depth discussions were relayed, Cinesite provided "two or three shots, seeing our Smurf built and animated, with our character curves on it, and our set pieces," Boas says, "And seeing all that come together for the first time, that was a great kind of moment."

That success allowed them to move on to the rest of the big blue cast.

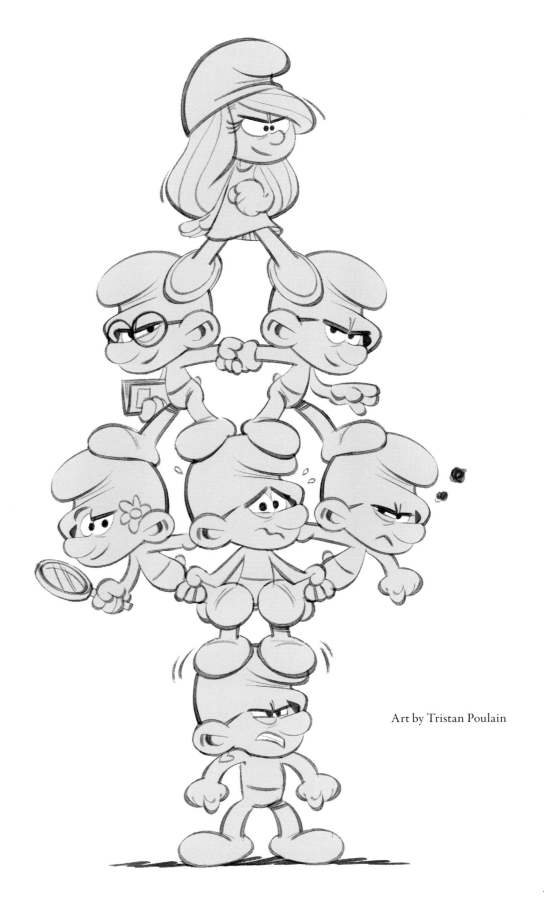

Art by Tristan Poulain

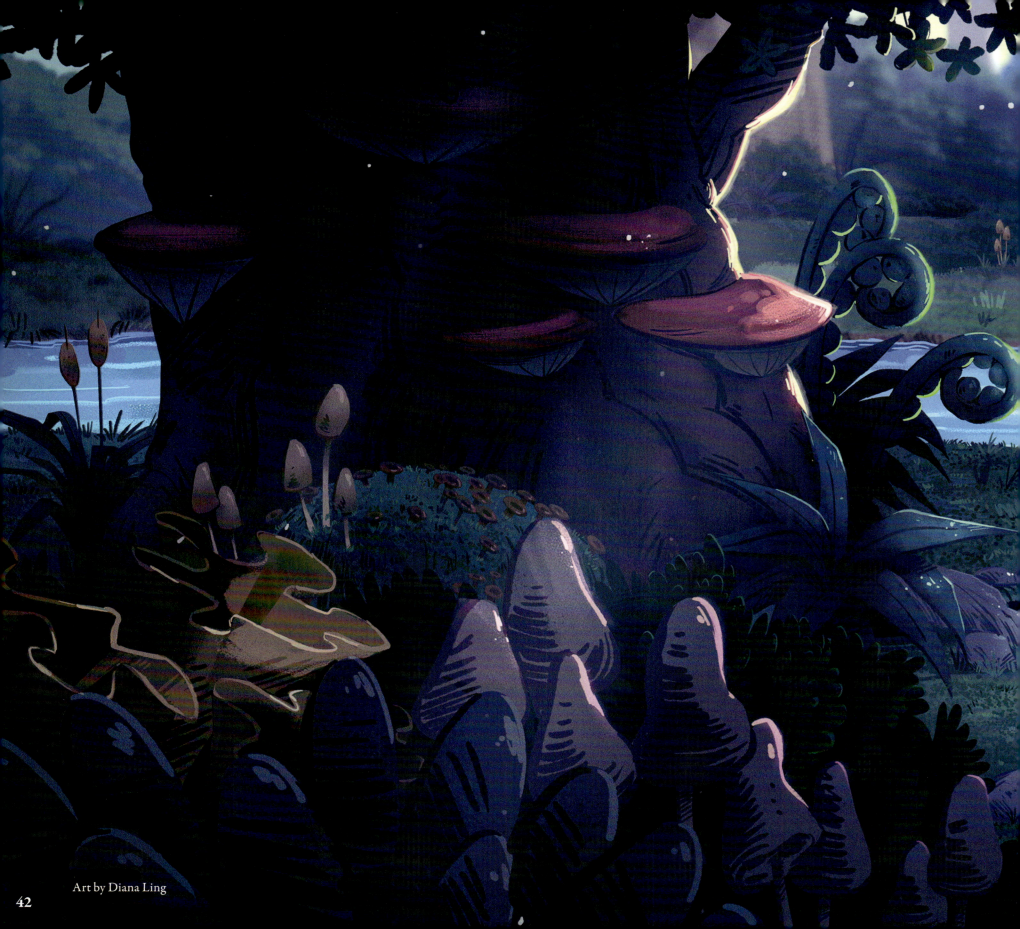
Art by Diana Ling

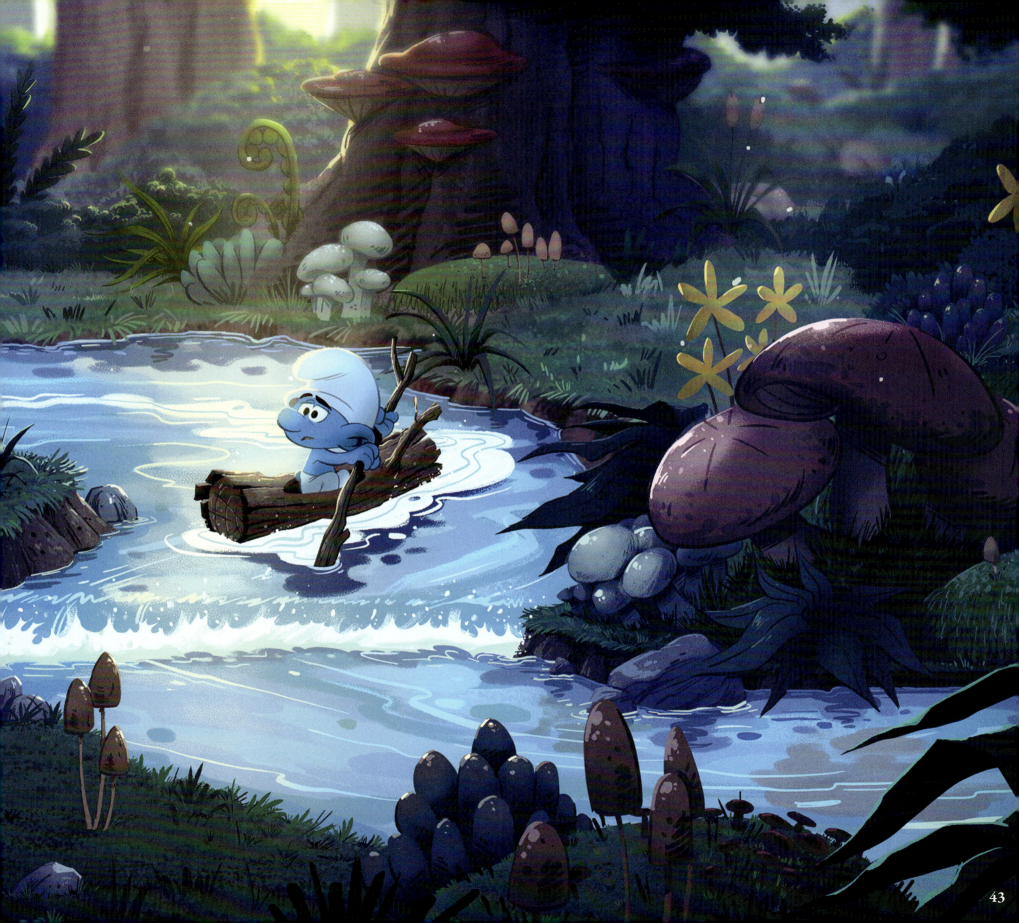

PAPA SMURF voiced by John Goodman

Papa Smurf is the founder and head of Smurf Village, and the first Smurf to have his own identity. A powerful practitioner of magic, Papa was introduced as a mystical advisor to humans in the pages of *"La Flûte à six trous,"* the *Johan et Pirlouit* yarn that would eventually come to be known as *The Smurfs and the Magic Flute*. In that story he owns up to being 542 years-old (the rest of the Smurfs only being about one-hundred years-old or so.

"Papa is this paternal, protective figure," states Chris Miller. "His one goal in life is just to keep his Smurfs safe. We delve into the creation of Smurf Village and what compelled Papa to create this sort of utopian place, this place where everybody can have a 'thing,' have a satisfying, fulfilled life, and be safe, safe, safe."

Art by Tristan Poulain

Art by Margaret Wuller

Mouth expressions
by Tristan Poulain

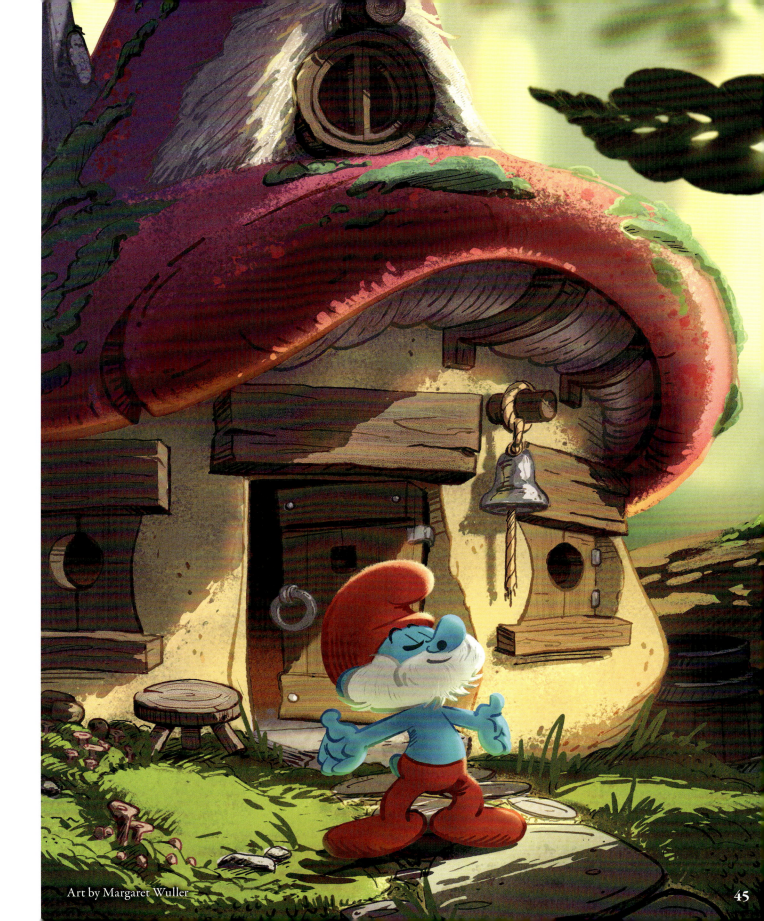

Art by Margaret Wuller

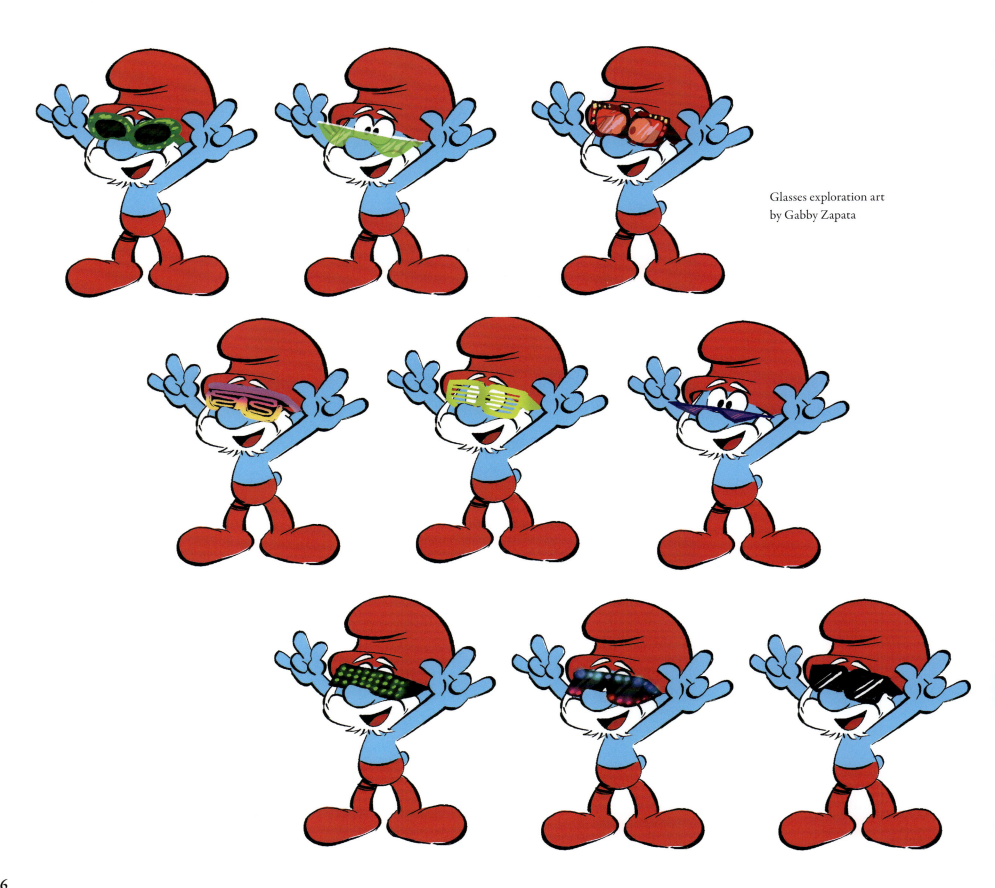

Glasses exploration art by Gabby Zapata

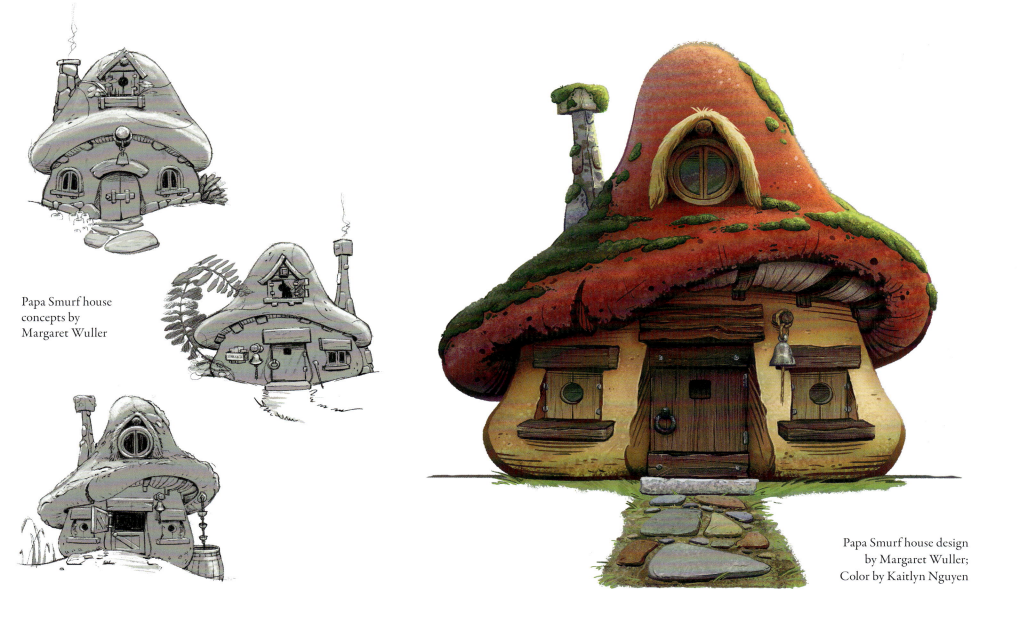

Papa Smurf house concepts by Margaret Wuller

Papa Smurf house design by Margaret Wuller; Color by Kaitlyn Nguyen

It's quite a twist then, when it's Papa Smurf himself who is stolen into a vortex and his young protectees have to set out and find him to bring him back safely.

"You know," muses Miller "I think the lesson learned for him is like you can't just shut yourself away from the rest of the world. You can still live there. It's a lesson that was a long time [coming, though]."

Concensus among the cast and crew was that the casting of Papa's voice was, in a word: "perfect."

"We wanted to cast John a year before we actually ended up getting him," admits Miller. "That's somebody we wanted from the jump. Yeah, it's pretty great. He's great."

Visually, Papa doesn't deviate too far from the basic Smurf, except for the color of his hat and pants, a change made by Nine Culliford to denote Papa's difference in status. As for the choice of hue itself, red became the chief candidate as it was a primary color and a component of blue's complementary color so it would contrast well with his skin.

The only issue with bringing a page perfect Papa to life was his beard, which according to Margaret Wuller had to be "cheated"—much like the other Smurfs' mouths, "so that it always had this perfect angle to the camera."

VILLAGE SMURFS

For the purposes of this book, these are characters who, over the course of the Smurfs' history, have shown they have a "thing" and were "properly" named within the existing canon of comics, animated cartoons, movies, etc. up to and including this very film.

As previously mentioned, as part of their assigned identity these Smurfs have also been given some bit of added detail to their design to differentiate them from the others. The ones featured in 2025's *Smurfs* are, in no particular order:

Brainy visual development art by Tristan Poulain

BRAINY SMURF: Brainy is depicted as an insufferable know-it-all who is quick to preach to his fellow Smurfs about their perceived shortcomings or the sometimes overstated virtues of Papa Smurf (who can barely stand Brainy's sermonizing himself). Brainy is often rewarded for his condescending attitude with swift punishment. Xolo Maridueña voices Brainy in *Smurfs*.

Brainy character art
by Gabby Zapata

VANITY SMURF: Actress and writer Maya Erskine provides the voice for Vanity in this production. Vanity Smurf is, as his name tells us, almost exclusively concerned with his own appearance.

HEFTY SMURF: Hefty is the strongest, toughest Smurf in the village. Hefty can be identified by his heart-shaped arm tattoos. He's voiced in this movie by Alex Winter.

GROUCHY SMURF: Once a regular-tempered Smurf, he was, like all the other inhabitants of Smurf Village, turned "grouchy" by the Bzz Fly pandemic in the pages of 1959's *The Black Smurfs*. Unfortunately, Papa's tuberose pollen cure wasn't able to completely cure Grouchy of the affliction, leaving him with a disposition to hate everything and tell the world about it. *Smurfs* director Chris Miller pulls double duty by voicing him in the 2025 film.

WORRY SMURF: Worry Smurf is the one vortex adventurer newly created for *Smurfs* and is voiced by Billie Lourd, a third-generation Hollywood actress.

Art by Gabby Zapata

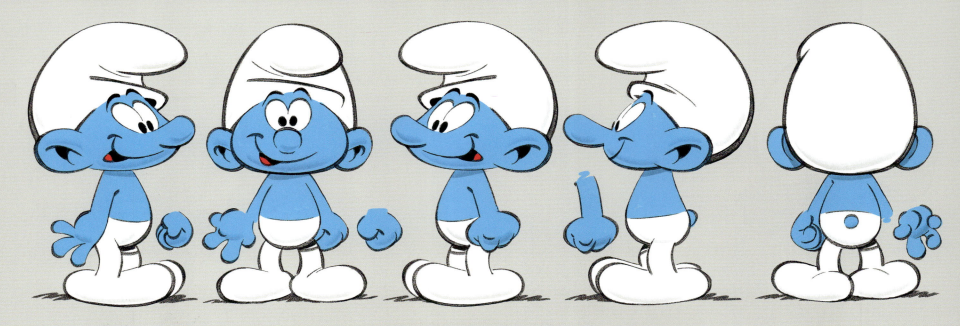

Turnaround art by Tristan Poulain

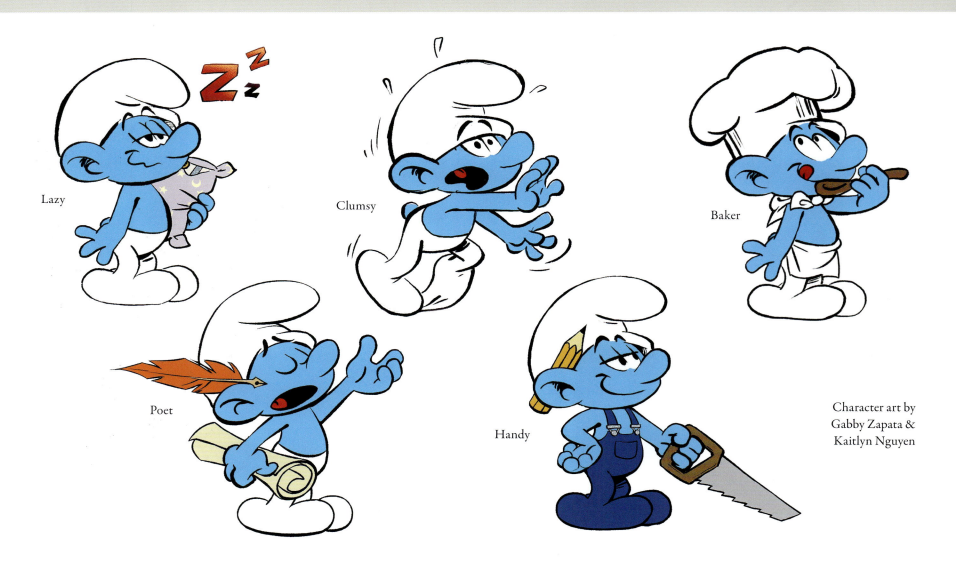

Lazy

Clumsy

Baker

Poet

Handy

Character art by Gabby Zapata & Kaitlyn Nguyen

50

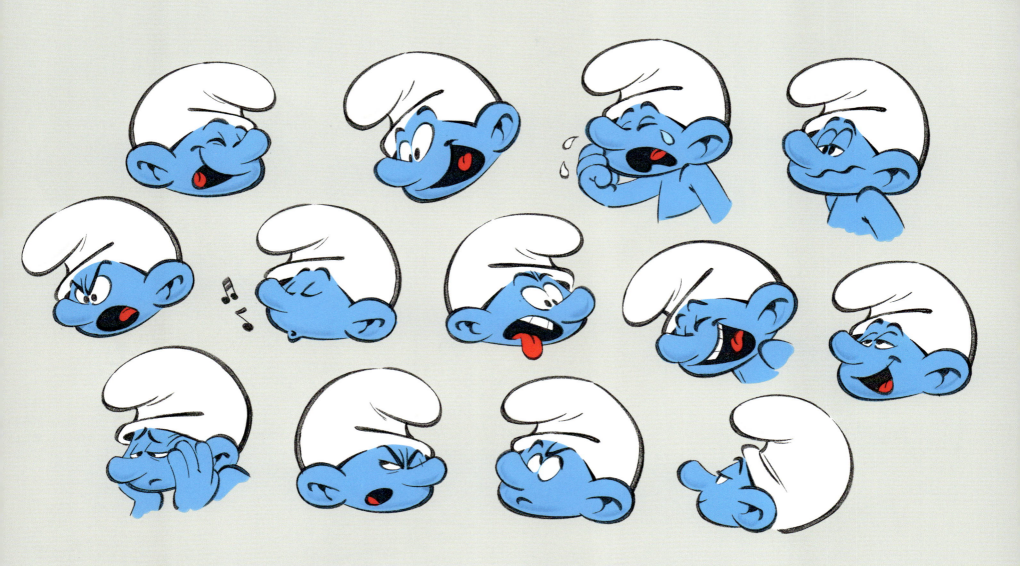

Smurf expressions by Tristan Poulain

NO NAME voiced by James Corden

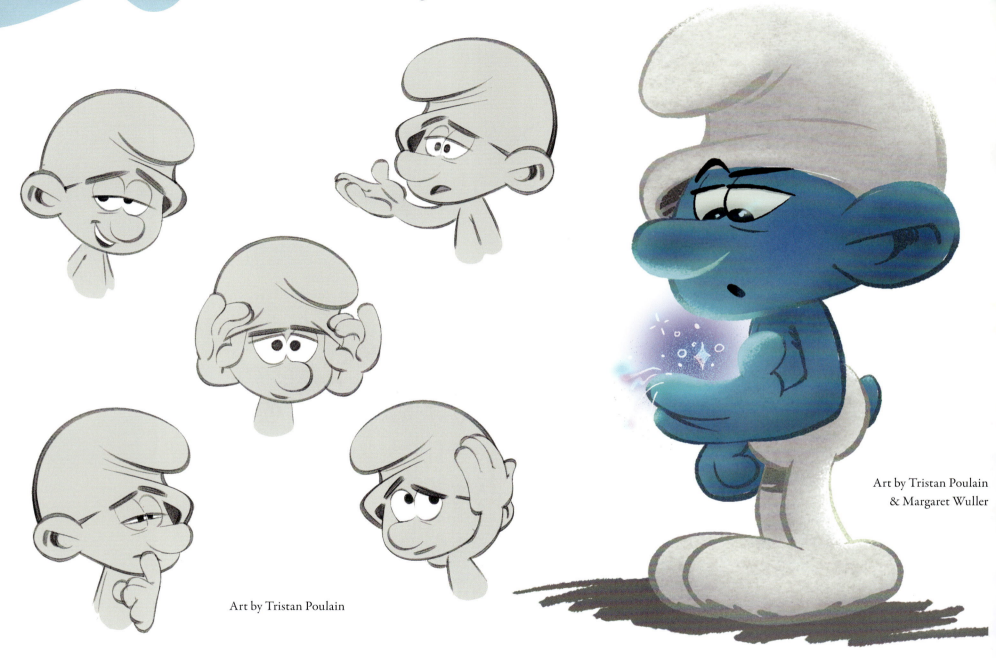

Art by Tristan Poulain

Art by Tristan Poulain
& Margaret Wuller

No Name was created specifically to be the "lead Smurf" of the 2025 film. "In [this] world where every Smurf has 'a thing'," says Chris Miller, "you're born with your identity. [But he's] 'No Name,' which he cannot come to terms with, this not having a thing. It's making him crazy, actually. This sort of obsessive hunt."

No Name is not completely alone, however. "Smurfette is his best friend," Miller assures us. "She can relate to him because Smurfette is not actually from Smurf Village. She knows what it feels like to be an outsider and that's really the root of their friendship. She tells him to hang in there. She knows what it feels like to not belong, to feel like an outsider and just encourages him to embrace what you have, the love of your friends, your community. And eventually you're going to figure out who you are."

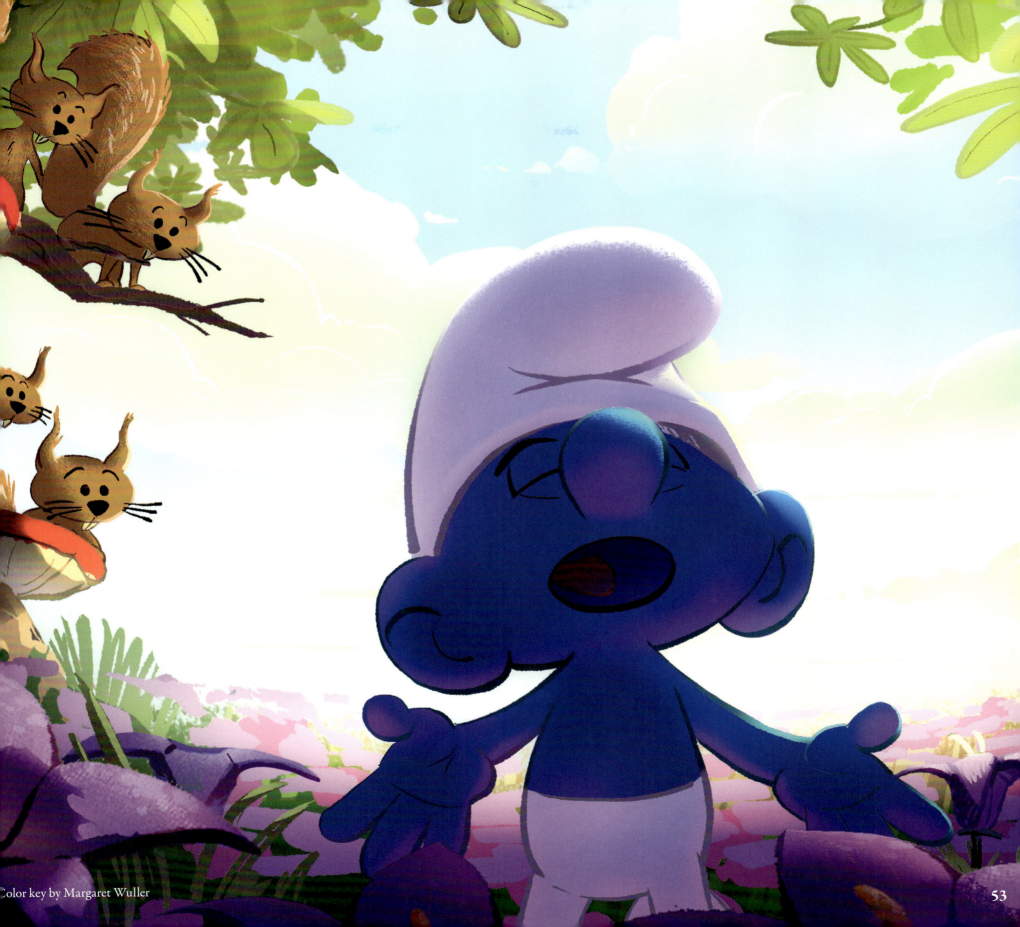
Color key by Margaret Wuller

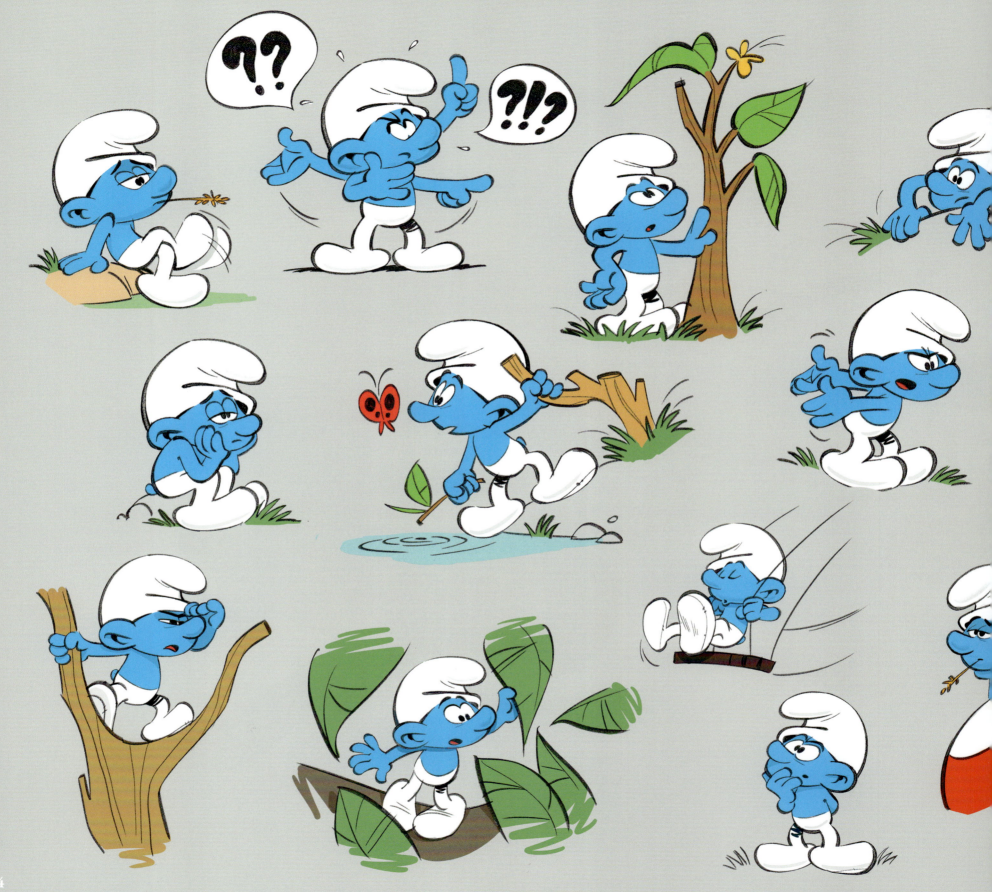

"And then he's given it, or he thinks he's found it, and it's like this light bulb goes off for him. His whole life has changed and opened up."

That's only the beginning of his journey (and the film) though. "It's his realization through the course of the story that he's really part of a bigger 'thing.' It's actually not about 'me finding my individual stamp,' which feels like a good, contemporary message. No need to be in a spotlight, or be about self more than community; Your individual strength actually comes from your community."

Visually, Max Boas describes No Name as "the ultimate generic Smurf."

"He's just blank," agrees Margaret Wuller. "To try to pull him out from the crowd was really a struggle. We had all of these different devices, like bags and scarves and name tags and all of these things to label him. But, it always brought him out too much and it defeated the purpose, because he's supposed to be generic. He's supposed to just be one that can get lost in the crowd."

"So, we gave him these little under eye bags," explains Boas. "He's concerned. He's always worried about who he is. His eyelids are a little droopier compared to a wide-eyed Smurf."

"He's got the hooded lids," adds Wuller. "He doesn't have the side crook in his mouth. It's just more of a gentle little swoop. His expressions are a little bit more unique to his journey [than the other Smurfs], and I think that decision to go that way is just so lovely, and so pure without kind of sticking a label on him."

That kind of thoughtfulness in the design and animation required similar effort from his vocal performer, and Matt Landon believes they got that performance out of James Corden.

"No Name is the heart and soul of the film," Landon says. "There's a vulnerability to that character and the performance that James brought to him. There's charm, and there's humor, and he sings beautifully in the film. It's one of my favorite moments when he sings about his inability to connect to Smurf Village and, you know, it's a trick. It's a trick to do that with a character and not make them feel [like a] sad sack. He's vulnerable, but he's smart and he's self-aware, and I think all of that stuff comes through. And, you know, we were lucky to have James Corden."

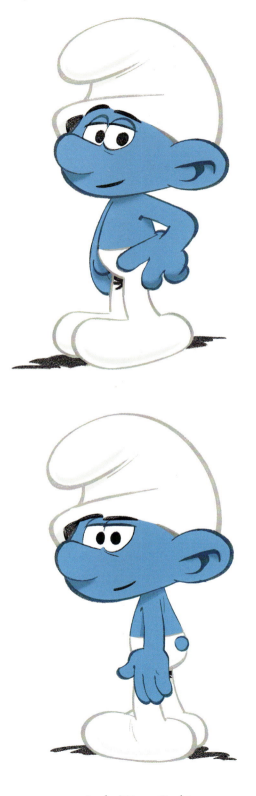

No Name visual development art by Tristan Poulain

Art by Tristan Poulain

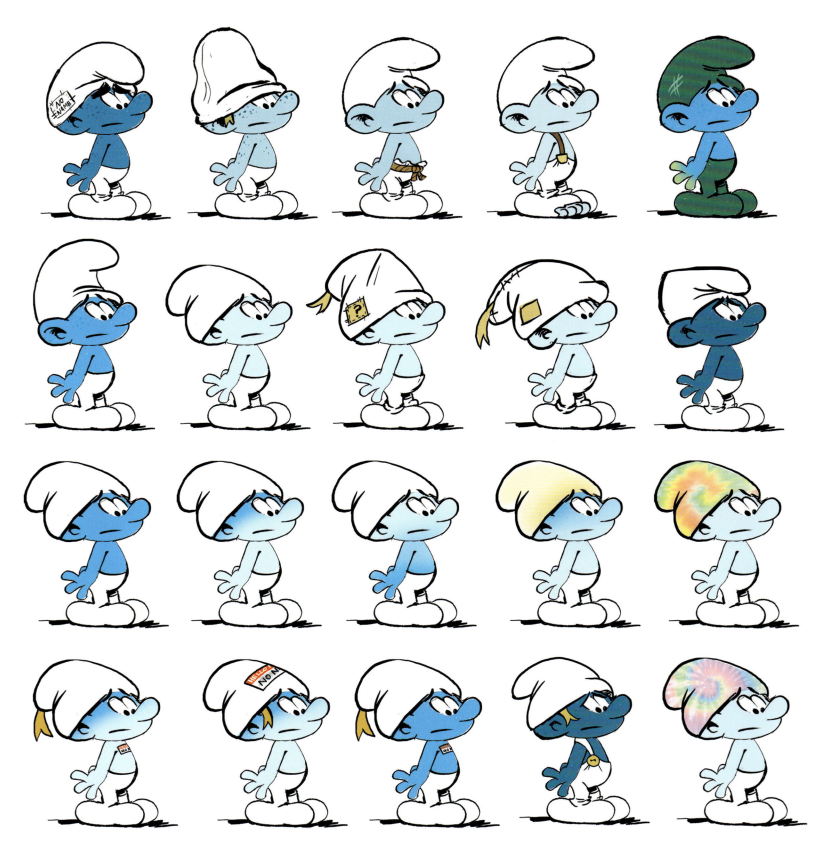

No Name exploration art by Gabby Zapata

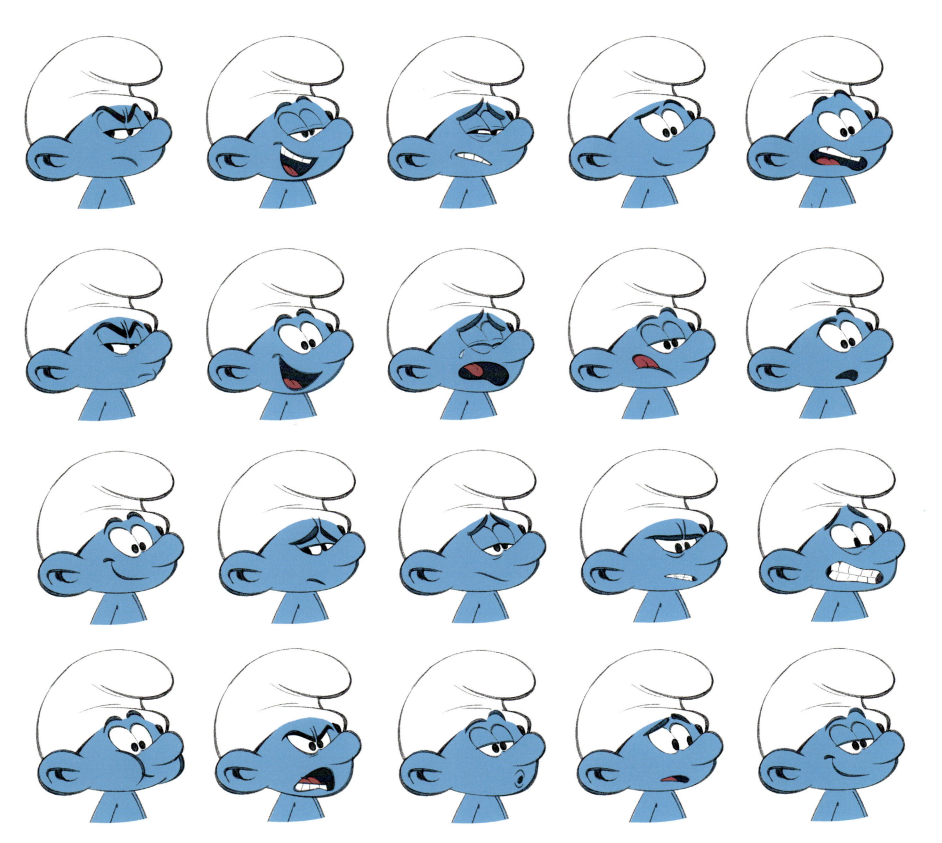

No Name expressions by Tristan Poulain

SMURFETTE voiced by Rihanna

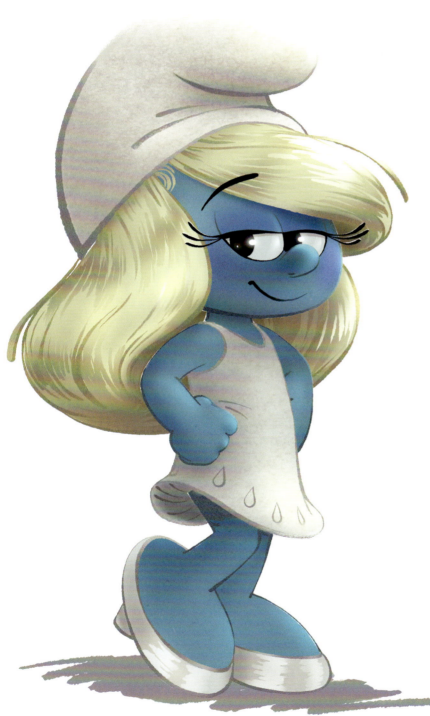

Art by Paulette Emerson
& Margaret Wuller

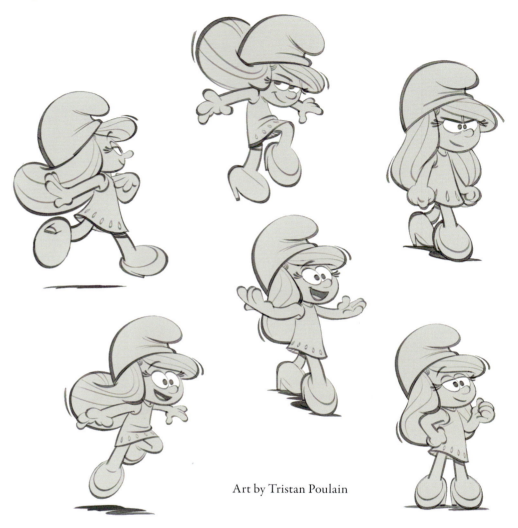

Art by Tristan Poulain

Rounding out the roster is perhaps the most recognizable Smurf in the village, Smurfette. Created by Gargamel to spy on and help the wizard destroy Smurf Village, Smurfette tapped into her strong will (and some of Papa Smurf's magic) to overcome her origins to become the sweetheart we know her as today. Far more than just "the female Smurf" that even her name suggests, she's a free-thinking contributor to the welfare of Smurf-kind, and by no means "a damsel in distress."

And Chris Miller promises that "in the entry of this movie, she's pretty involved. She's evolved, and she has been through a lot, she was an outsider who was accepted by this community. She feels like she's got 'it' figured out. In fact, she's a bit of a life coach and a mentor to No Name, who's on his own identity search. But, she's going to find along the way that: 'Oh, maybe I didn't really have all that worked out. Maybe I was repressing some of my insecurities,' and that's her chief challenge in the movie."

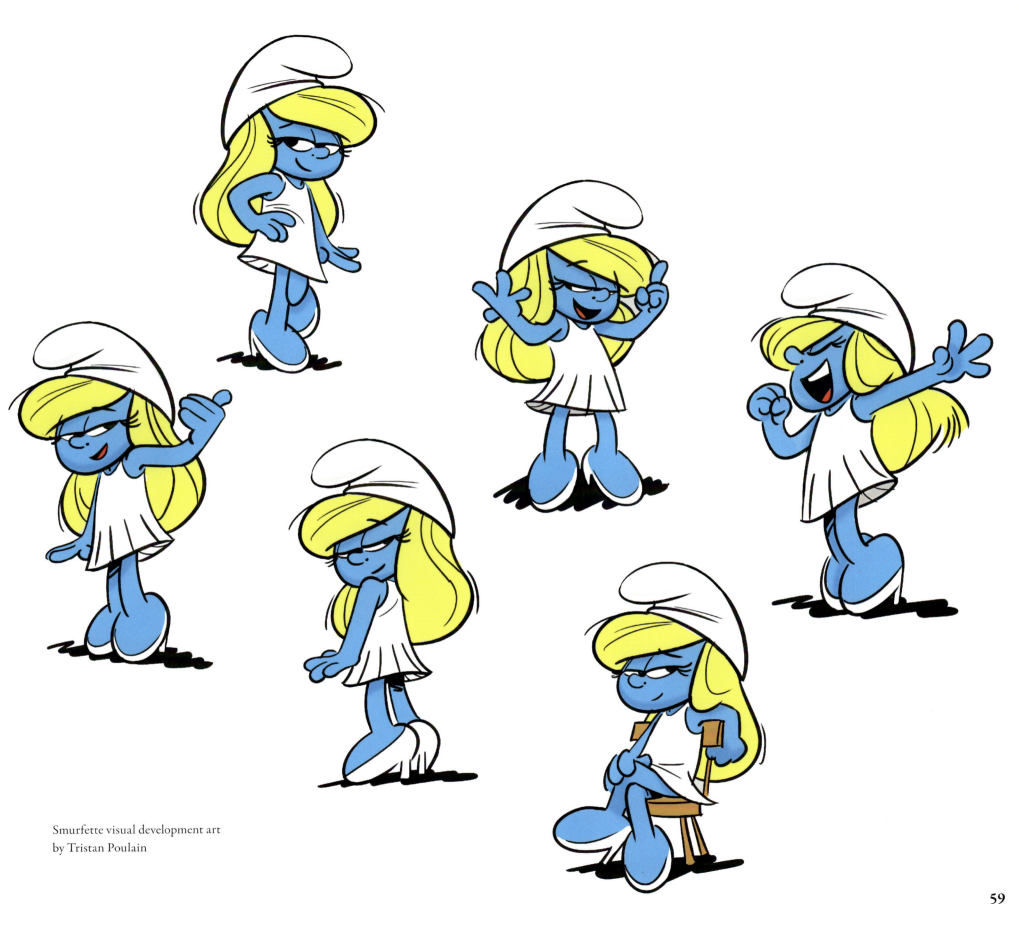

Smurfette visual development art
by Tristan Poulain

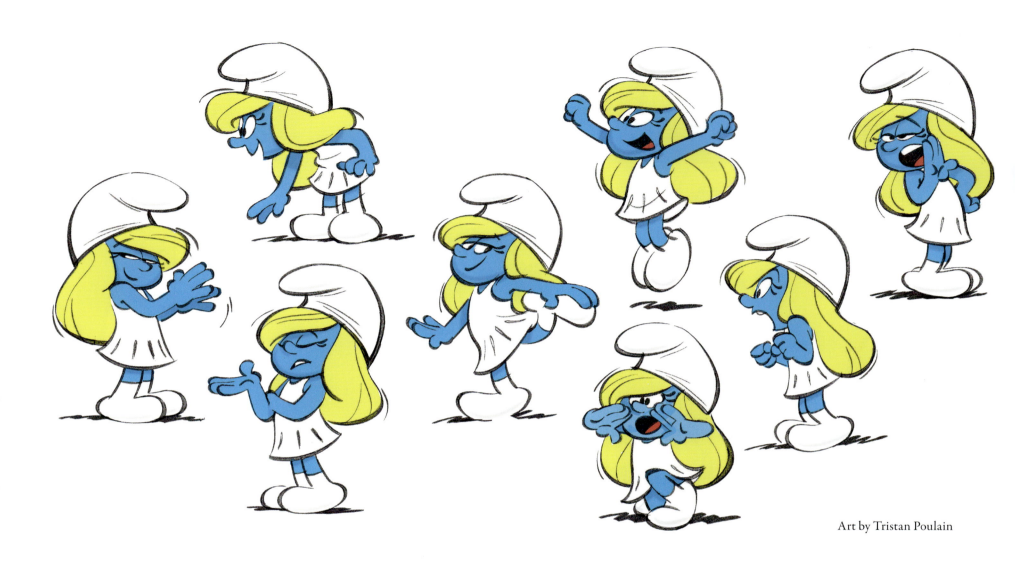

Art by Tristan Poulain

The chief challenge for the filmmakers and the art team of *Smurfs* was how to bring the look of Smurfette from the previous century into 2025 for their feature film.

Character designer Tristan Poulain took the lead with initial sketches, but co-director Matt Landon credits most of the success with the handling of Smurfette to art director, Margaret Wuller. "I don't think we'd have as elegant and beautiful Smurfette without Margaret," he says. "She brought so much to the look of this movie. She's insanely talented."

One of the first steps was updating the fashion icon's dress. "I have a daughter, and when she sees this 1950s looking dress on Smurfette, she's like: 'What? Why does the girl look like that?' But, we can't change her too much, because we still want her to be Smurfette, because we love Smurfette, but we want to give her more."

For the wardrobe, Wuller says that "more" came in very subtle changes. "The bottom of our dress made her feel a little bit, for lack of a better word, younger. Her character in this movie was really self-assured and confident and wise, and it felt right to streamline her dress and make it this kind of an 'Ode to a Mushroom' flipped upside down. Part of the design, too was to get this figure eight bottom, so that it always kicked up on one side to show a little leg. But, it maintained this very flowy, figure-eight, hoop skirt style. And then keeping that tear drop pattern on there, because that's her."

While style was certainly a concern, Wuller admits that she devoted much of her time on the character to one of Smurfette's key physical traits—her hair.

"There was a moment when we thought: 'Hey, we have this opportunity, should we redefine her hair?'" Wuller recalls. "'We have Rihanna. Should we create that friendship between the legacy character of Smurfette with the present-day actor that's going to portray her?' So we went through a lot of hair designs and even had back and forth talks with Rihanna's personal hair stylist. We all ended up in a place where we really just loved her legacy hair. We felt like it changed her too much to push it into another space. You want to honor the thing that everyone loves and knows, but then you also want to introduce something fresh into it, so that the audience feels like they're getting something special that was created for this journey."

The art director went on to detail the look: "We took her legacy hair and then by giving her a lower drape bang and then the introduction of these baby hairs," they achieved the perfect balance they were looking for.

"That was the 'Rihanna moment'," she recalls of adding the singer's signature follicular flourish, "When we were talking with her hairstylist who said 'Rihanna loves the legacy hair, but wants to know, what if we just do this one little accent'?"

Landon recalls how the performer affected the dialog as well. "Before we ever did any [recording sessions] with her," he states, "she had said that she was taking on the role of the this 'little blue badass' and that sort of informed how we looked at the character. We knew that's what Rihanna sparked to, so we thought, let's run with this and it was great. It was just sort of a great sort of North Star for Smurfette."

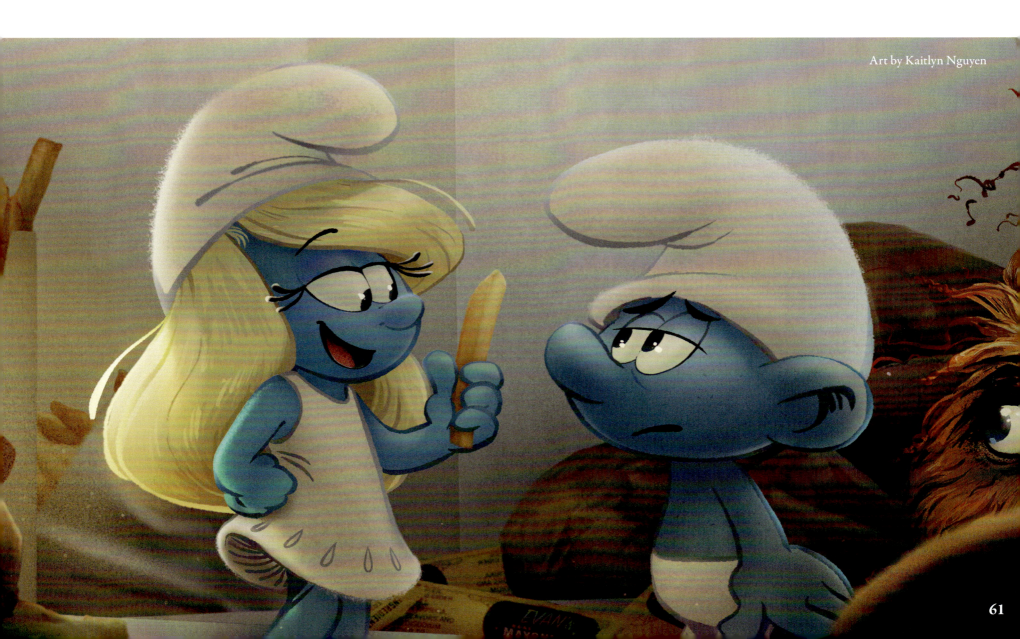

Art by Kaitlyn Nguyen

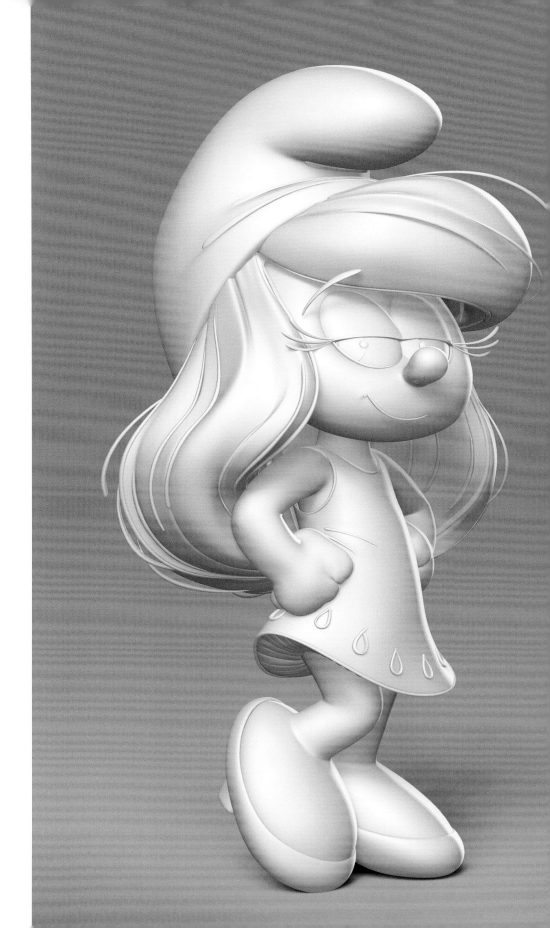
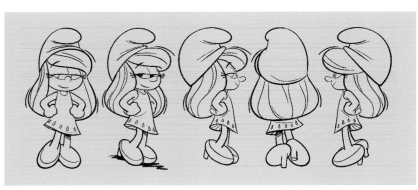

Smurfette visual development art
by Tristan Poulain

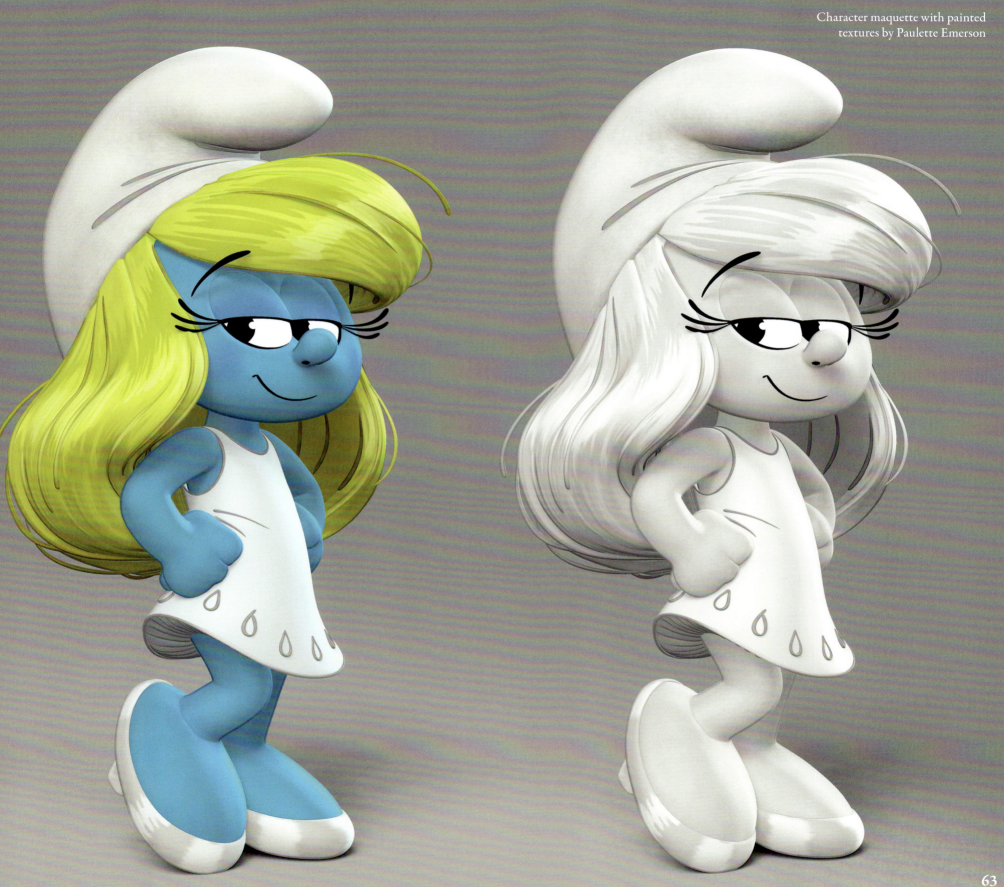
Character maquette with painted textures by Paulette Emerson

THE ART OF MUSIC

Music has been a part of the Smurfs magic from the very beginning.

Their first comic book adventure, "*La flûte à six trous*" (later renamed and translated as *The Smurfs and the Magic Flute*) saw the little blue elves aiding in a quest to fight the power of a lost magical instrument of their own making. A key scene from that story has the Smurfs singing a song ("It's the smurf-smurf-smurf...") that would become a regular, recurring gag in the original Peyo stories and eventually be given an actual tune by Oscar and Grammy winner Michel Legrand when *The Smurfs and the Magic Flute* was adapted into a 1975 feature film.

Over the decades, the three subsequent movies maintained their connection to melody, mainly in the casting of Smurfette, who has been voiced by Katy Perry (*The Smurfs* and *The Smurfs 2*) and Demi Lovato (*Smurfs: The Lost Village*), both chart-topping singers who contributed vocals to songs on their respective soundtracks. *Smurfs* (2025) continues that tradition by featuring Rihanna in the same role—however, she not only performs numbers throughout the film but served as a writer and producer of the film's original songs in collaboration with music directors Jay Brown and Ty Smith.

Director Chris Miller says, "What I appreciate about her, in terms of participating with the film, is that she's a storyteller, right? She knows the tone of the movie, so she can zero in on the music as a filmmaker, as a storyteller, and knows where the lines are."

Art director Margaret Wuller adds that the Smurfette song is "so wonderful" that when she heard a demo version played on an iPhone, "I started crying in the conference room because I thought it was such a touching song. And it's still my favorite. It's so good."

Also contributing to the sonic landscape is English composer Henry Jackman, who previously worked with Miller on *Puss in Boots*. "Henry Jackman's contribution to this film [has] been amazing," the director says. "He's brought this vibe to the score that feels like it's from the '80s," he adds, likening it to that era's "big action-adventure music. It's really, really extraordinary. And then to Henry's credit, marrying what Rihanna has offered, what Jay Brown, and Ty Smith have offered. Henry has just found a way to kind of glue it all seamless[ly]. It's one of my favorite scores he's ever done."

Even more notable to fans is that the music taps into not only the vibe of '80s action movies but the theme song of the '80s Smurfs cartoon (written by Hoyt Curtin), strains of which can be heard as viewers enter the village to see Papa leading his Smurfs in their morning exercise routine/opening dance number.

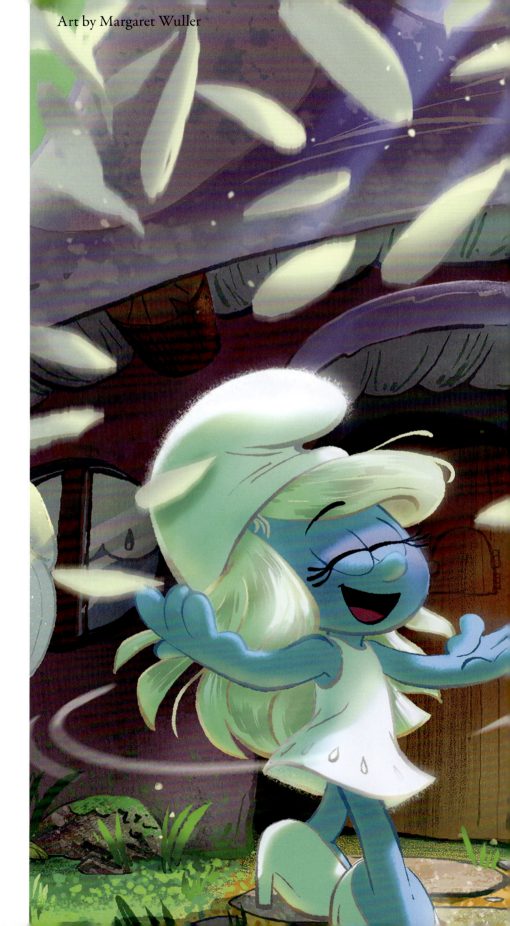

Art by Margaret Wuller

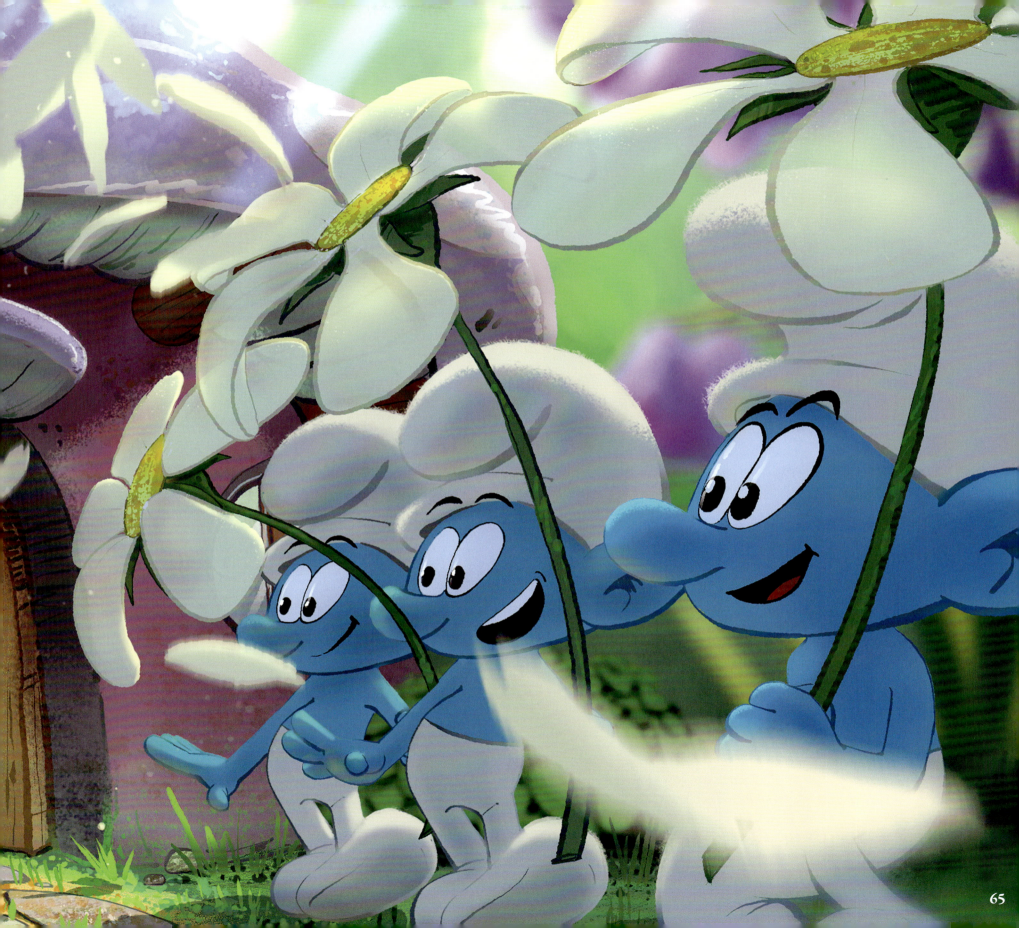

CRITTER COMPANIONS

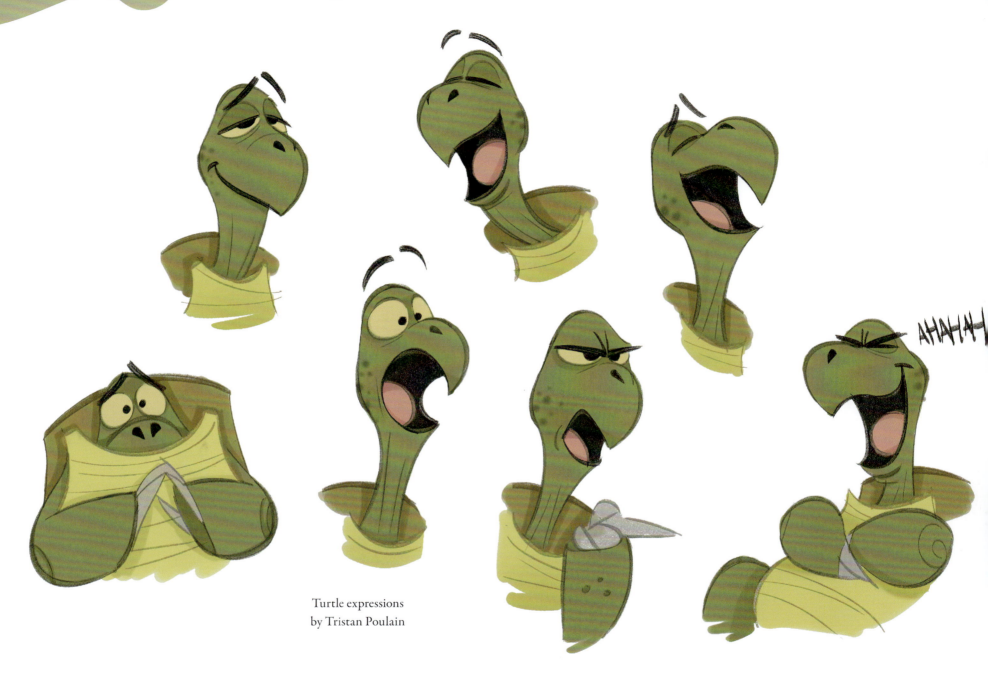

Turtle expressions
by Tristan Poulain

As children of the forest, the Smurfs are very in tune with the natural world around them, often befriending the wildlife that shares their ecosystem. From storks to puppies, caterpillars to butterflies, Smurf tales across all media have no shortage of animal allies and insectoid sidekicks. In *Smurfs*, one such character is Turtle, described by co-director Matt Landon as "a musician who just kind of hangs around on the edge of Smurf Village and gets sucked along for the ride." In his case literally—but more on that later. Turtle is voiced by Christopher Comstock, A.K.A. Marshmello, an American DJ and record producer who is as well known for his sweet-treat-shaped helmet (which completely conceals his face) as for his dance mixes. Chris Miller says he plays the "pretty beloved character" well. "The only trick with Marshmello is, how do you mic [him]?" Miller jokes. "But we figured it out."

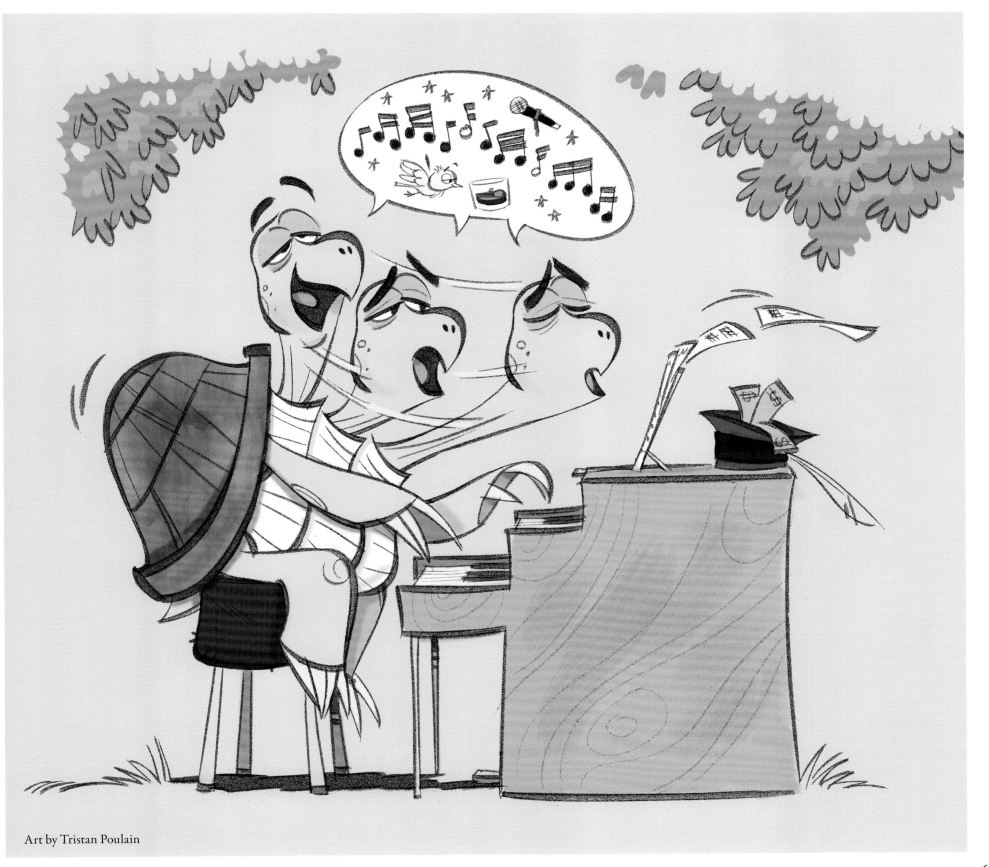
Art by Tristan Poulain

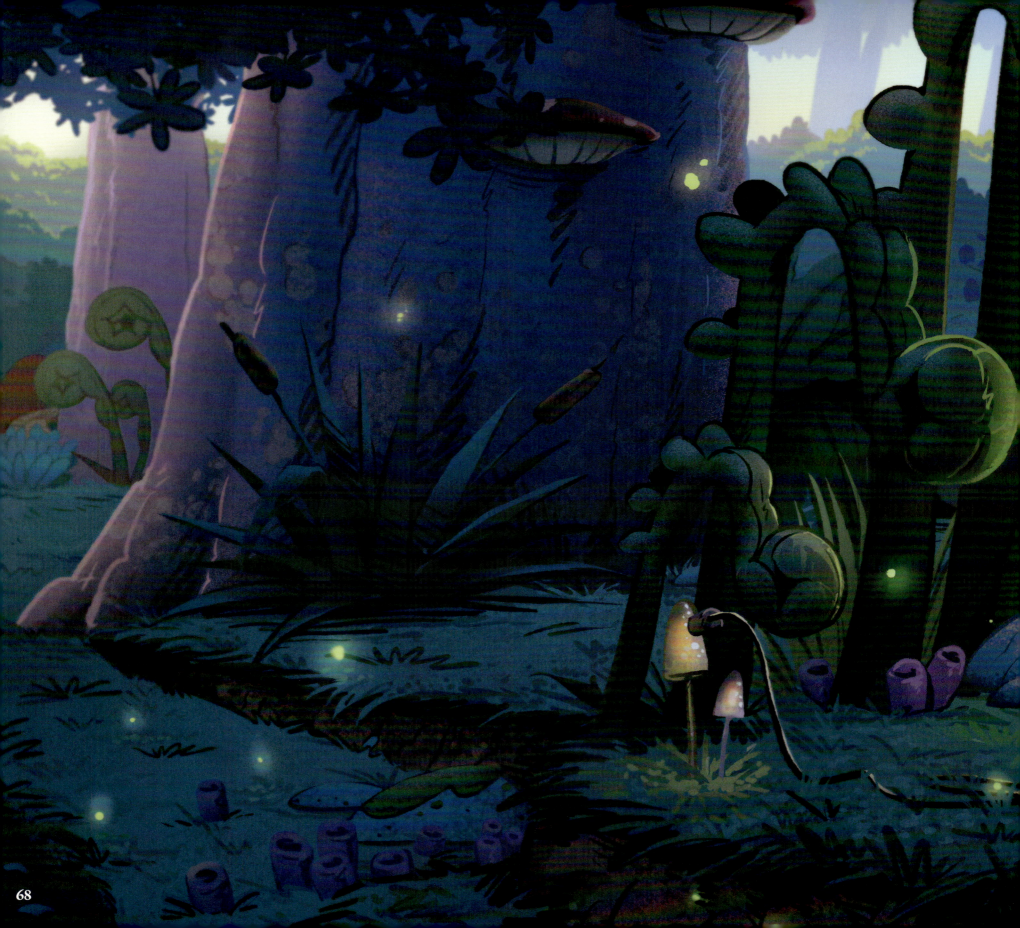

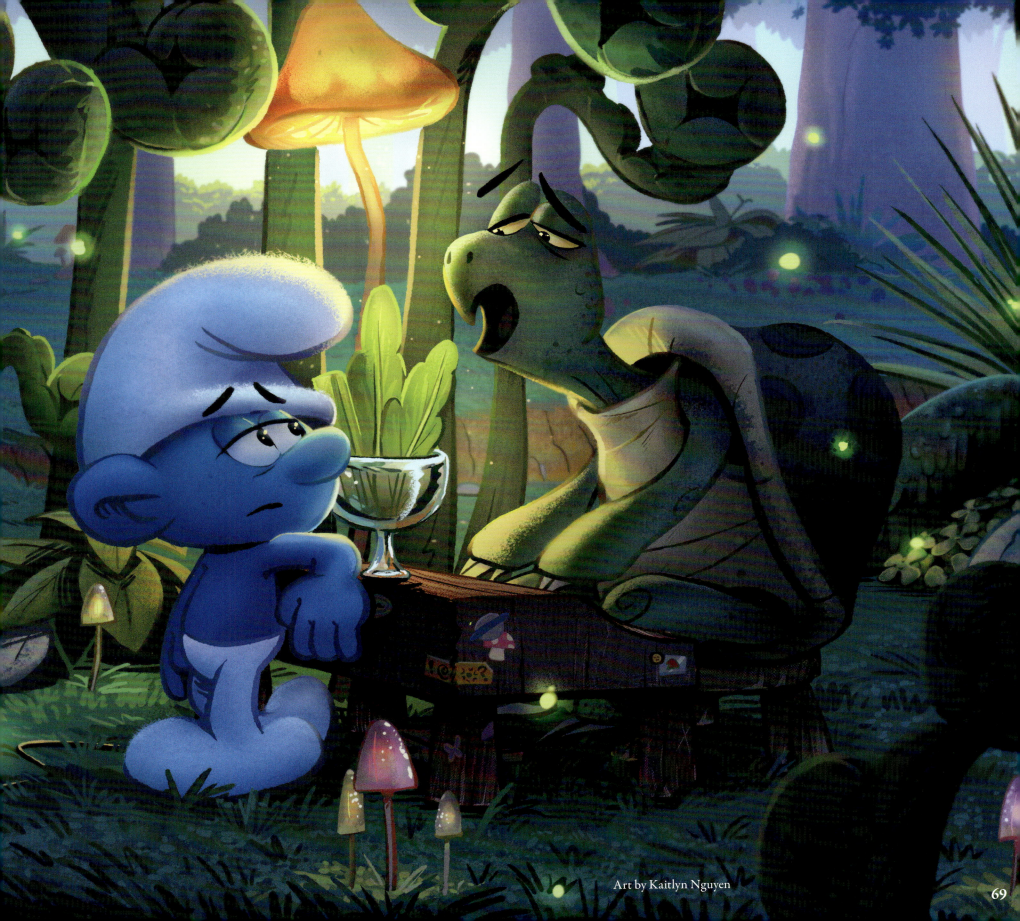
Art by Kaitlyn Nguyen

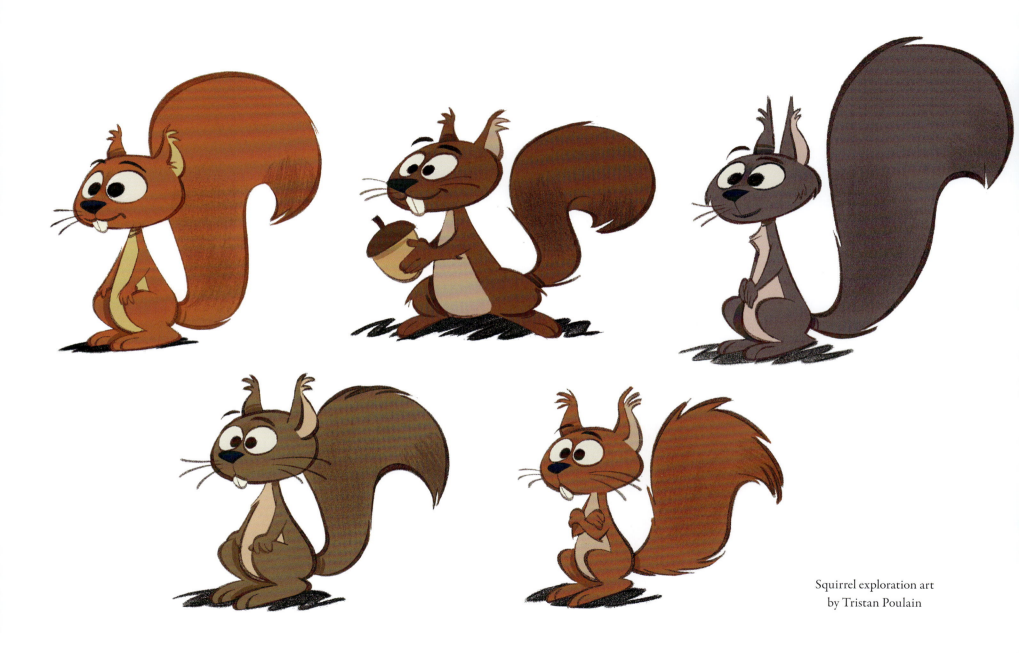

Squirrel exploration art by Tristan Poulain

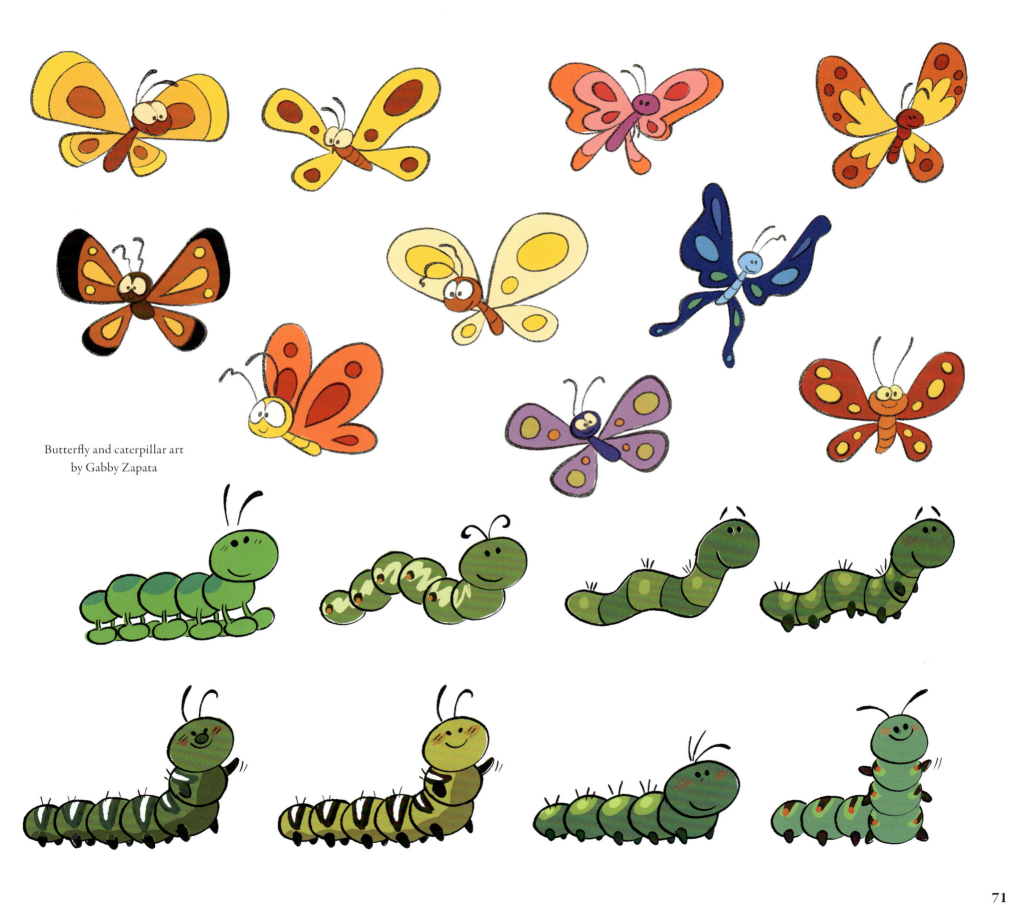

Butterfly and caterpillar art by Gabby Zapata

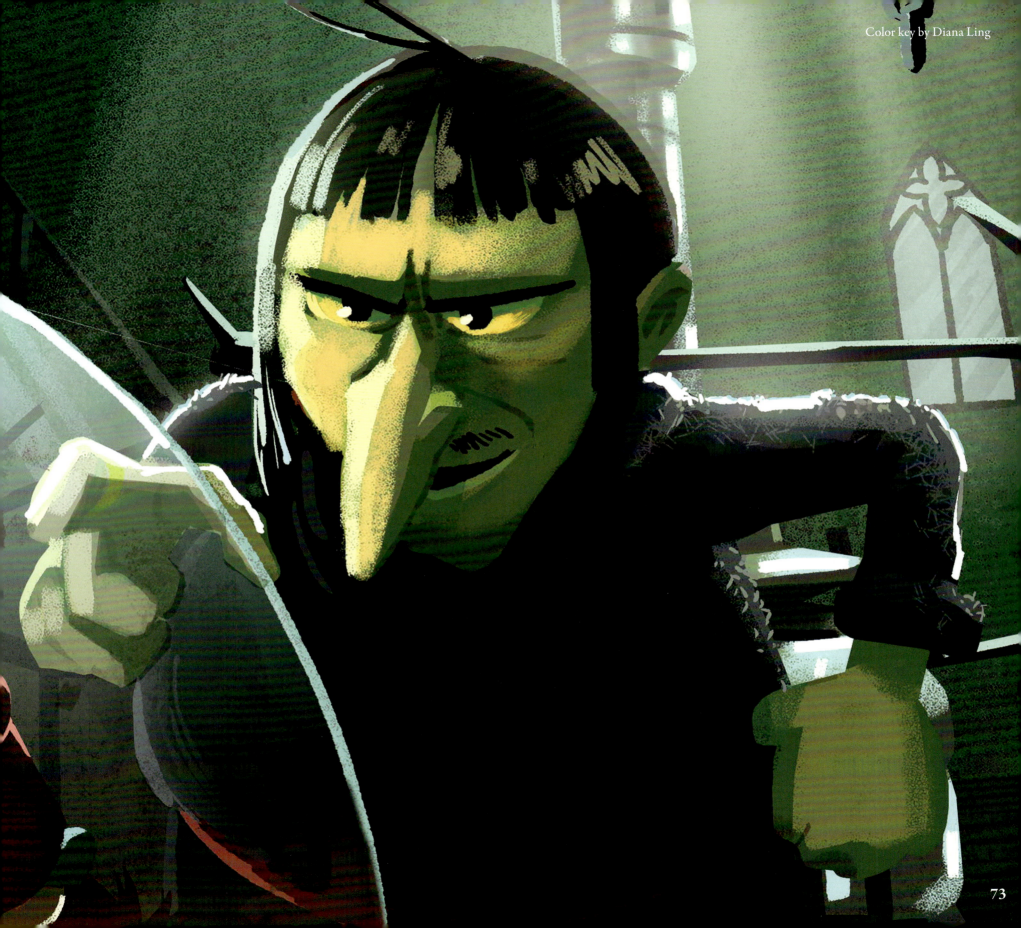

Color key by Diana Ling

Bring on the bad guys!

In a panic over the loss of their Papa, the Smurfs suspect that his disappearance is the work of their archnemesis, Gargamel. Smurfette and the others convince No Name to open another portal to capture the magician and his mangy feline sidekick, Azrael.

Meanwhile, in a darkened castle that straddles dimensions, we discover that No Name's new abilities have caught the attention of a mysterious new villain—Razamel, Gargamel's "evil-er" brother!

Eager to please the Alliance of Evil Wizards, a cadre of powerful sorcerers that live beyond space and time, Razamel has used the vortex to kidnap their sworn enemy, Papa Smurf, who they believe holds the key to releasing the full extent of their dark magic!

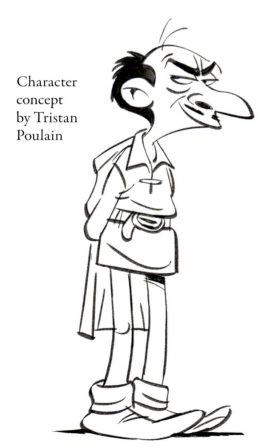

Character concept by Tristan Poulain

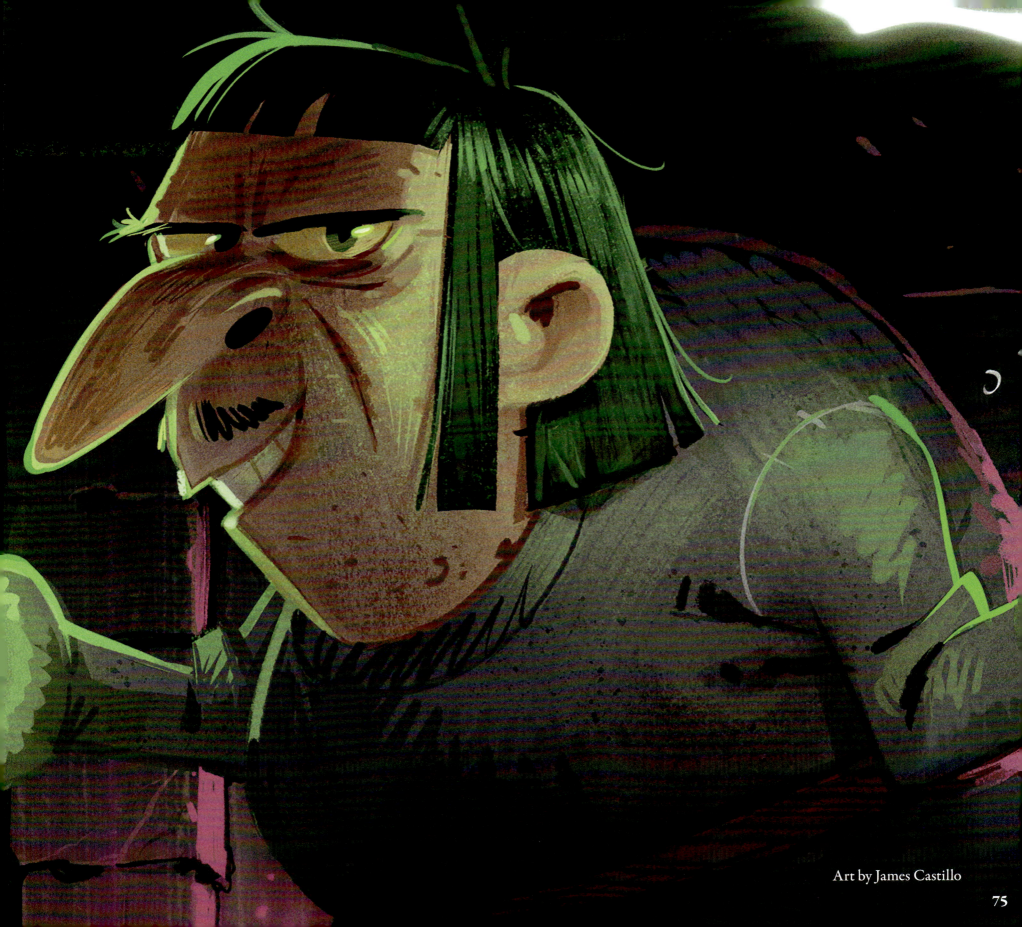

Art by James Castillo

GARGAMEL voiced by JP Karliak

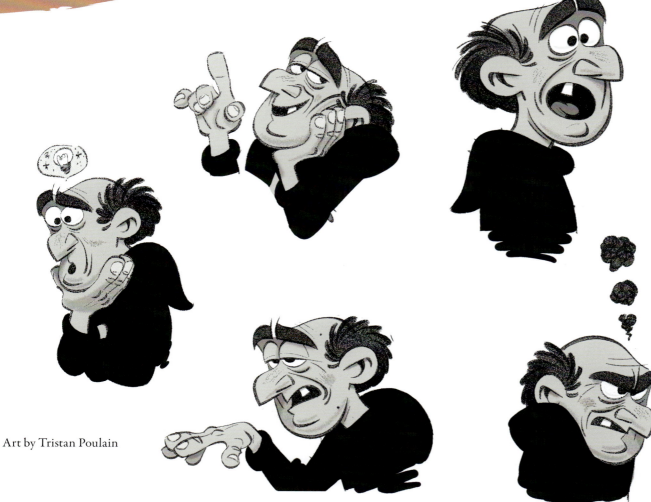

Art by Tristan Poulain

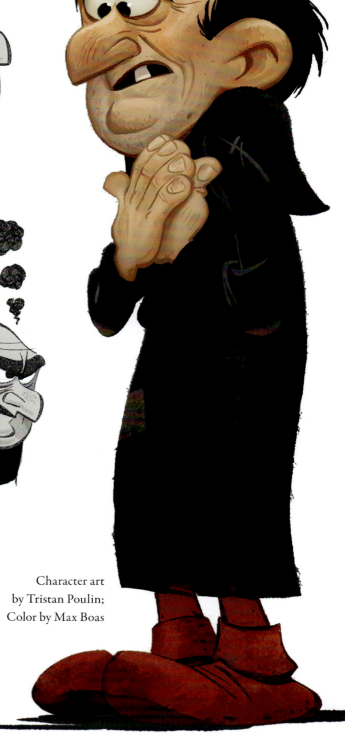

Character art by Tristan Poulin; Color by Max Boas

While discussions of "legacy characters" mostly center around the Smurfs, it would be wrong to ignore their human-sized archnemesis, Gargamel (and his cat Azrael.) Gargamel has been lurking around Smurf Village since December 10th, 1959.

"Gargamel has been trying to infiltrate Smurf Village for decades, for eons, without much success," according to Chris Miller. "They've always been able to handle him."

Although true to the core of the character, the 2025 film chose to paint Gargamel with a slightly different and softer brush than previous depictions. "He's a little more buffoonish," offers actor JP Karliak—a self-described "workhorse voice-over actor" whose voice can be heard just about everywhere including such popular television shows and video games as Disney/Marvel's *X-Men 97* (as Morph) and *Suicide Sqaud: Kill The Justice League* (as the Joker)—who assumed this incarnation of Gargamel's voice-acting responsibilities.

Most of this shift in the villain's demeanor and portrayal can be attributed to the presence of Gargamel's brother, Razamel, a new addition to the Smurfs' rogues gallery.

"The big bad is the big bad until the bigger badder bad comes in," Karliak says, "and his brother is really a menace." He adds, "because they're brothers, [Gargamel] does have that sort of 'oh, I, I want to impress him. I want him to like me. I want him to think that I'm cool and doing good things.' So, he suddenly goes from being so threatening to being very like the little brother [although he's older], like, you know: 'please like me.'"

Art by Tristan Poulain

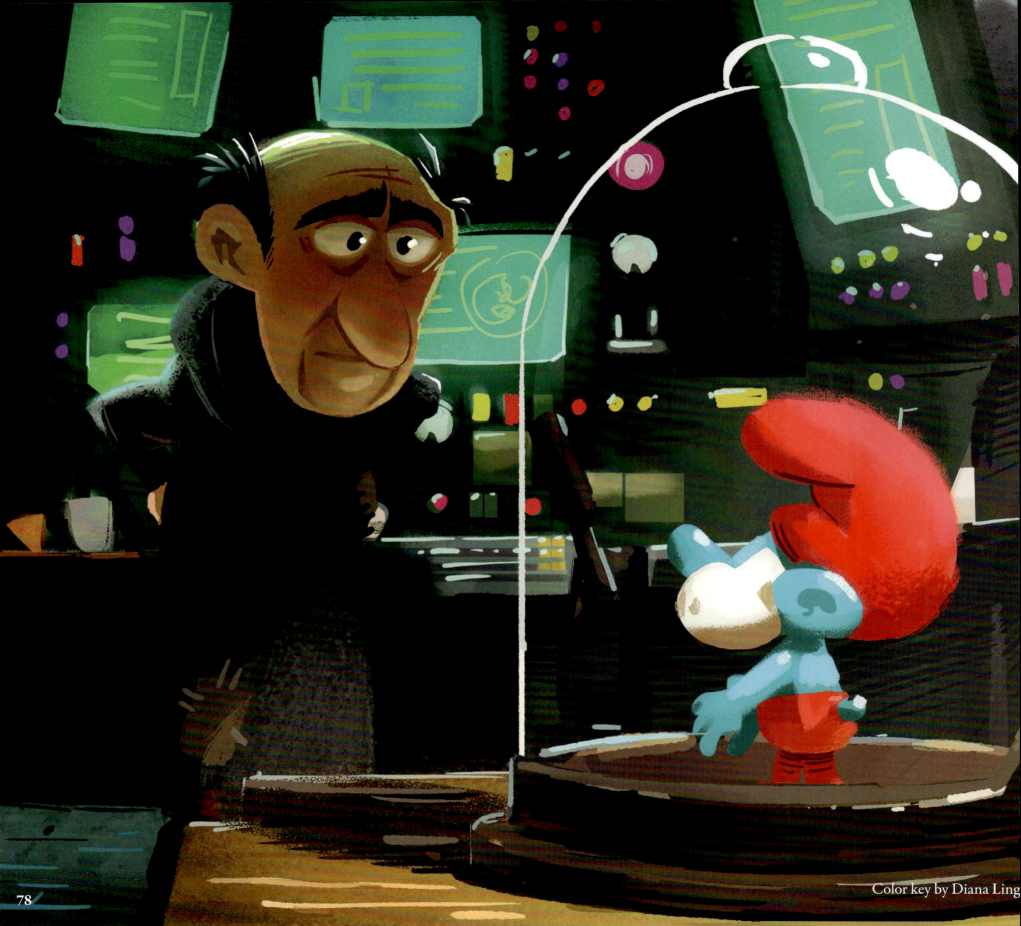

Color key by Diana Ling

Fans of Gargamel may be disappointed in the screenplay's first act as their favorite wrongdoer (and his cat) are toned down a bit and seemingly sidelined, but Miller promises that is all a means of contributing to the overall drama of the story and the character.

"There are big revelations" and twists "in this film, but I want to be clear that Gargamel's not a fan of the Smurfs. The Smurfs need to be wary of him. There's a promise of something greater beyond this movie," the director says. "[Gargamel] becomes more vengeful, [at one point] he's got to create an alliance with the Smurfs, who he's been hunting down for most of his life. But it's like: 'we'll do this together, but, you know, by the end after we do this though, we're going back to the way it was.' We kind of reset it at the end."

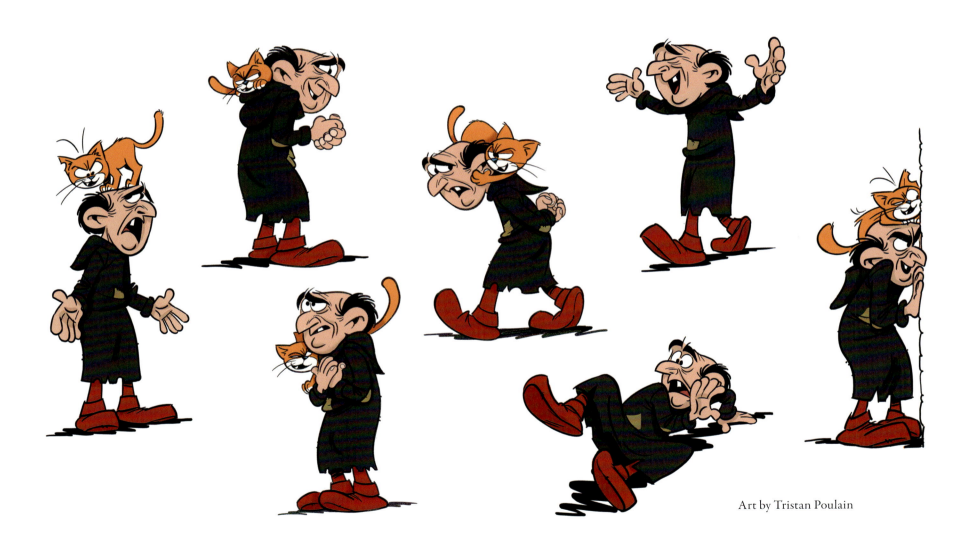

Art by Tristan Poulain

AZRAEL

Azrael mouth expressions
by Tristan Poulain

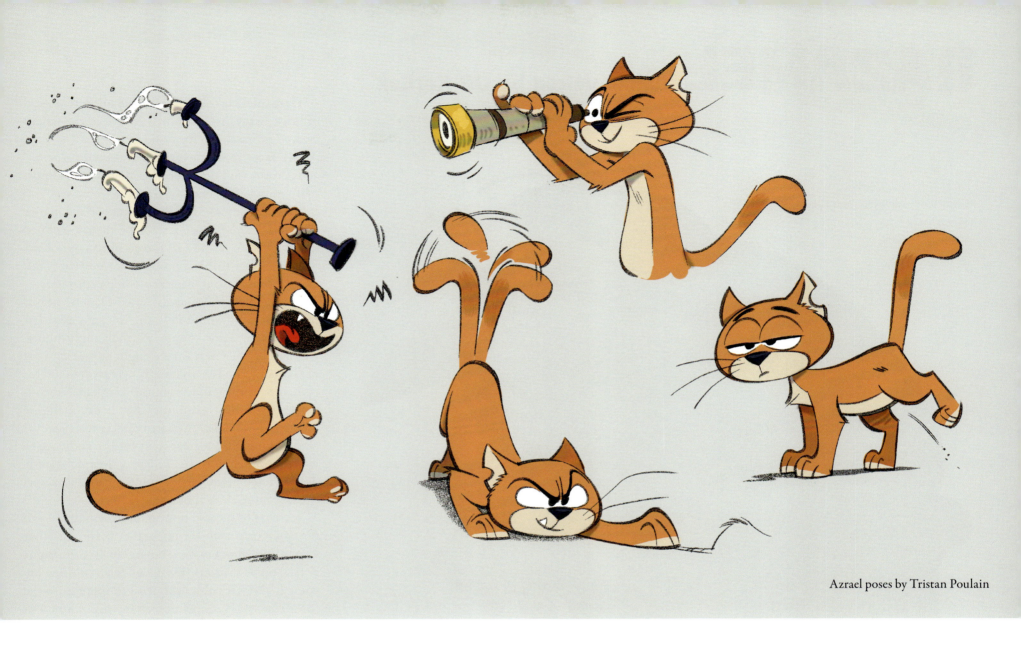

Azrael poses by Tristan Poulain

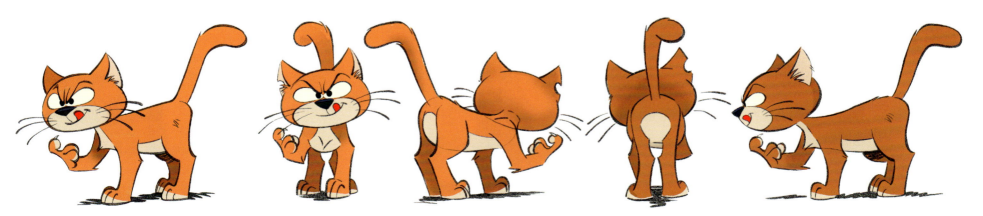

Azrael turnaround art by Gabby Zapata & Tristan Poulain

81

RAZAMEL (also) voiced by JP Karliak

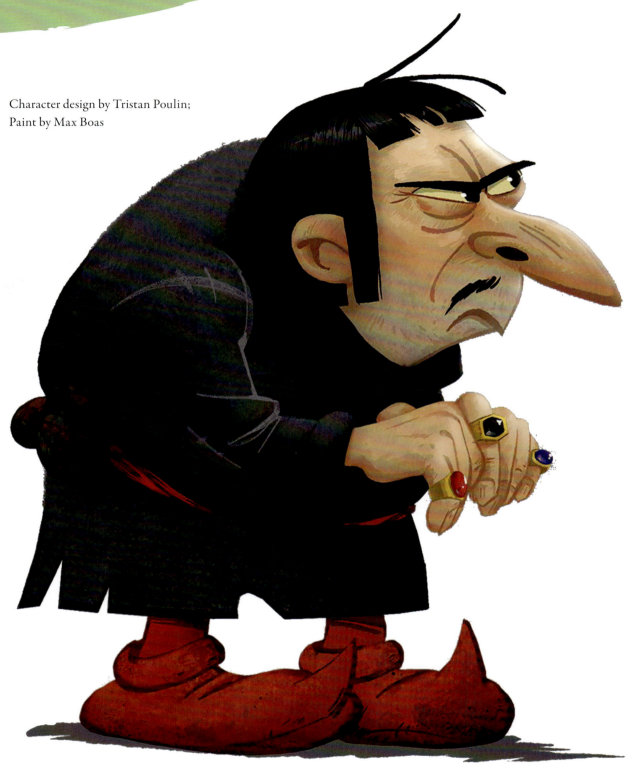

Character design by Tristan Poulin;
Paint by Max Boas

"Gargamel's brother Razamel is a different kind of beast," says director Chris Miller of the villain created expressly for his film.

"My favorite character? It's Razamel for sure," adds production designer Max Boas. "He's almost like a more evil version of Gargamel."

Miller continues: "He's a member of the Alliance of Evil Wizards, which is a conglomeration of bad folk who want to take all the goodness out of the universe. And this is a problem for everyone, not just the Smurfs, but existence—in its entirety."

Although their "Mamah" and "Dadah" hoped that their sons would rule the universe together someday, at some point in their upbringing, younger brother Razamel's might surpassed that of Gargamel, and as his power increased, so did his contempt for his older sibling. Gargamel spends most of the film assuming that because they're brothers, he and Razamel are best friends, however Miller notes: "It's a great treat for the audience to watch this relationship, where Gargamel clearly doesn't understand what's going on, and Razamel can't be more clear about how he feels."

"It's neat to be able to originate a villain and to put your own spin on it," says Karliak. "I think what's fun about what somebody like Razamel is he's on a mission. He loves when things are going his way, it's absolute glee, but there's also the fun of [how] Razamel reports to this council of wizards, and he's pretty low on that totem pole. He's considered sort of an idiot and a failure.

"So, it's interesting to watch him have that counterpoint with Gargamel—where he's being really pompous and treating his brother like crap, and then he goes into these board meetings with this council, and he's acting almost exactly like [Gargamel] does."

This dichotomy of highs and lows applied to more than the power dynamic Razamel has with the other wizards, including his brother. It's summed up in his general lifestyle which art director Margaret Wuller described thusly: "He's always trying to make rent. Like, that's the kind

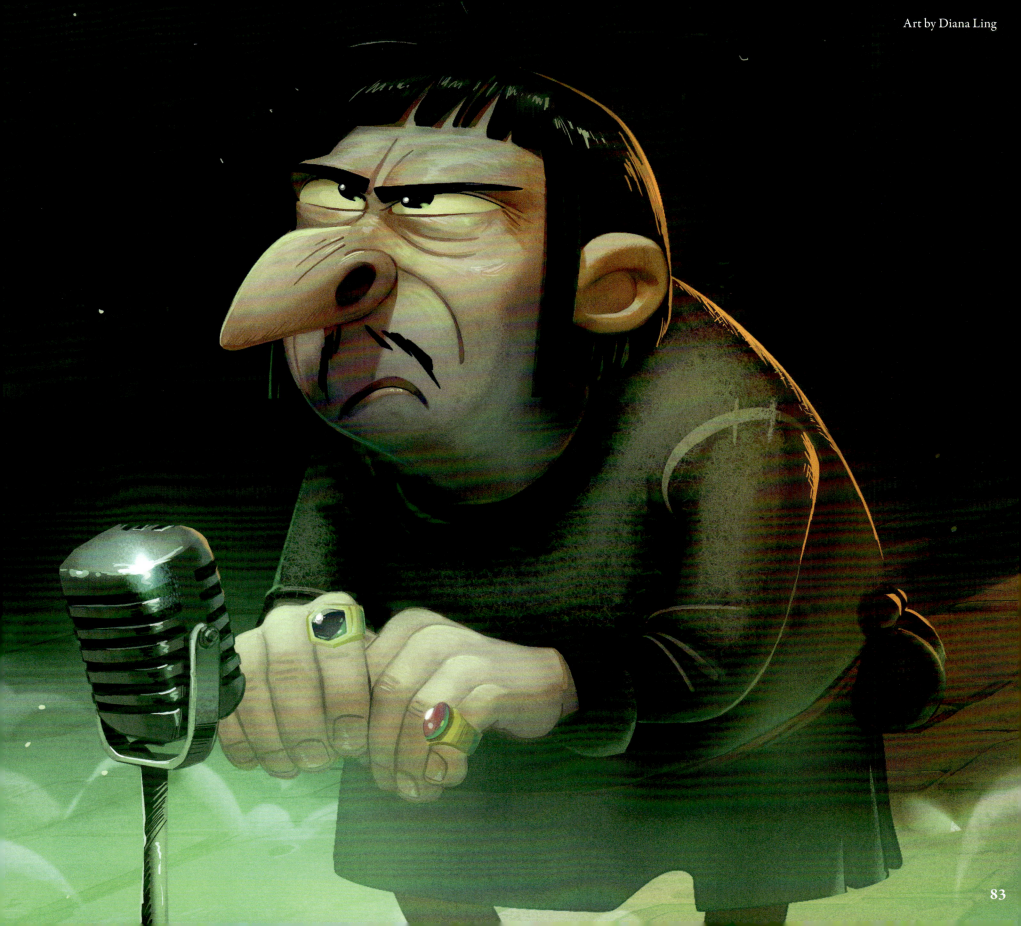

Art by Diana Ling

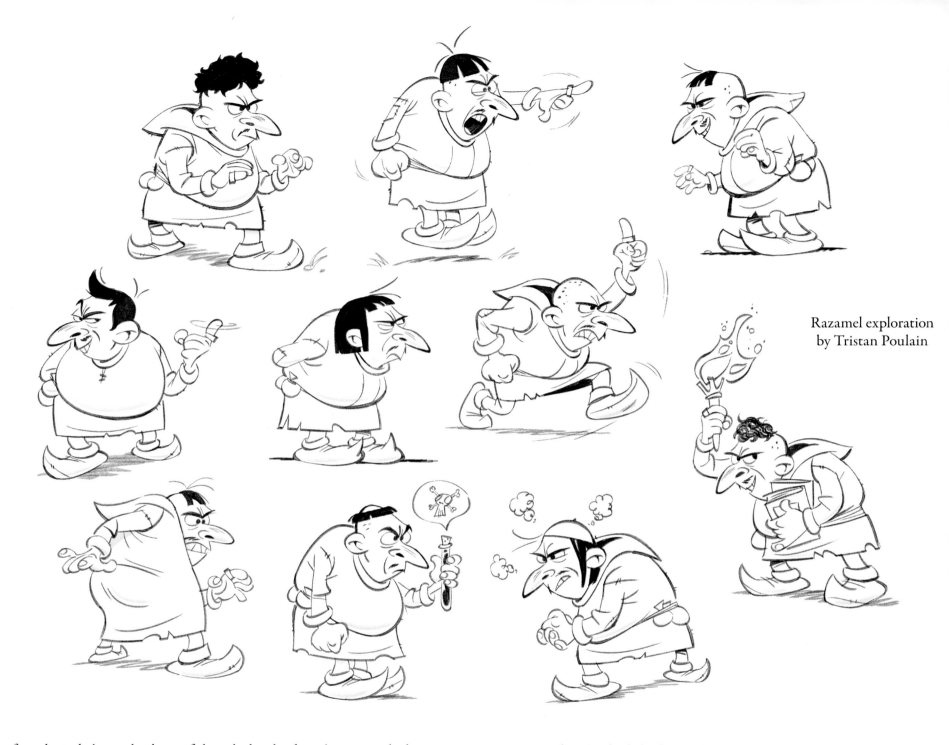

Razamel exploration by Tristan Poulain

of guy he is, he's got this beautiful castle, but he doesn't quite make his rent on time, so everything's a little hodge-podgy." "Hodge-podgy" is a word that can certainly apply to the character's design as well, which, Boas went over in loving detail during an interview for this book: "He has a medieval haircut, kind of a mullet, long sideburns, and the cropped bangs kind of give him a silly look and it's hard to keep that asymmetry going on with his hair into a 3D model of that. Having the [software] controls to position that became a real challenge [for the animators]. He has a hunchback and hair overlapping that volume [of his hunch], and in 3D, we had to cheat it. So, we found the middle ground of where that hair could live, where it could rest, and not have his head shoved completely into his body."

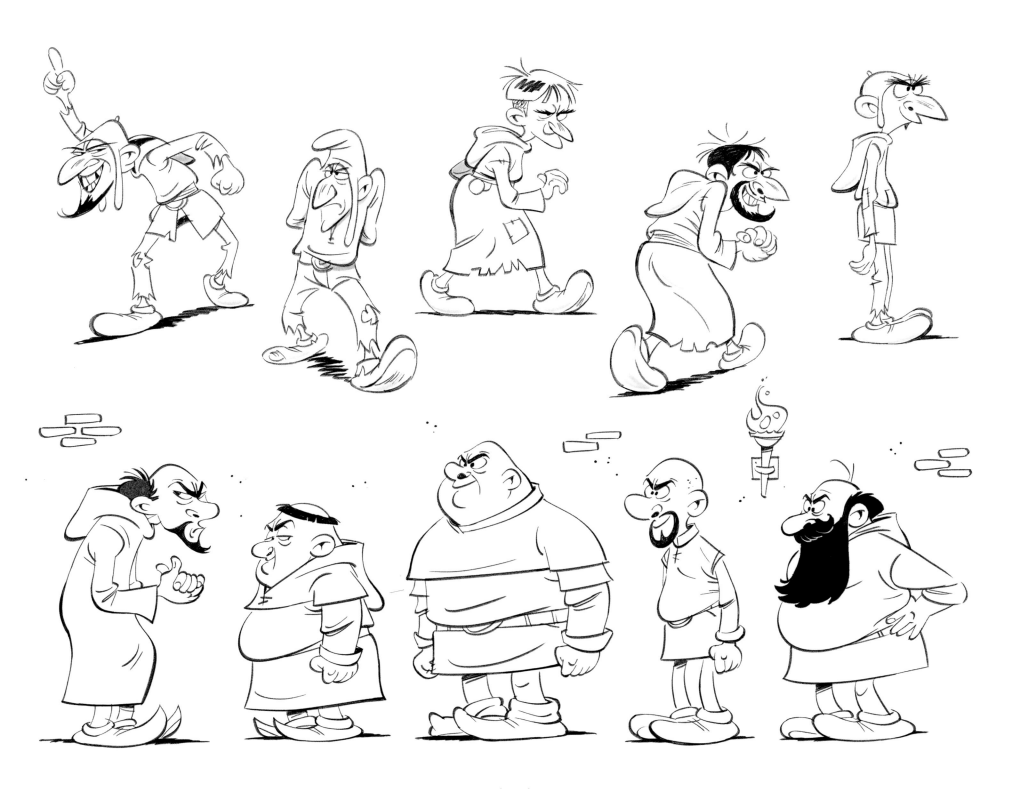

Razamel exploration
by Tristan Poulain

Character maquette by Paulette Emerson

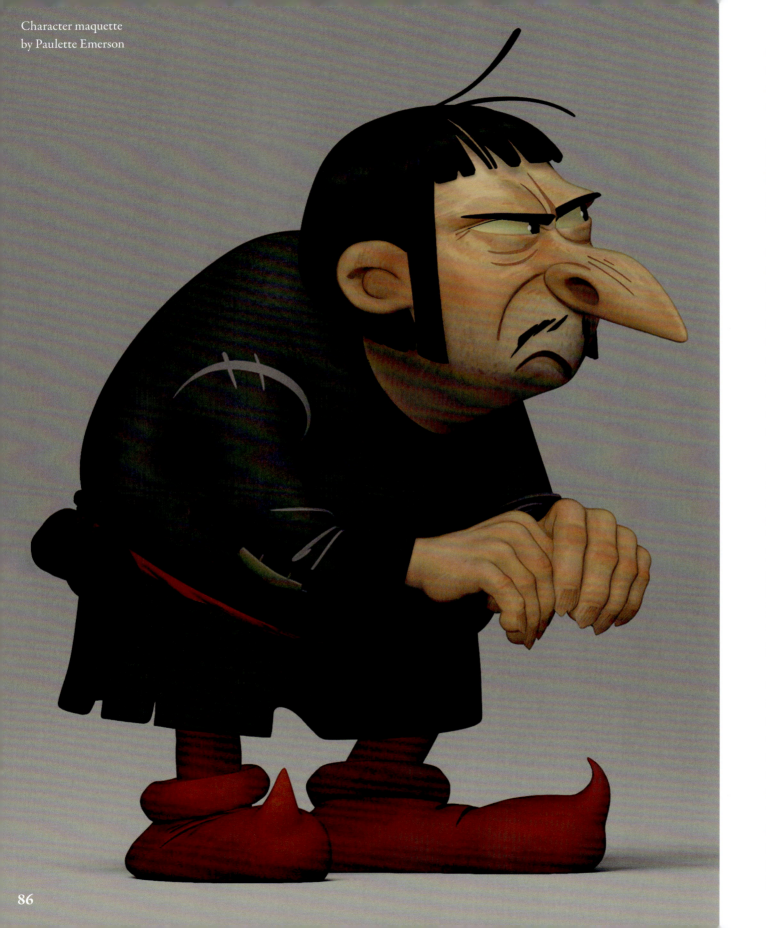

"His anatomy looks quite odd. At one point, we did a 'draw over' of his skeleton, with his spine. It was really distorted, but hopefully you don't think about that when you're watching it."

"How did we find his scale?" Boas asks ready to explain the answer. "So, a Smurf is six inches. [Chris Miller] really liked him to feel relatable to a Smurf. That makes Razamel a two-and-a-half-foot [tall] character, which is really odd.

"If you put Razamel next to a table and chair, those chairs have to be, like, a baby chair—but to the audience, it shouldn't feel like it's too small. So, everything's kind of scaled to him in the castle. It created an average height of our animated humans to be right around that three-to-four-foot range. I think it was always in Chris's mind that [Razamel] would be a smaller character compared to Gargamel, who's about three feet tall."

Other details further tie him to the world of the film and clue the audience to Razamel's power. Boas explains: "I think when [Razamel's] painting [was completed], we gave him yellow eyes. The other wizards [of the Alliance of Evil Wizards] have yellow eyes too, giving them that connection. We gave him some rings to make him feel like he's a, I don't know if 'god' is the right word, but just making him feel magical powerful."

JP Karliak, who himself can offer a thing or two about creating the character, overall agrees with the assessment of Razamel's mystical aspirations, but says that the ultimate combination of voice and movement undercuts any real sense gravitas or serious threat Razamel may present. "He leans more cartoony," says the actor. "You get the big cackling laughs, and the prat falls, all sorts of stuff that that make animation 'sing.' It's that Looney Tunes sort of [vibe]."

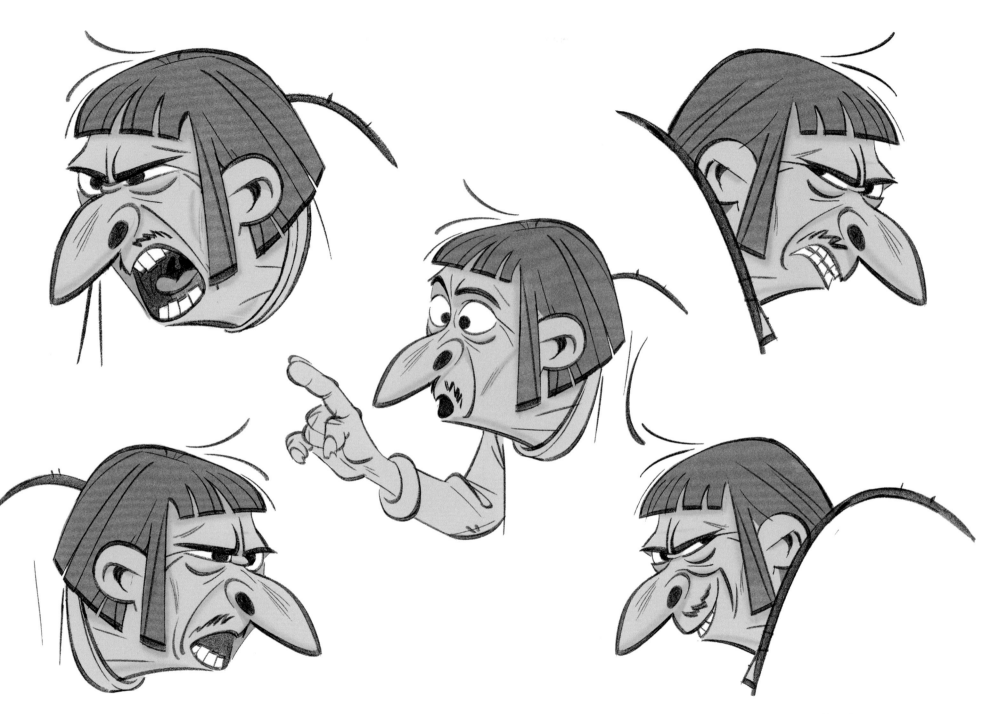

Facial expressions
by Tristan Poulain

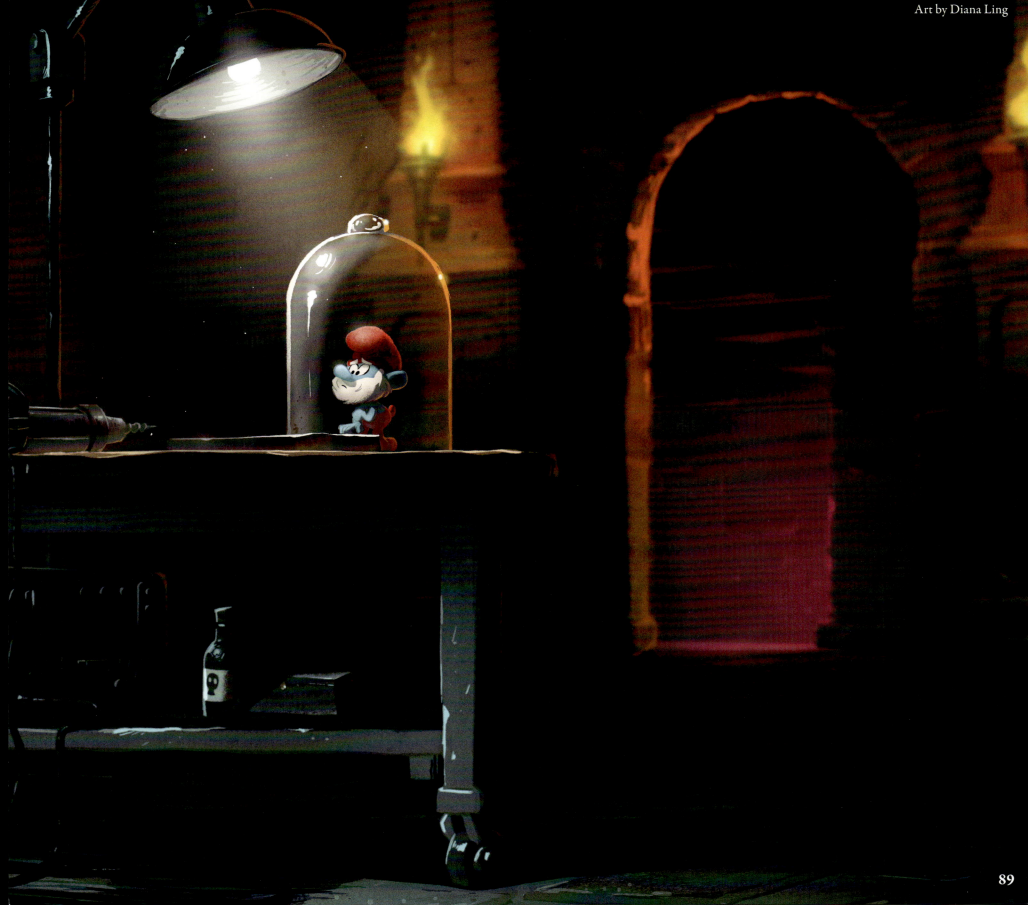

Art by Diana Ling

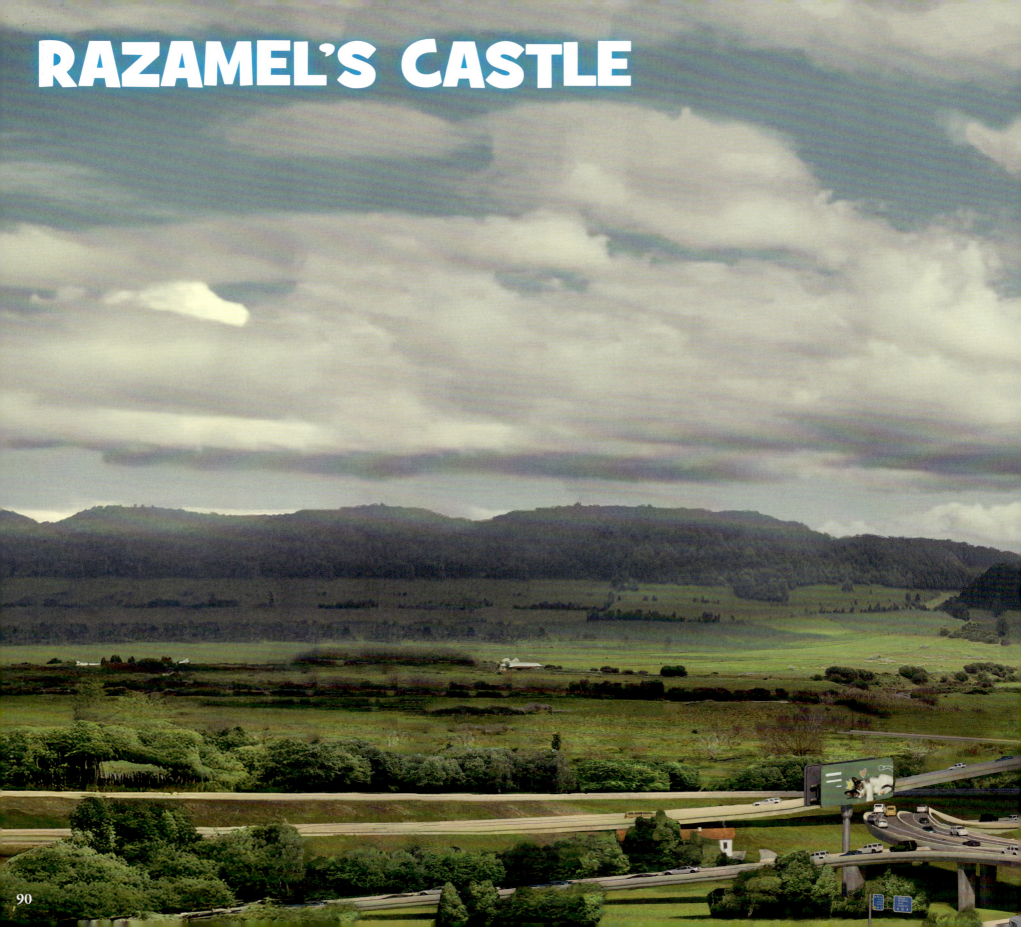

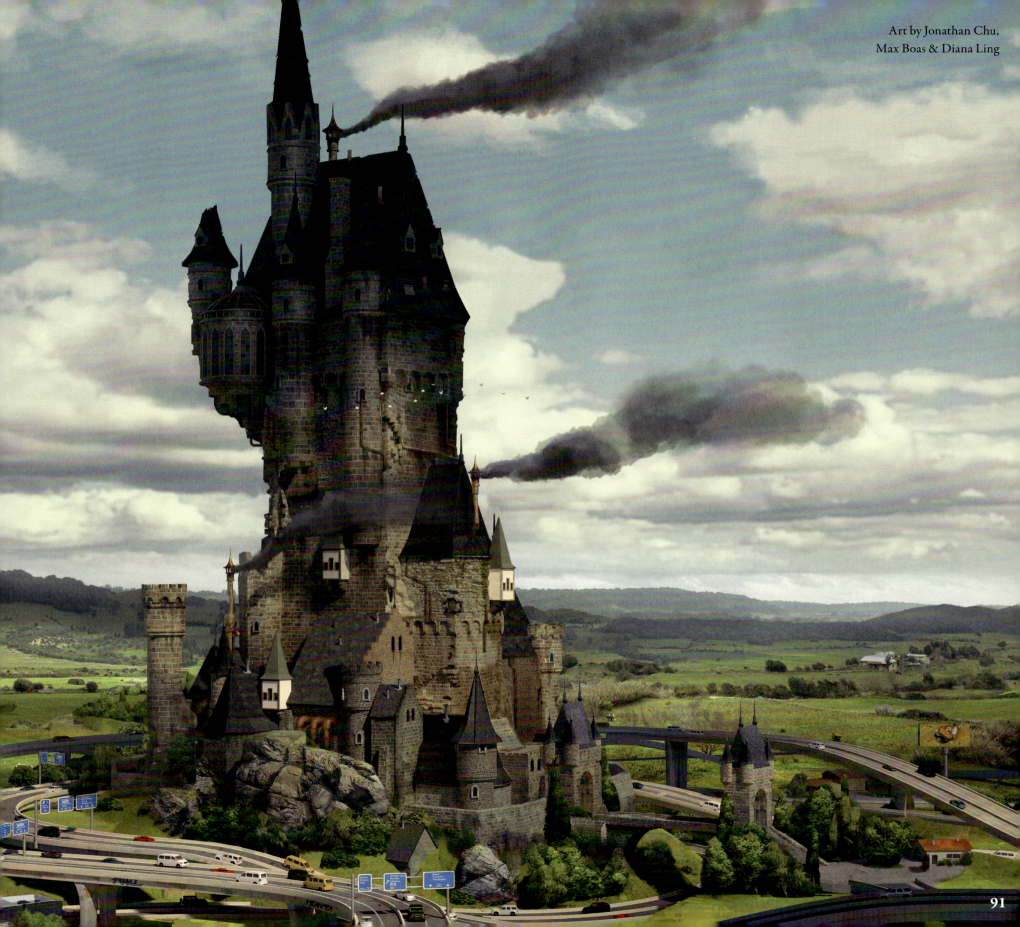
Art by Jonathan Chu, Max Boas & Diana Ling

In Munich, Germany, off the notorious Autobahn motorway, there is a strange castle with a stranger inhabitant lurking in its extraordinary, otherworldly halls.

"When we see it from the outside [it's] a live-action plate. It's a real thing. A real place," Max Boas says of Razamel's lair. "We go inside, and it's our animated castle. So, anything goes. It's made up of hallways and rooms and it feels vertical and expansive."

"It's a twisted world, kind of Escher-esque in a way," the production designer adds, invoking the impossible structure and geometry of 20th century Dutch graphic artist M.C. Escher. "I think the castle was really fun to develop."

Boas describes crafting the centuries of neglect and misuse that give the romantic structure a gothic appeal: "It's leaking. There's water damage. There's a level of decay within his surroundings. There's extra oil staining. It's just kind of a sad living. A sad castle life."

Margaret Wuller further discusses the art direction for the location, which, although a figment of fantasy, has some roots in actual architecture:

> There is [another] castle in Germany. It's called Neuschwanstein and it's what Walt Disney [based] the Sleeping Beauty Castle [on]. [It's] like the epitome of fantasy. King Ludwig II was the one who commissioned it at the time of the Industrial Revolution. People weren't really making medieval castles [at the time], except him.
>
> My point is that if you tour through Germany, some of these castles were made far more recently than you would imagine. They have modern amenities. Lift systems, you know, pulleys for moving tables to dining rooms from the servants' area. There were all of these modern updates. So, the way I, at least, thought of this—in designing Razamel's castle— was not like "Oh, he only exists in medieval times," but Razamel and Gargamel and the Smurfs, they kind of span the ages. They're not just bookended into this one period. Even though that's where they're from, they have lived for many more years than you and I.

Art by Diana Ling

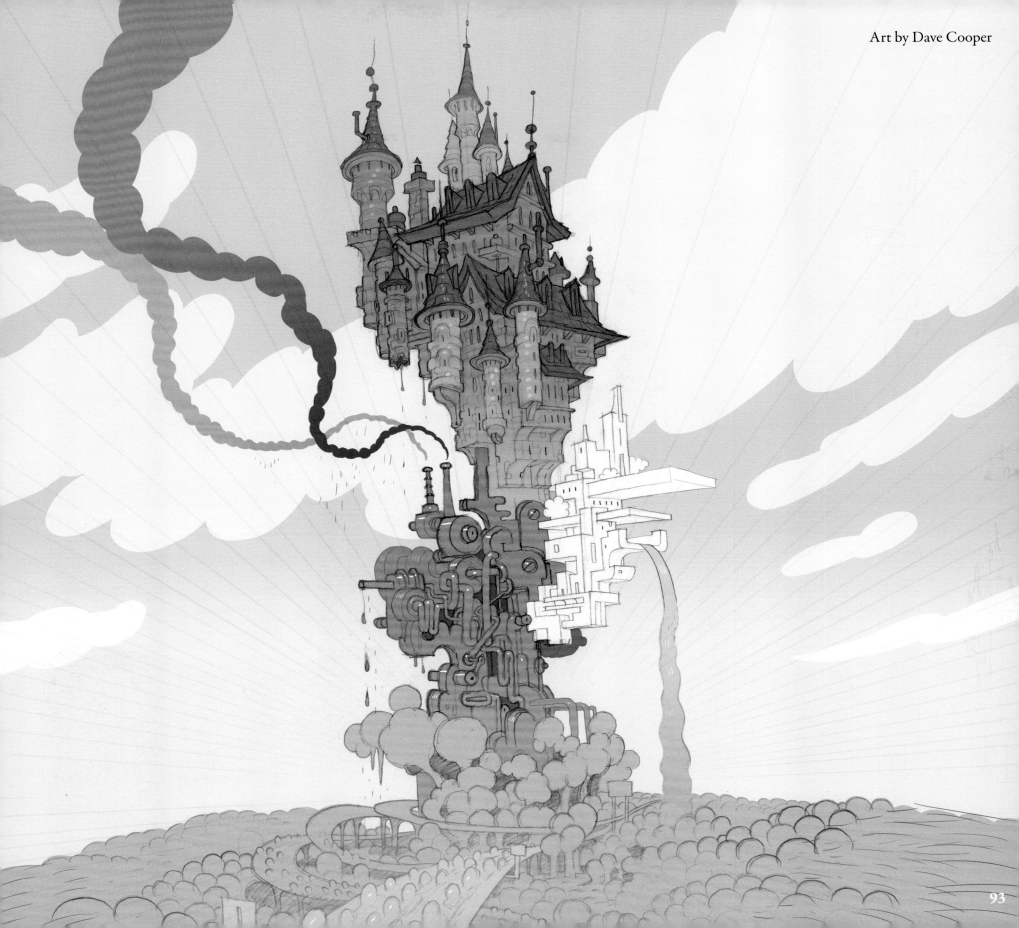

Art by Dave Cooper

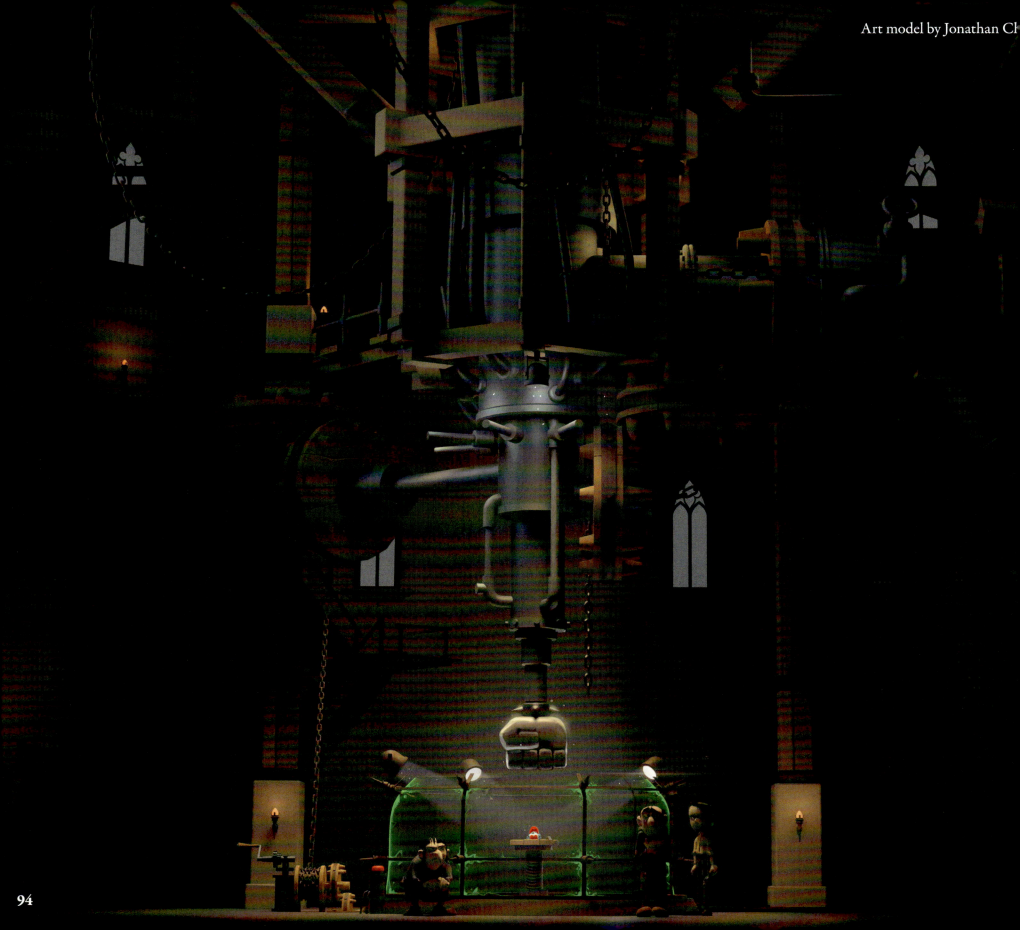

Art model by Jonathan Ch

So, as in Smurf Village, there's some future-forward hybrid technology populating the damp walls of the dwelling, and it plays into not only the look but the story of the film.

"There's this moment when Razamel is revealed," Wuller explains. "You come into this bedroom and it's dark and he's asleep, levitating with this fog behind him and when we were figuring out 'Well, where is the steam coming from?' we decided that he had nasal problems. So, he has one of those humidifiers that's going off in his room. And so, he's got a little bell pulley system by his bed so he can ring his assistant, but then he also has a humidifier that plugs in somewhere. That's just a funny juxtaposition of technology, and that's sprinkled throughout. He's got a lute in his room, but then he has a supercomputer that he's kind of mocked together."

Boas describes the tattered tech as "barely duct-taped together." He recalls, "We [looked] at retro computers, not modern-day, so, early '60s computers, '80s keyboards, things like that and it had to have a handmade quality, more of an analog feeling to it."

"We thought, well, maybe this supercomputer is actually powered by steam and not by electricity," Wuller says, bringing in that old-world quality to her discussion of the machinery. "One of our artists pulled up this amazing video reference of steam-powered tractors—the sounds and the steam and that big crank that you pull down—and [we] incorporated that into this machine." The chaotic momentum of the design continued from there. "And so, although the medieval times were sort of a jumping-off point, [the gadgets] spanned anything from then to the 1980s. We began to loosen up on what time these characters were living in, obviously going then further into the live action sequences—those are modern day."

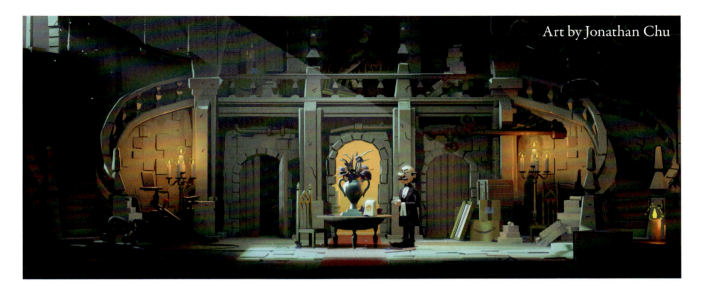

Art by Jonathan Chu

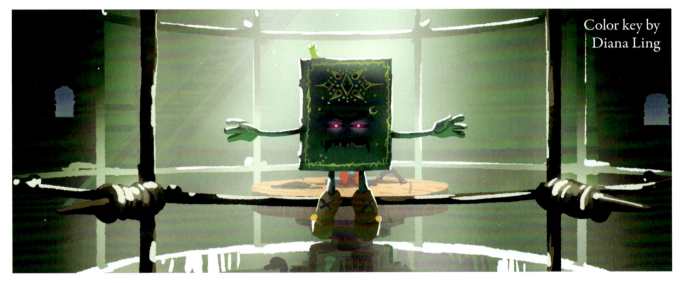

Color key by Diana Ling

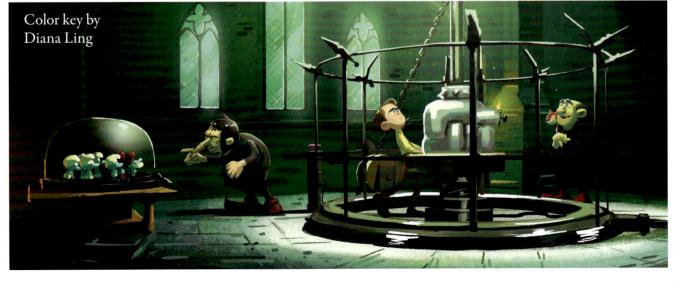

Color key by Diana Ling

Control room computer concept by Jonathan Chu

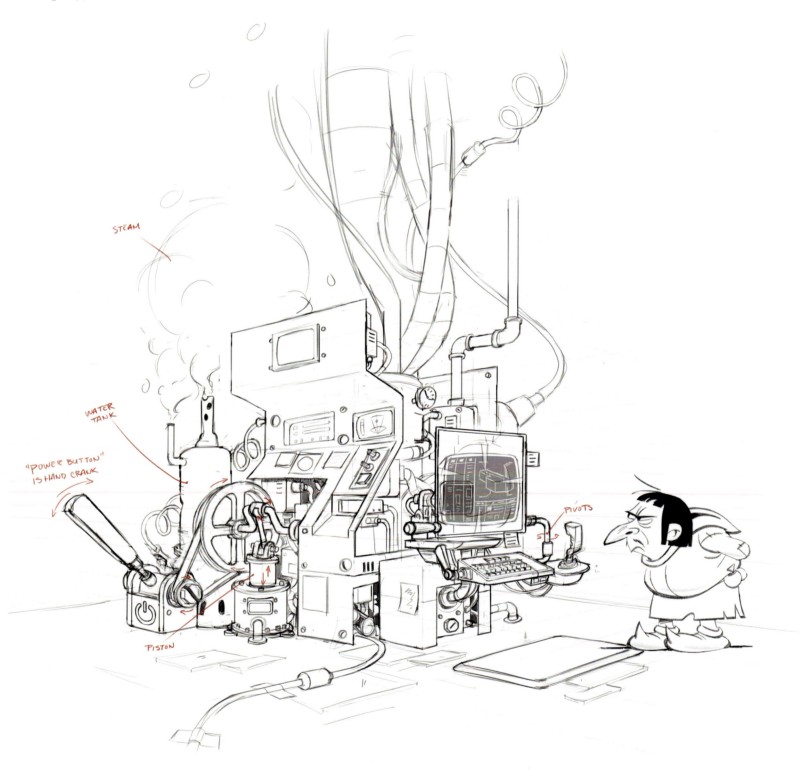

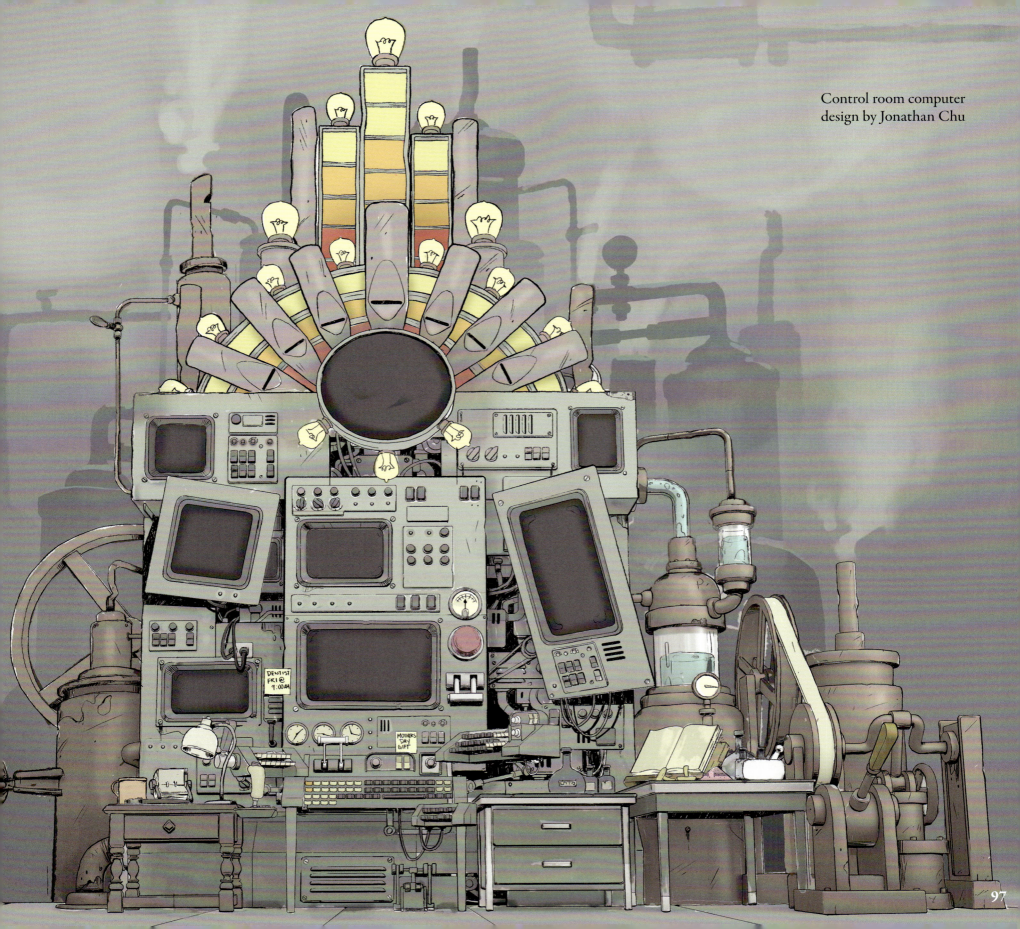

Control room computer design by Jonathan Chu

Razamel's bedroom design by Angie Duran

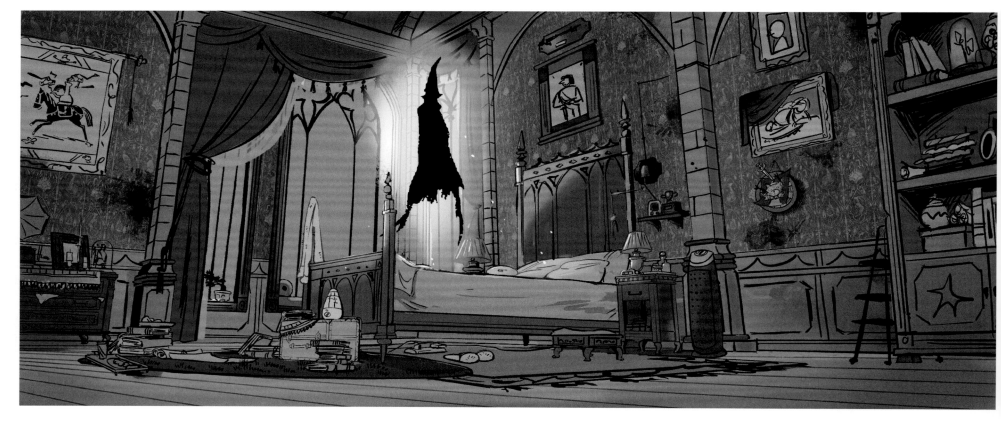

Solarium props by Diana Ling

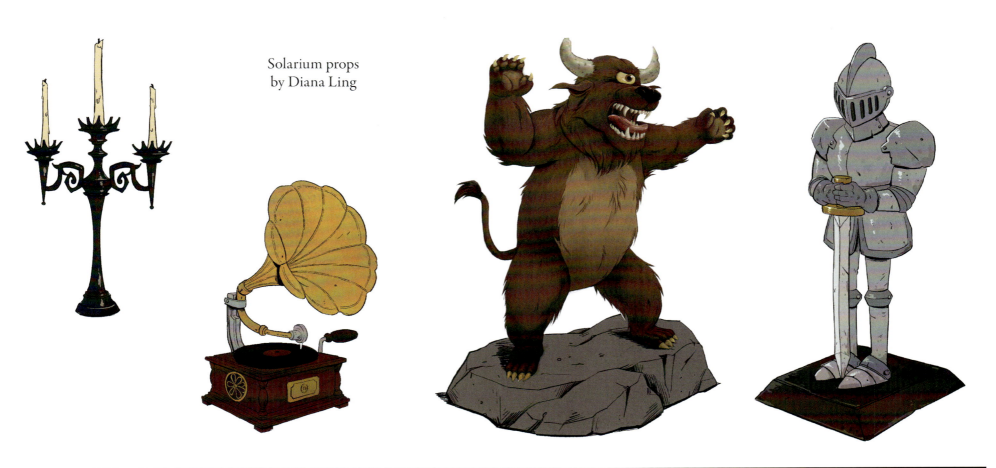

Art by Angie Duran

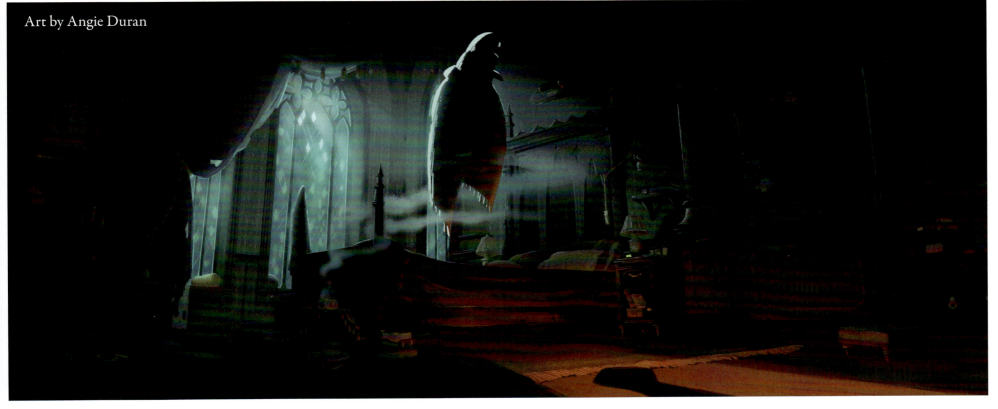

Torture table tools
by Angie Duran

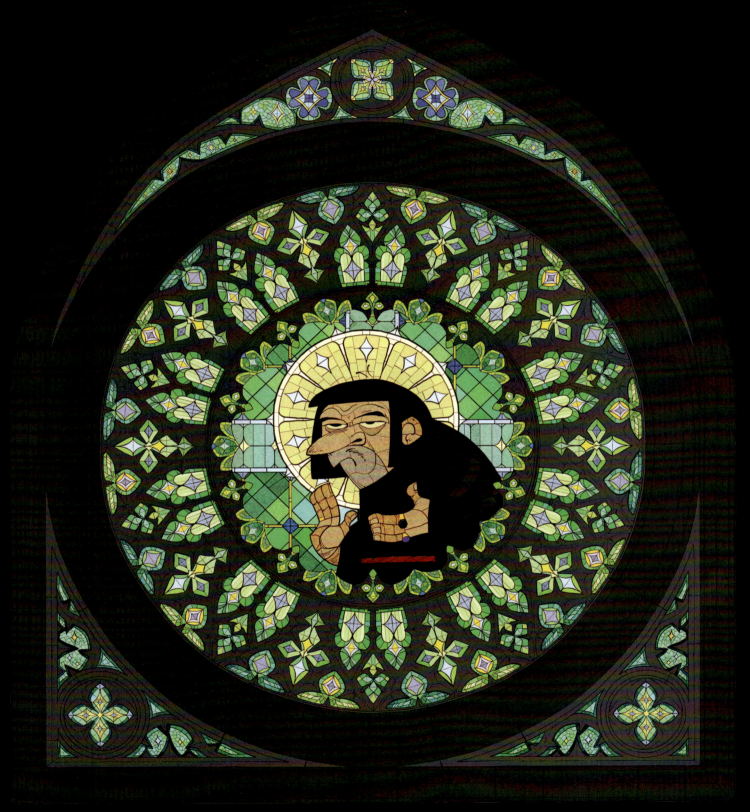

Squishodrome rose window by Grace Kum

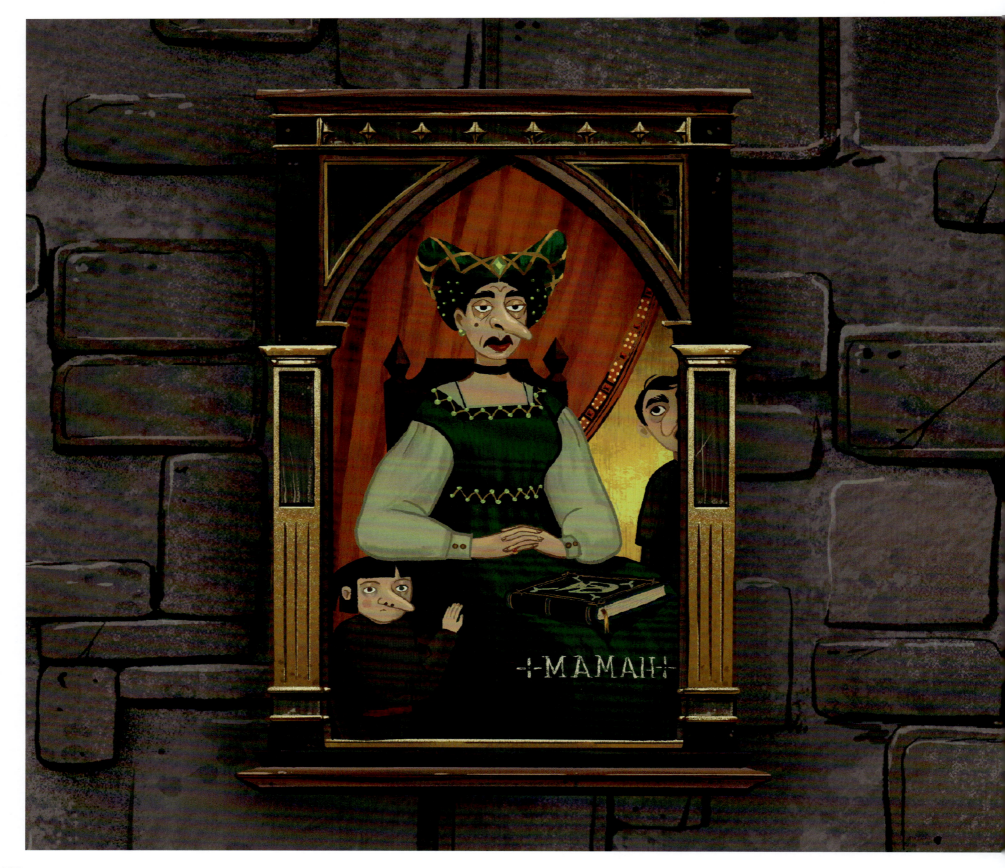

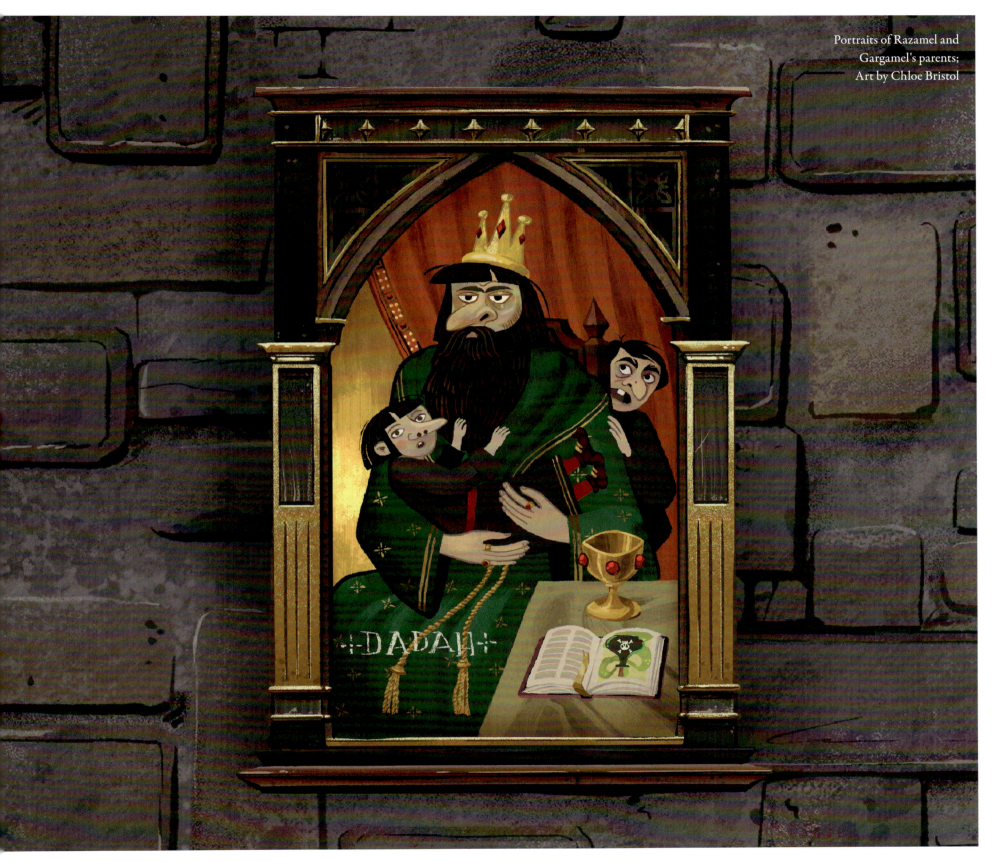

Portraits of Razamel and Gargamel's parents; Art by Chloe Bristol

Solarium design
by Diana Ling

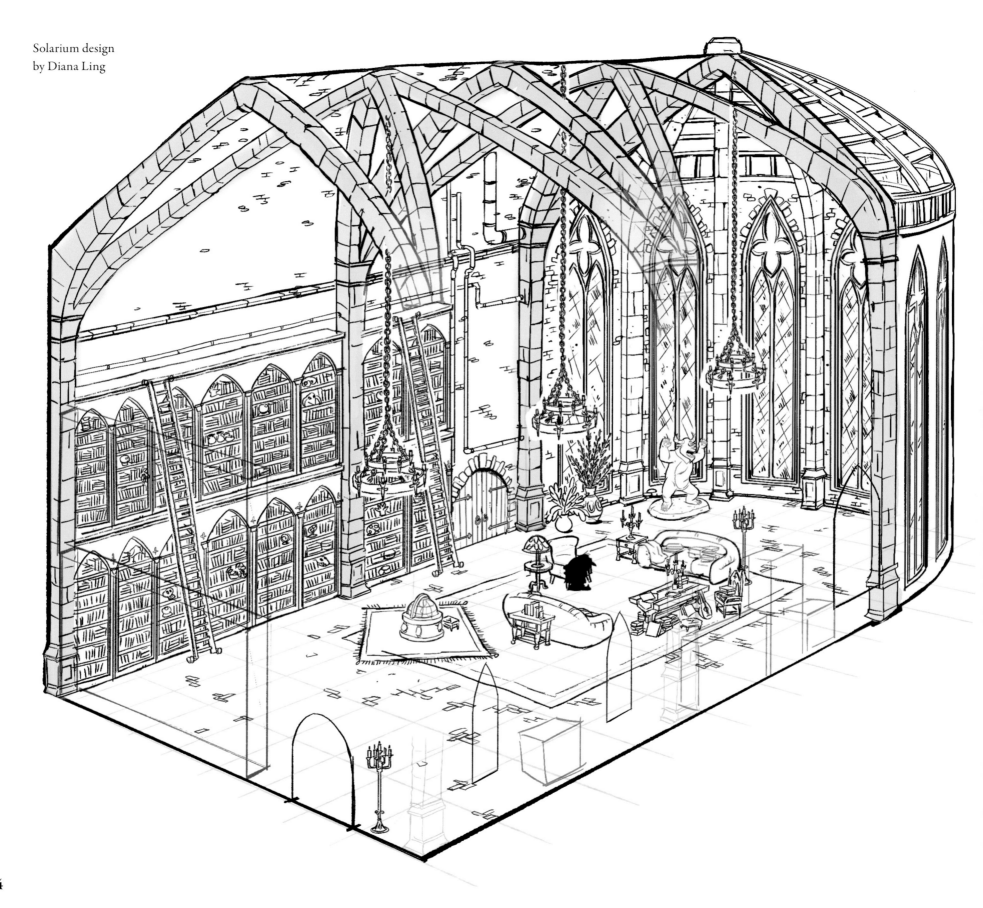

104

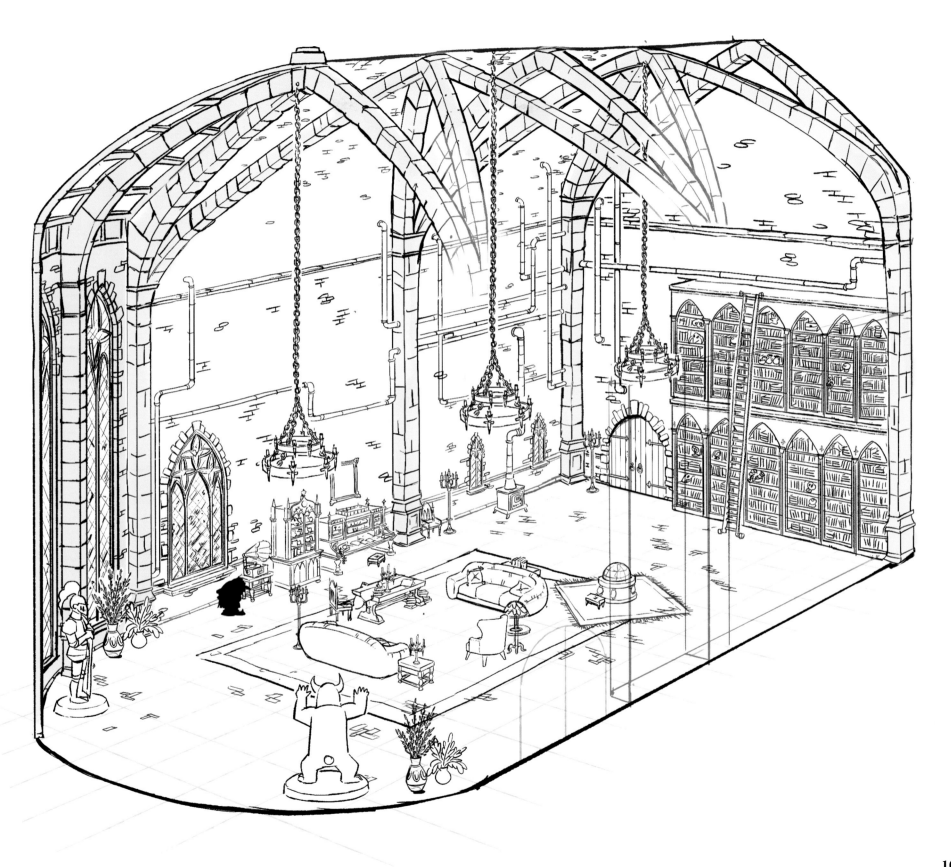

Squishodrome room line drawing by Jonathan Chu

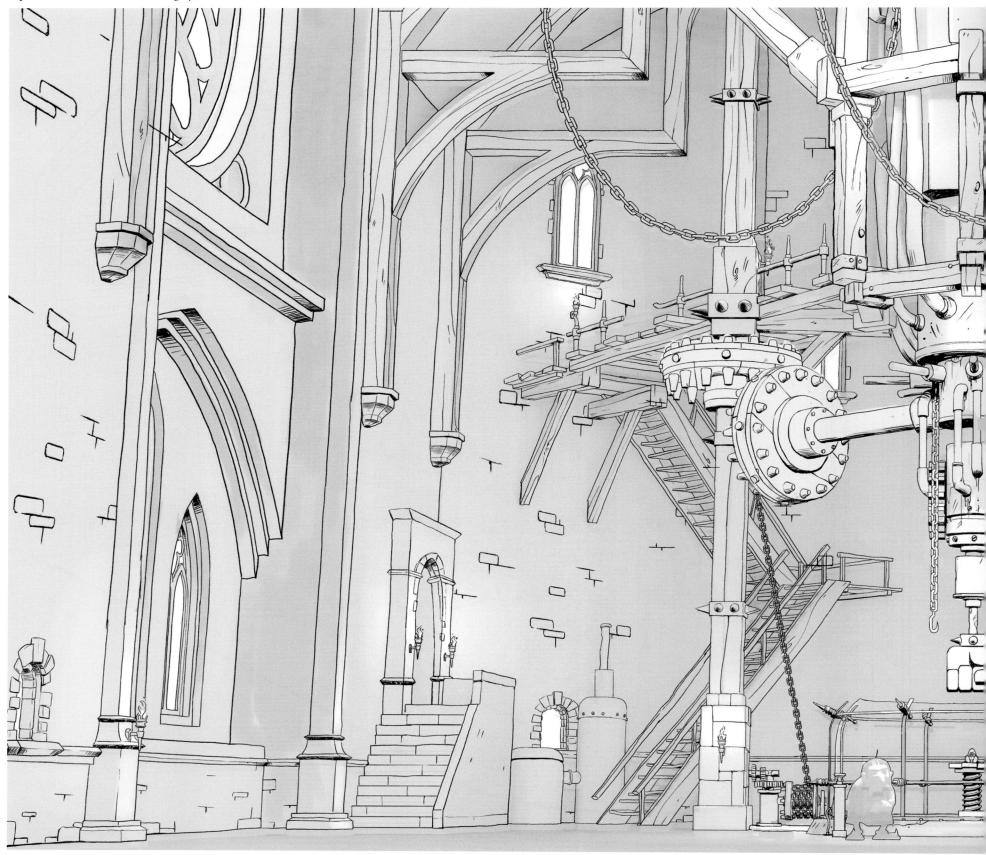

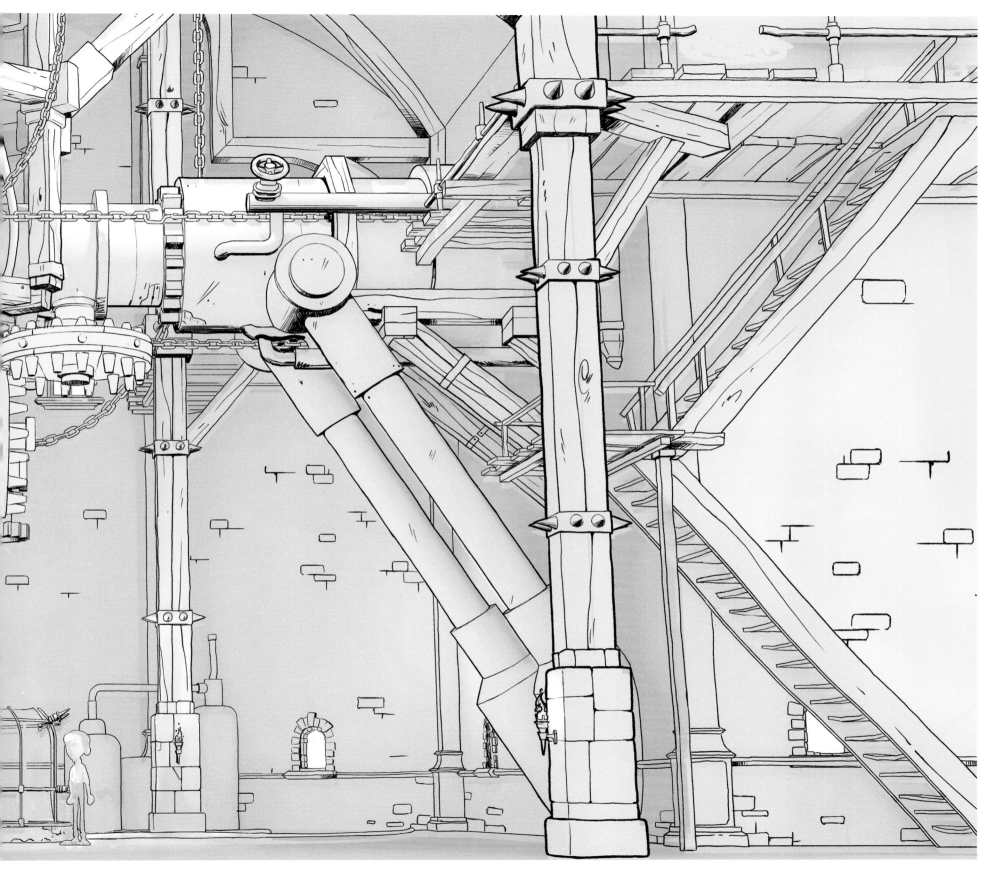

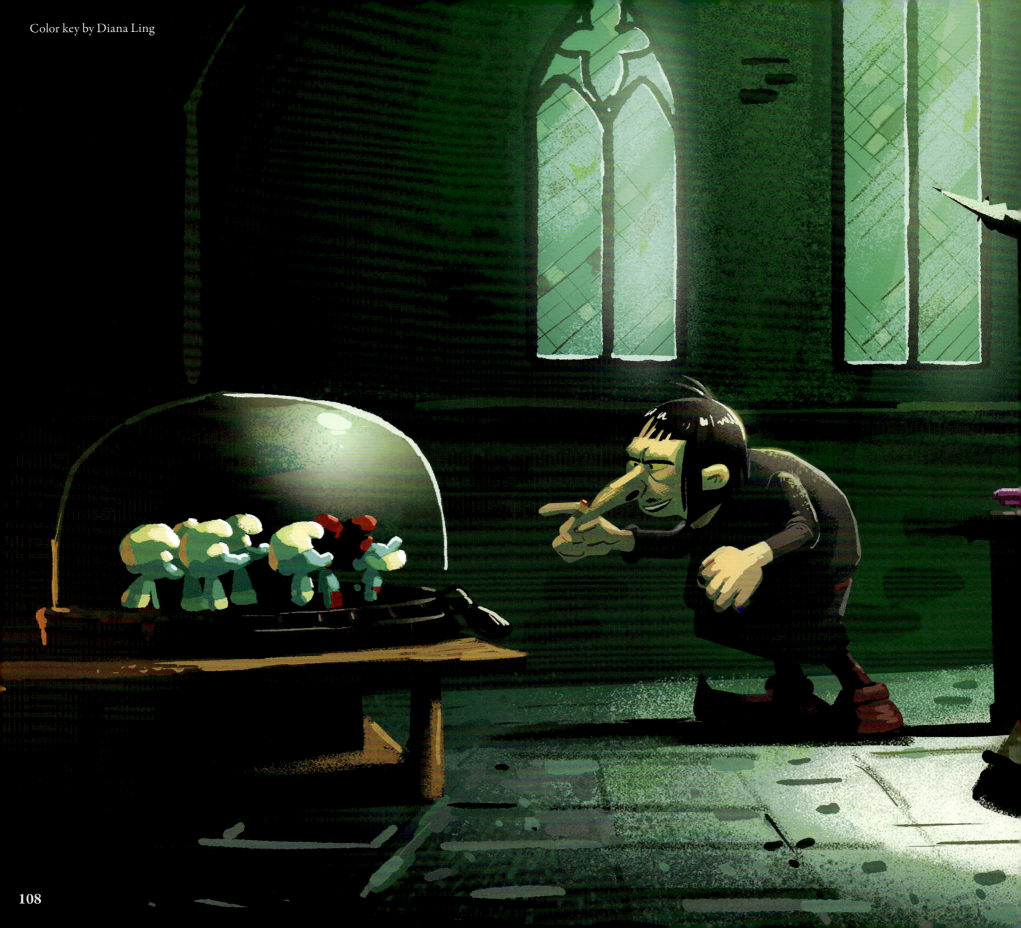

Color key by Diana Ling

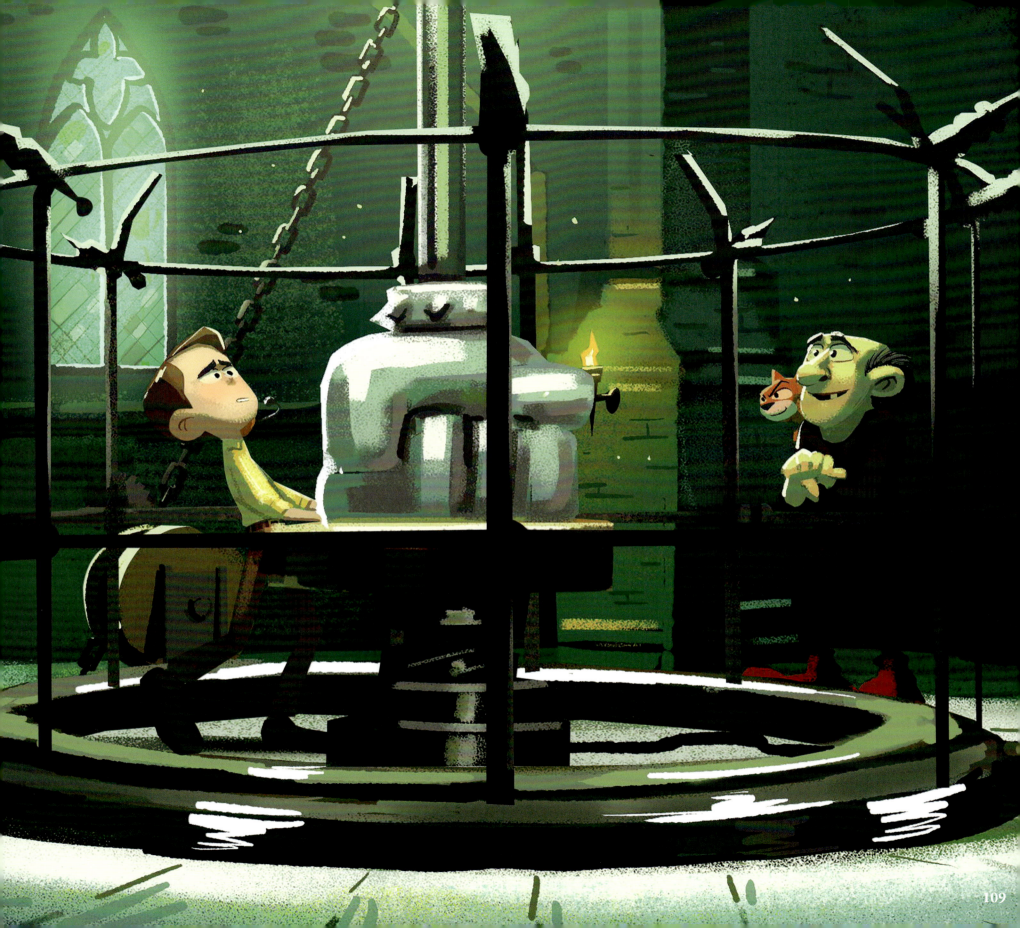

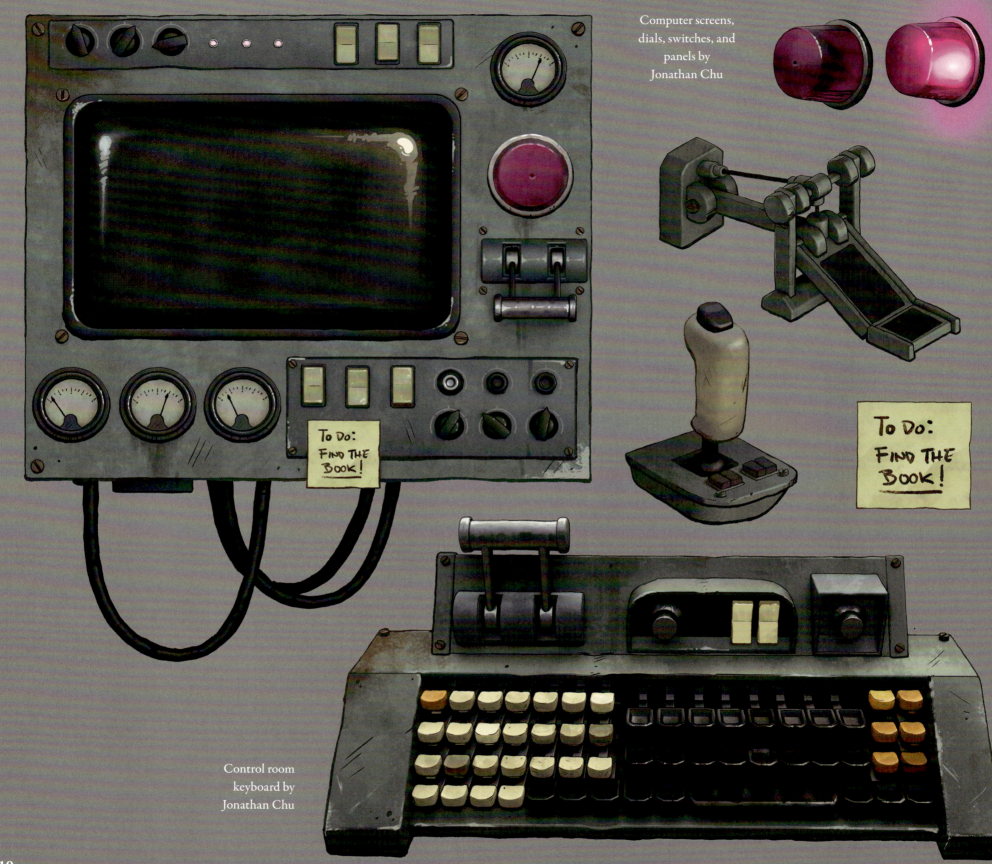

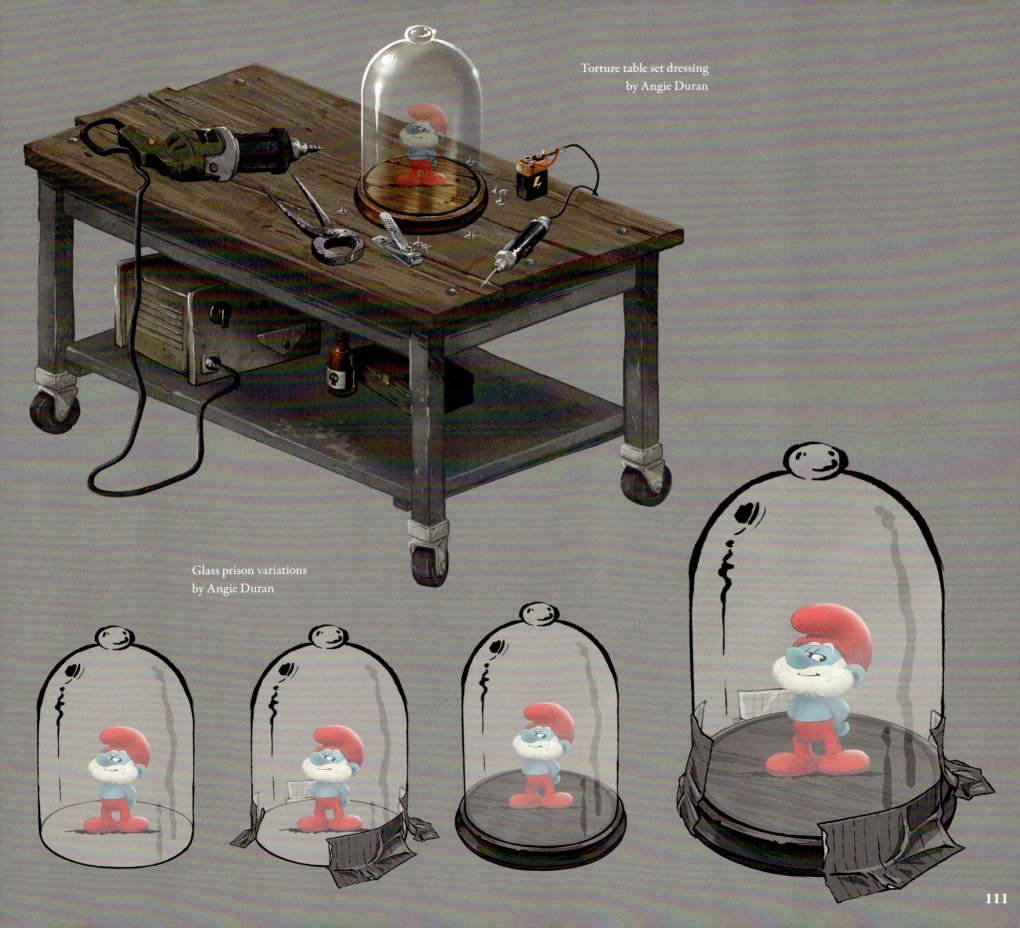

Torture table set dressing
by Angie Duran

Glass prison variations
by Angie Duran

JOEL voiced by Dan Levy

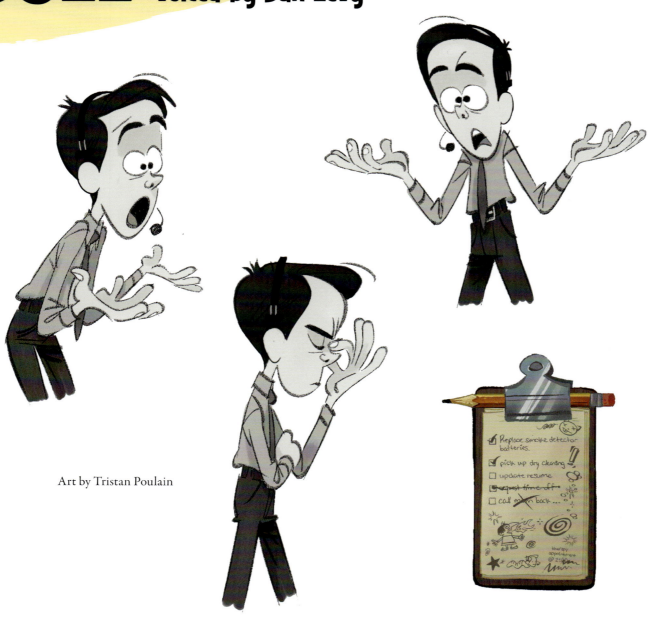

Art by Tristan Poulain

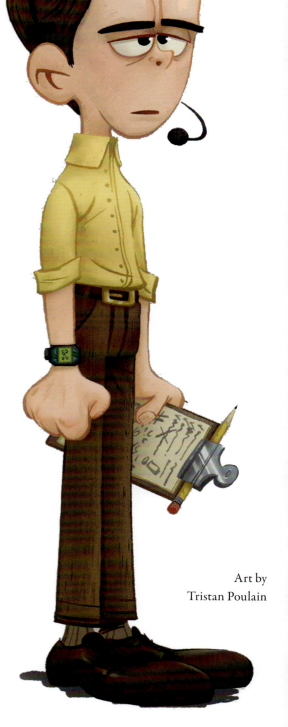

Art by Tristan Poulain

The equipment isn't the only anachronistic occupant of Razamel's castle. His assistant, Joel, has a time-out-of-place quality that adds to the anarchy of the evil abode.

"We have a more modern costuming for Joel," Max Boas points out. "I think that Chris [Miller] was always open for that idea, touches like a digital watch from the '80s, just thrown in for comedy. The little mouthpiece isn't attached to his headset—it's a 'flyaway' as a nod to the Peyo comics as well."

Joel's look isn't the only humorous aspect to the character. Miller says of the vocal performance, "Dan Levy is so good. He's hysterical to me."

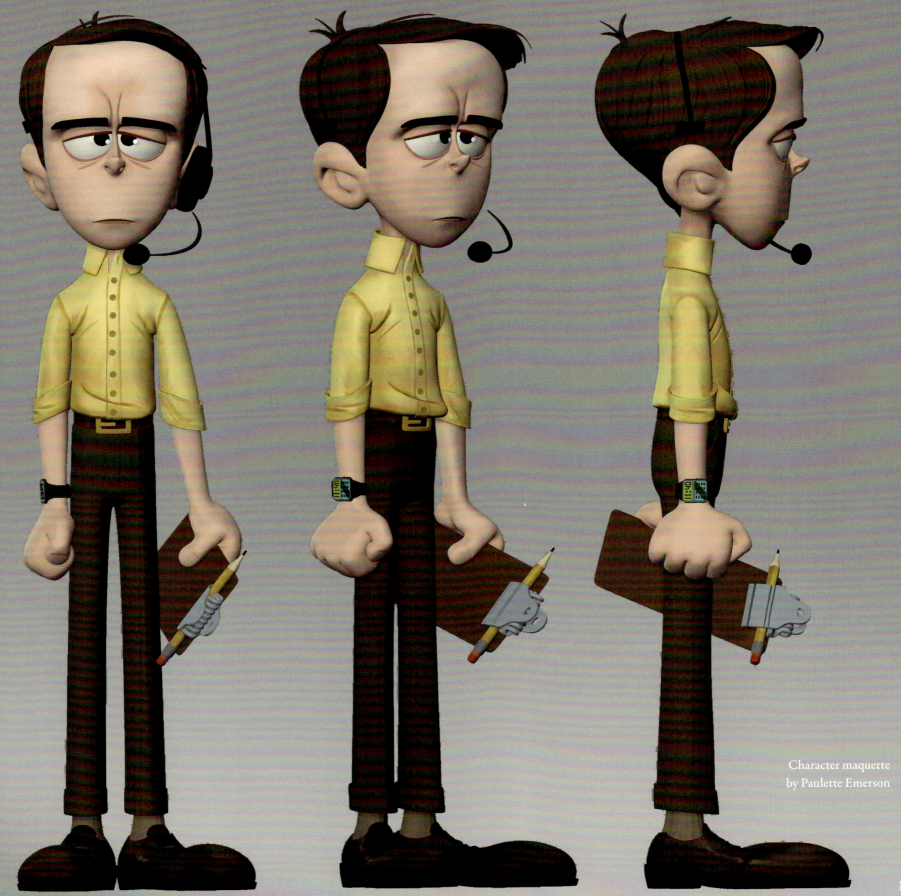

Character maquette by Paulette Emerson

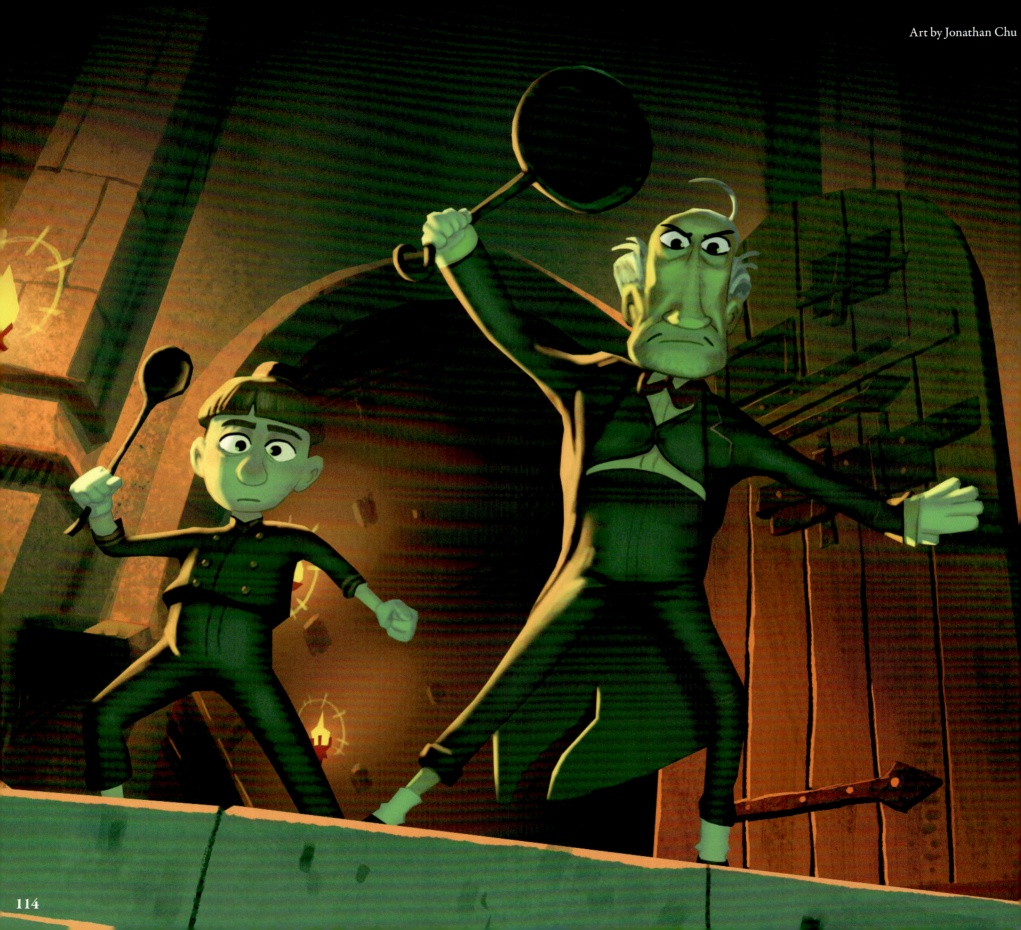

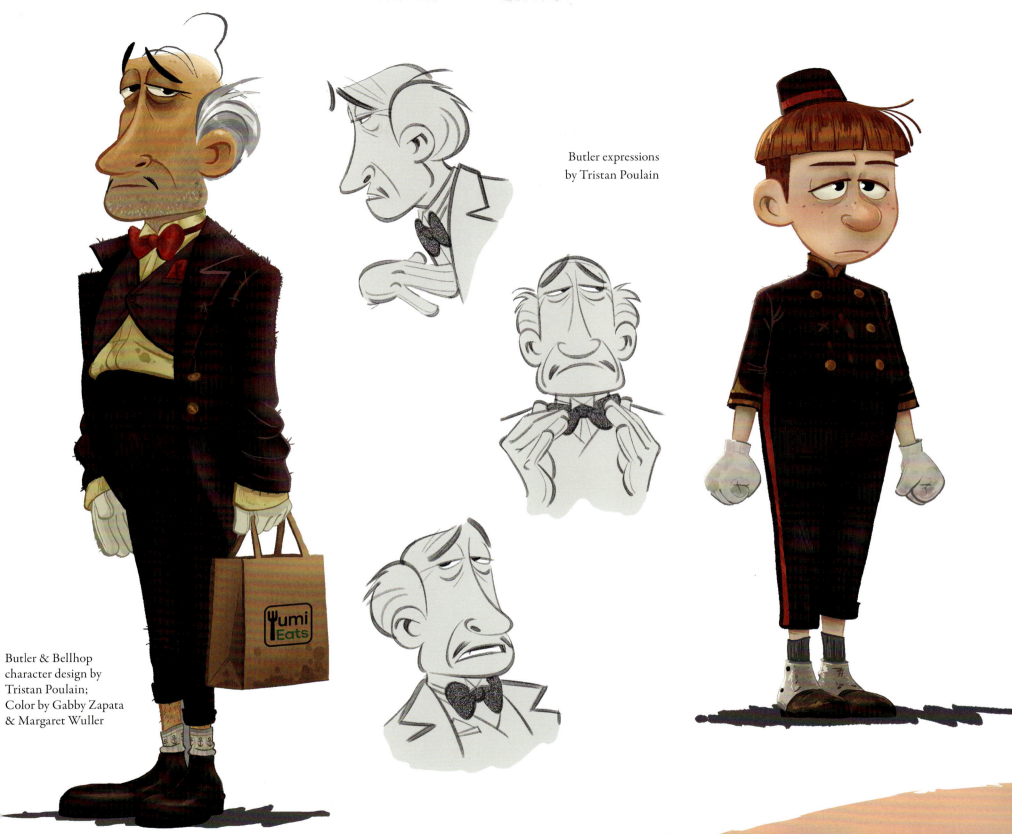

Butler expressions by Tristan Poulain

Butler & Bellhop character design by Tristan Poulain; Color by Gabby Zapata & Margaret Wuller

BUTLER & BELLHOP

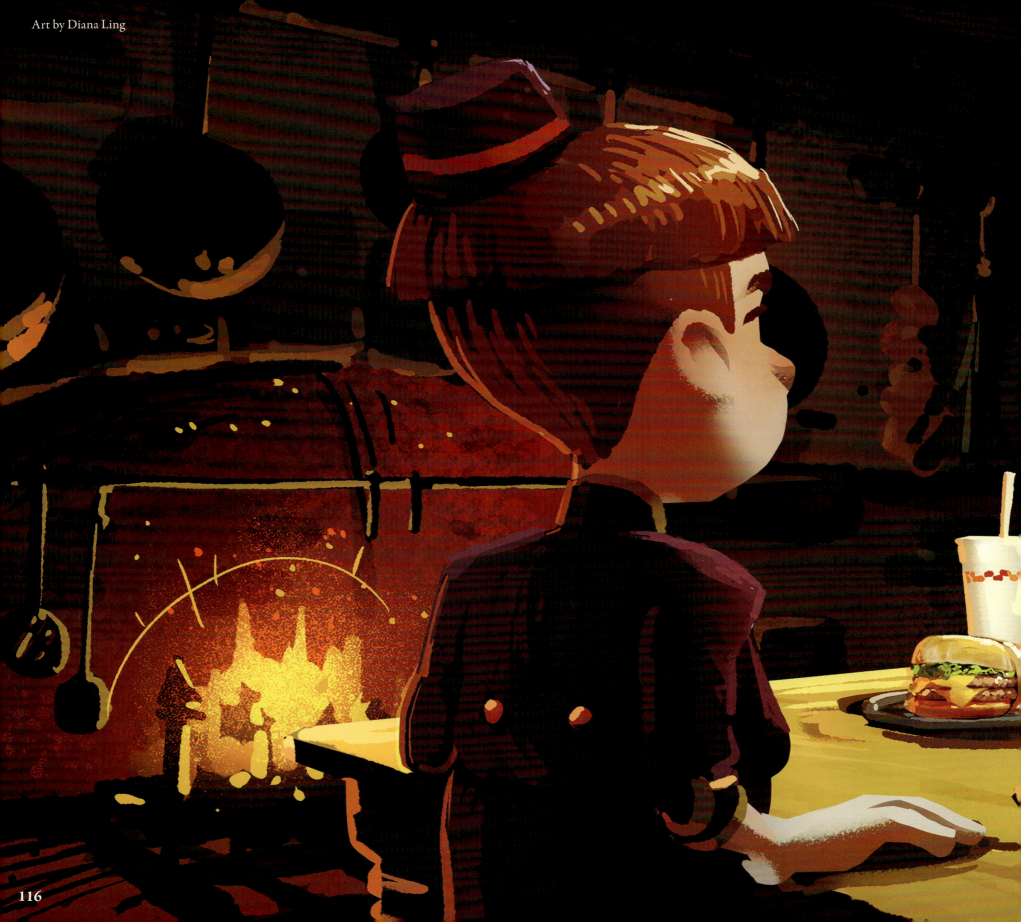

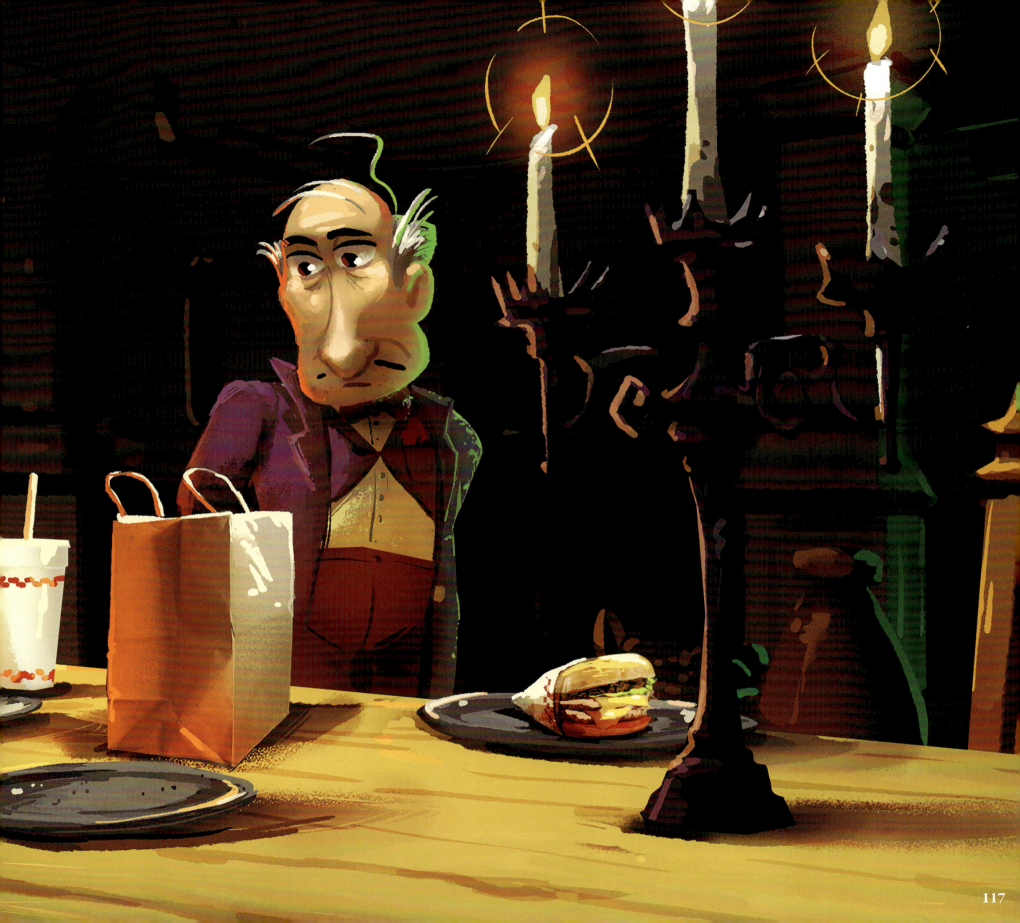

ALLIANCE OF EVIL WIZARDS:
Asmodius, Chernabog, and Jezabeth

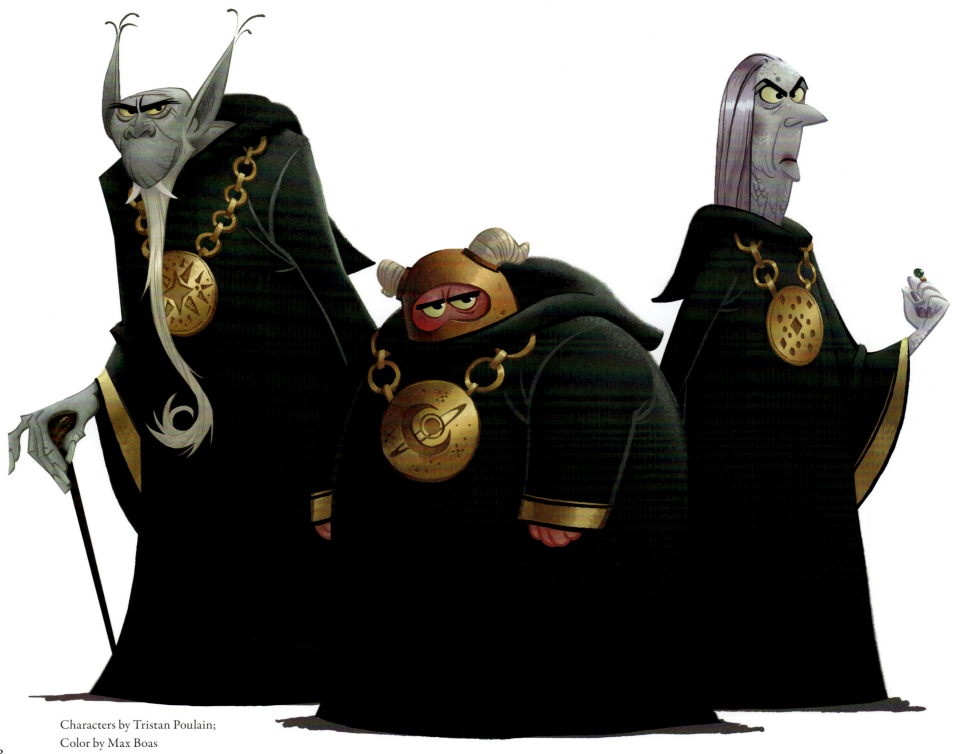

Characters by Tristan Poulain;
Color by Max Boas

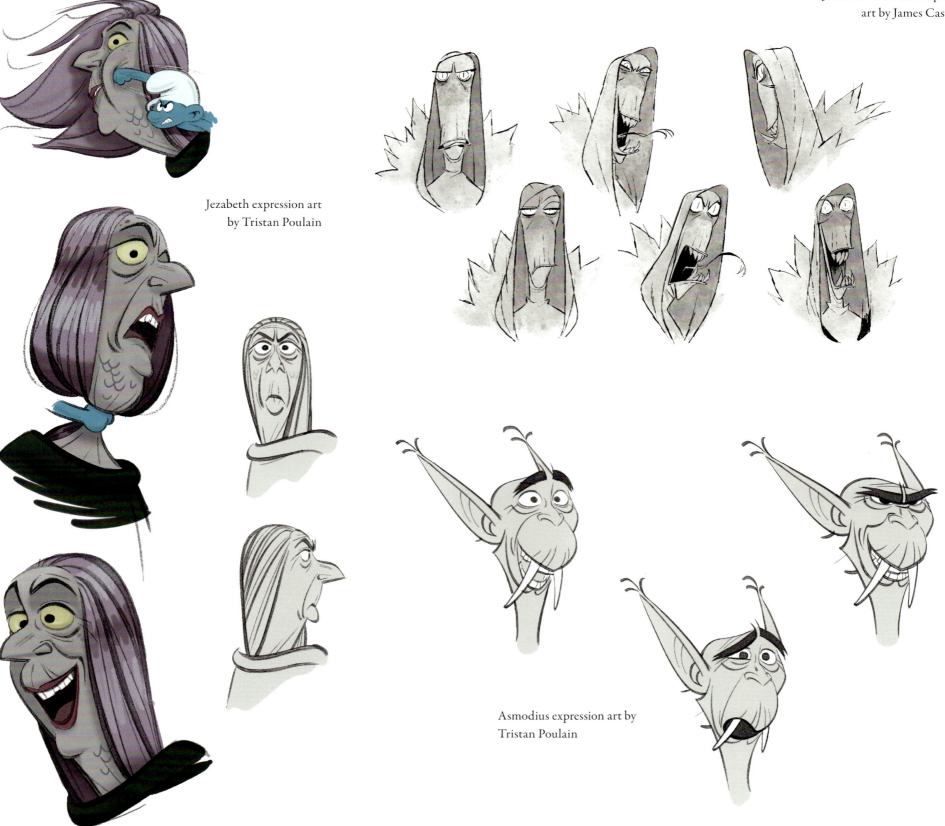

Jezabeth visual development art by James Castillo

Jezabeth expression art by Tristan Poulain

Asmodius expression art by Tristan Poulain

119

Wizards visual development art by James Castillo

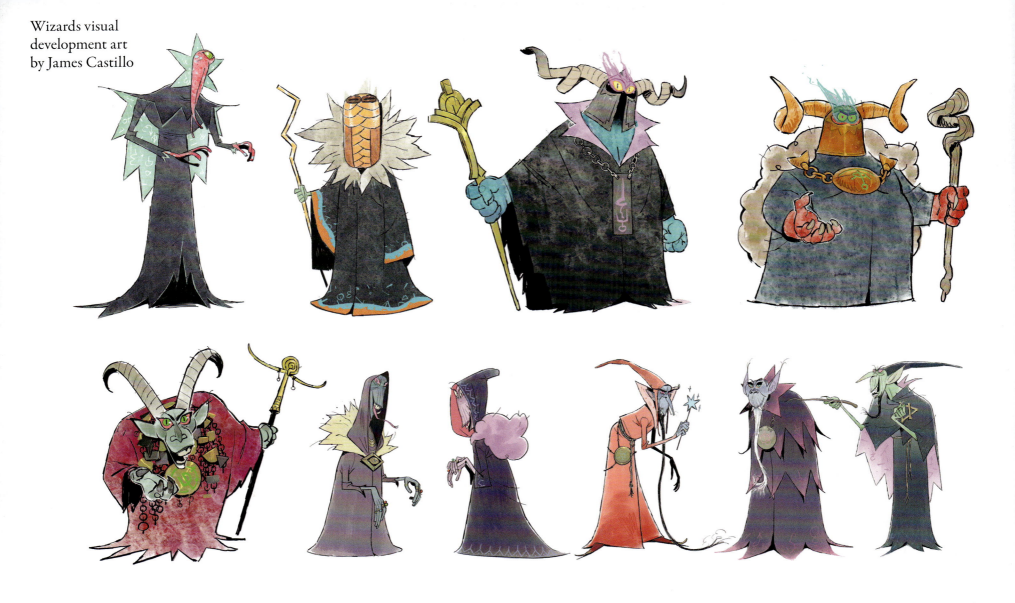

Created for the 2025 film, the Alliance of Evil Wizards is said to have been formed as a result of a treaty between a group of intergalactic sorcerers that was signed by Gargamel and Razamel's great-great-great-grandfather, Zazamel. One of the mandates of the coalition was to capture the four magic books that maintain the balance of peace and harmony in the universe.

The current roster—which includes Asmodius (Octavia Spencer), Jezabeth (Hannah Waddingham), Chernabog (Nick Kroll), and Razamel—was previously thwarted by a valiant assembly of Smurfs over a century before the start of the film, but they have not given up in their pursuit.

"[The wizards] live in four or five different dimensions or pocket universes," according to *Smurfs* co-director Matt Landon. "[They] need to get rid of [the Smurfs] so that they can control the world, make it all evil."

"All this backstory came from the art department," confesses Boas, regarding the characters' designs. "We were brainstorming different ideas, just to ground [our choices] in some purpose. They have these kind of intergalactic medals adorning them. Chernabog may be from Saturn, too much wasn't really found in the script about where they came from."

One thing that is certain is how Chris Miller enjoyed working with each of the talented performers who brought the wizards to vocal life. He says, "Octavia Spencer is a joy and understands humor and can deliver the funny. Nick Kroll is straight-down-the-middle funny. Sharp. Brilliant. Just a gift." And as for Waddingham? "Absolutely astounding actor. She should be the biggest star in the world, in my opinion."

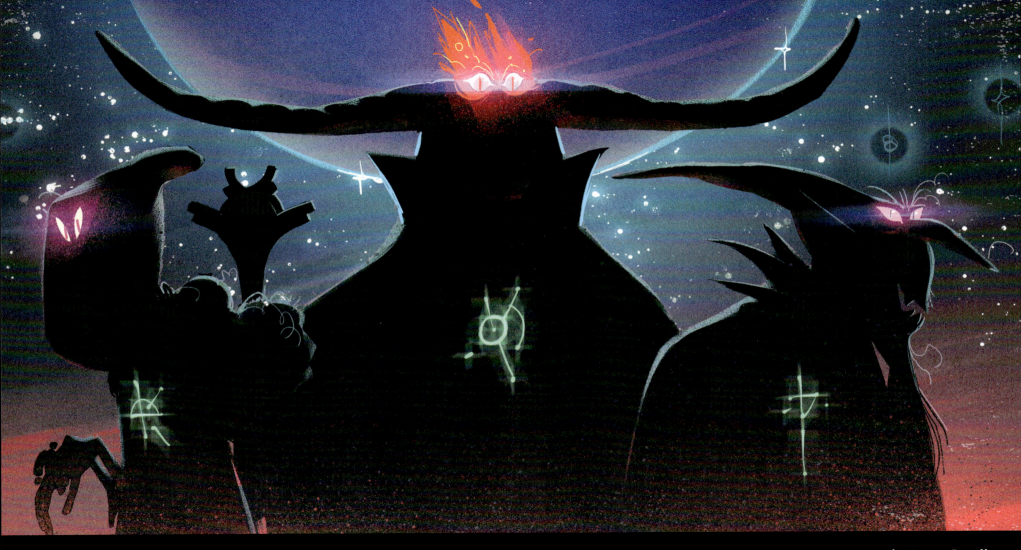

Art by James Castillo

Art by James Castillo

Art by Max Boas

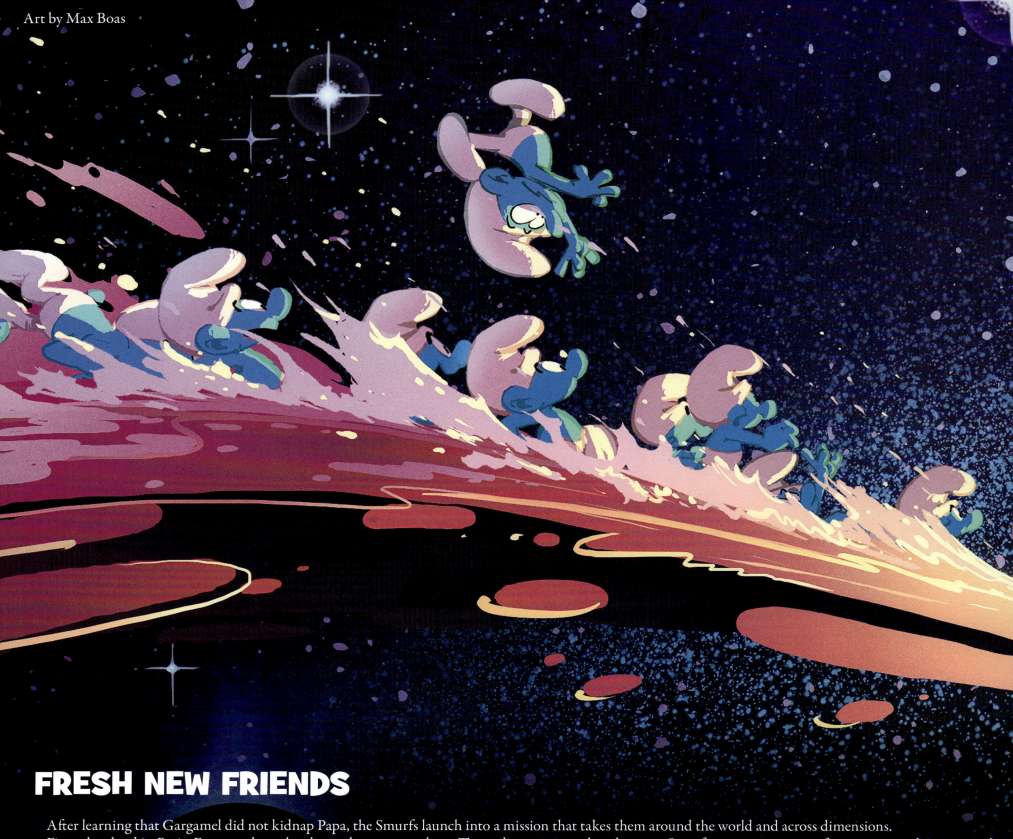

FRESH NEW FRIENDS

After learning that Gargamel did not kidnap Papa, the Smurfs launch into a mission that takes them around the world and across dimensions.
First, they land in Paris, France, where they learn they are not alone. The audience is introduced to new Smurfs: an organization of street-smart adventurers who protect the world from a larger evil. Their captain is Ken, the mysterious figure the Smurfs from Smurf Village were tasked with finding in order to restore order.

FAR OUT SPACES, PLACES, AND FACES

After a portal-related mishap, Ken guides the Smurfs through the Australian outback, where he tries to recruit the help of the world's greatest interdimensional navigators, the Snooterpoots. A semiferal tribe of fantastical furry creatures with a taste for danger—and cake—the Snooterpoots are led by an oracle, of sorts, named Mama Poot.

Despite a checkered past with Ken, Mama agrees to help Smurfette and No Name find Papa after Razamel siphons her clan and the other Smurfs into another portal of his own making. In order to get them all back, Mama loads our lead duo into her jalopy and shoots them across the outback and into the cosmos!

PARIS, LE PAYS DE KEN*
*PARIS, THE LAND OF KEN

Although the viewer is given a peek at the animated interior of Razamel's interdimensional live-action/CG castle earlier in the film, the first "live-action" location our heroes truly encounter is the streets of Paris, France.

Dumped by the psychedelic stargate into a nighttime cityscape that is the polar opposite of what they're accustomed to in the village, the Smurfs and their turtle companion (yes, he's still with them) experience a case of culture shock mixed with some dimensional travel delirium as they absorb the sights and sounds of the City of Lights, and its enormous and fast-paced inhabitants, who look and feel quite different.

As a director, Chris Miller was almost as overwhelmed as the Smurfs, as this marked the first time the lifelong animator had to helm a live-action shoot on a studio film.

"We shot in Turin, substituting as Paris," he recalls of the experience, which took place over "a pocket" of long spring nights in Italy. "Definitely a different gear for me, and an incredible experience, and what [filming live-action] takes, when I realize it, is an incredible crew and folks that [are] just so dedicated to the cause."

He calls out one key crew member in particular: Peter Callister, his director of photography. "I will owe him a debt of gratitude for eternity," Miller says. "Really helpful for me in those situations and just getting everything we needed."

Max Boas, who likewise was not familiar with working in live action, wondered how the "Paris" shots would work with the computer-generated material they had been working on. "Our animated world is very vibrant and colorful, and then when we're in our live-action plates, instantly we're in a naturalistic color palette," he explains. "We're shooting nature. We're shooting with a camera. There's an inherent contrast in it. Practical light sources that are on set and a full material range."

"We opened everything up to the real-world experiences of all textures, all colors," Margaret Wuller explains. "That was the concept behind it."

She explains that the fact that the Smurfs are "always kind of hidden" from human sight was helpful to mixing the CG and live action. "I think there was a playfulness with that idea. They're sneaky, which makes me think that they could exist in our world if we're just not seeing them."

"I didn't work on set per se," Boas says. "We got [photographic] plates back, animated characters on top [of those], and it was my job to make sure they were integrated."

His verdict of the process?

"I think with our show style, our graphic style of our characters and how we're lighting them, and our line work—it worked really well."

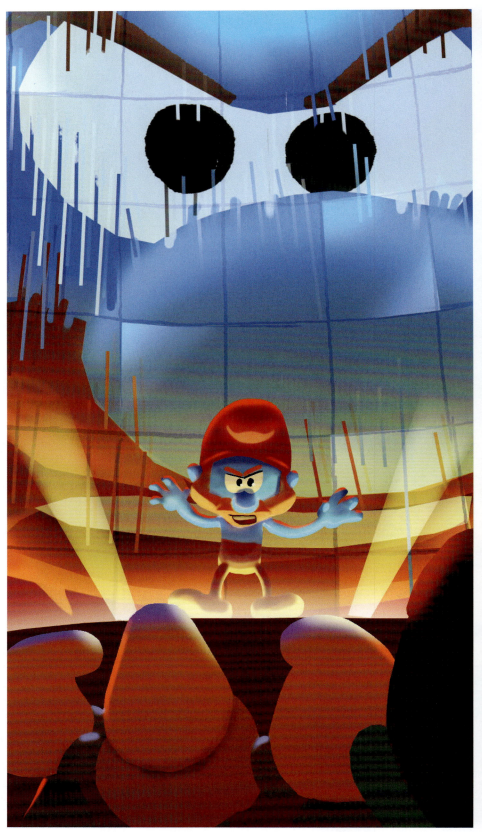

Art by Jonathan Chu

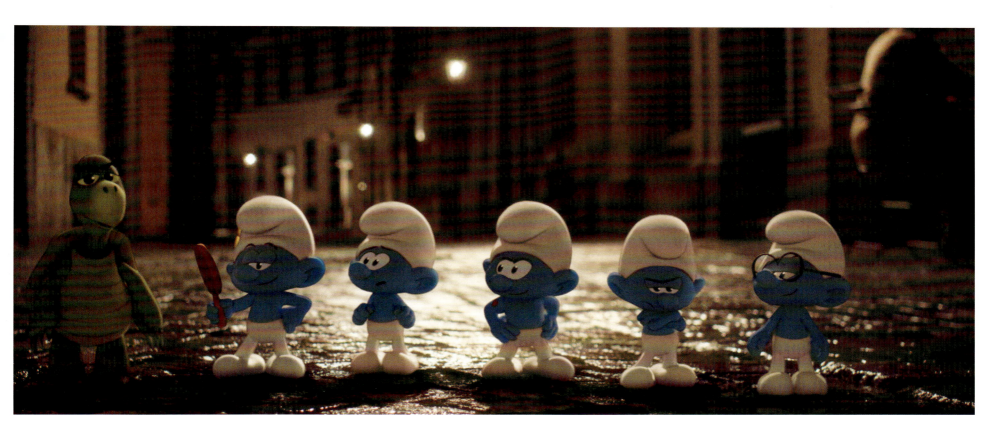

INTERNATIONAL NEIGHBORHOOD WATCH SMURFS

Scrambling through the city streets leads the travelers to an encounter with the International Neighborhood Watch Smurfs (INWS), Paris Division.

While this is far from the first time in Smurfs history that the residents of the village would realize that they're not the only colony of Smurfs in the universe, never before have they come across such a highly trained tactical unit, with such a modern sensibility.

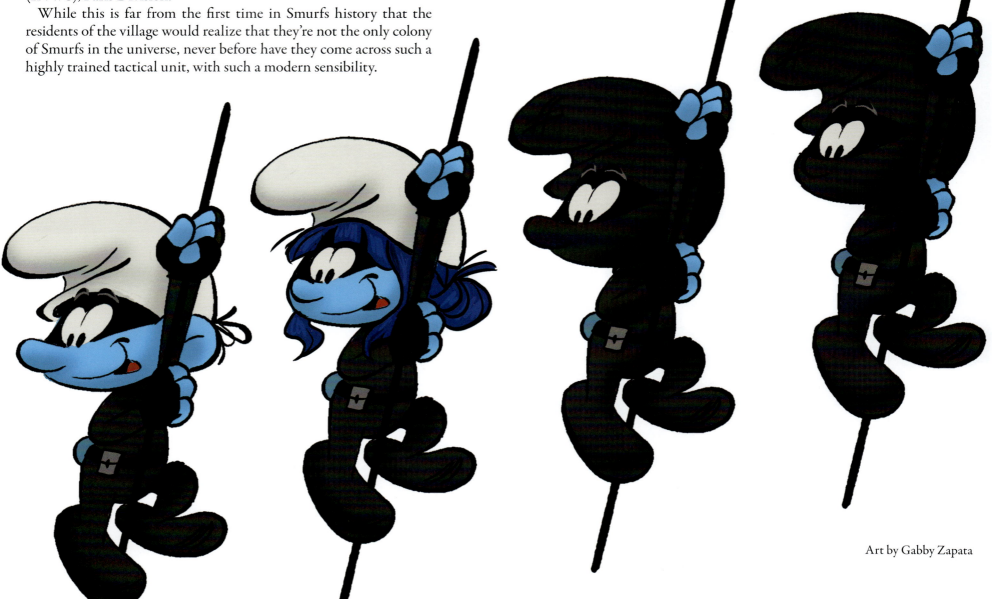

Art by Gabby Zapata

Max Boas describes the INWS as "these dark kind of beings sneaking around." Margaret Wullo clarifies that they may be "kind of ninjas," but "they're still Smurfs. They're still good."

In ensuring that the INWS maintained its righteousness, the design team had to ask themselves, "How far can we go with the ninja thing without it being violent?"

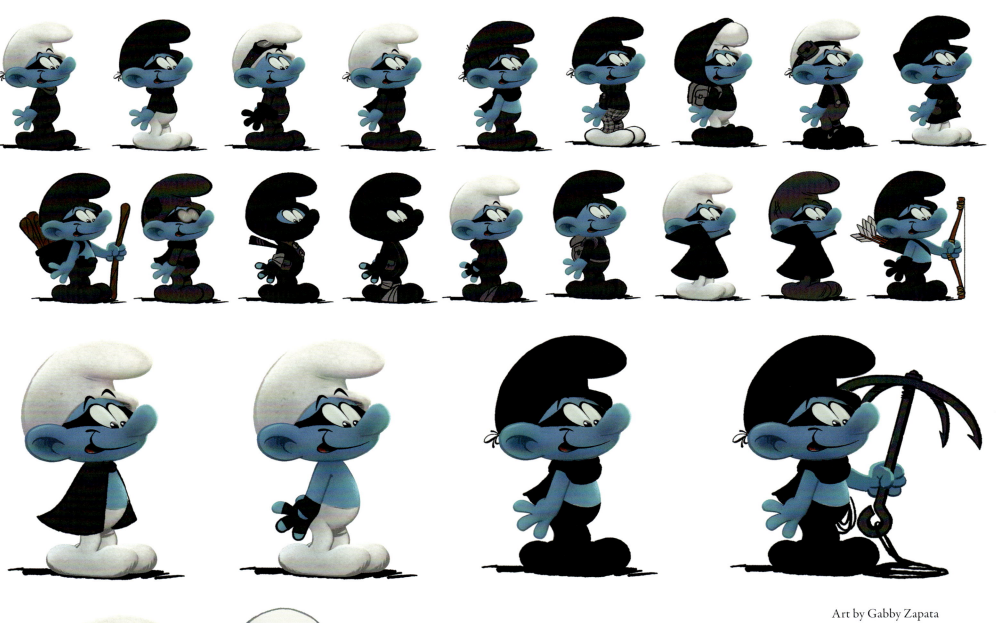

Art by Gabby Zapata

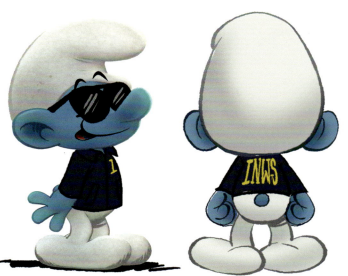

Wuller says the answer came down to depicting what tools the Smurfs carried on their missions to reveal their objective. "It's about their grappling hooks, swinging and rescuing, and less a lot about battle."

Their outfits had to be practical for the modern rescue ninja, as well. Boas says the jumpsuits, in playing to a retro aesthetic, became "kind of '90s tracksuits with fingerless gloves." And to provide a level of stealth, their hats are dark as opposed to the customary white except in the case of Moxie (voiced by Sandra Oh), their field captain, who wears a red cap to denote her leadership. For Boas, it's about "subtle differences."

MOXIE

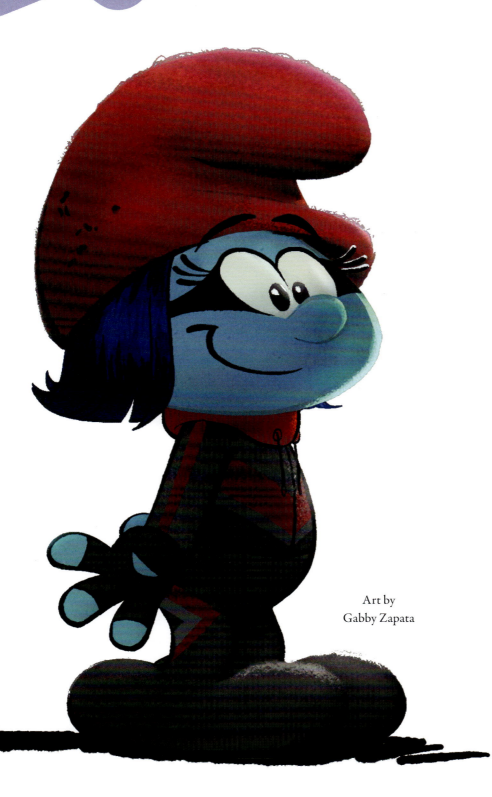

Art by Gabby Zapata

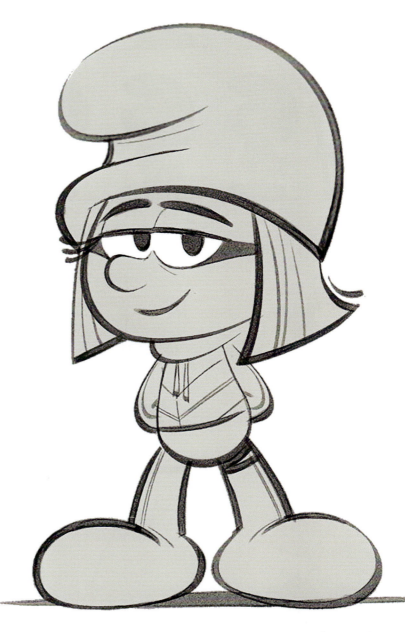

Character design by Tristan Poulain

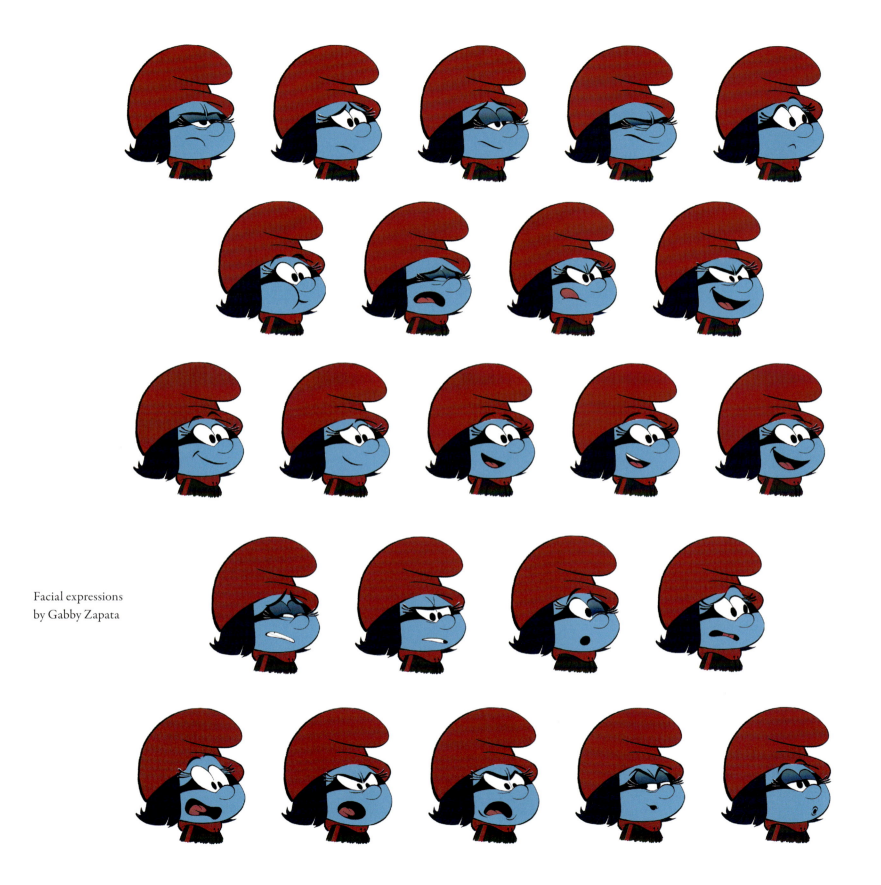

Facial expressions by Gabby Zapata

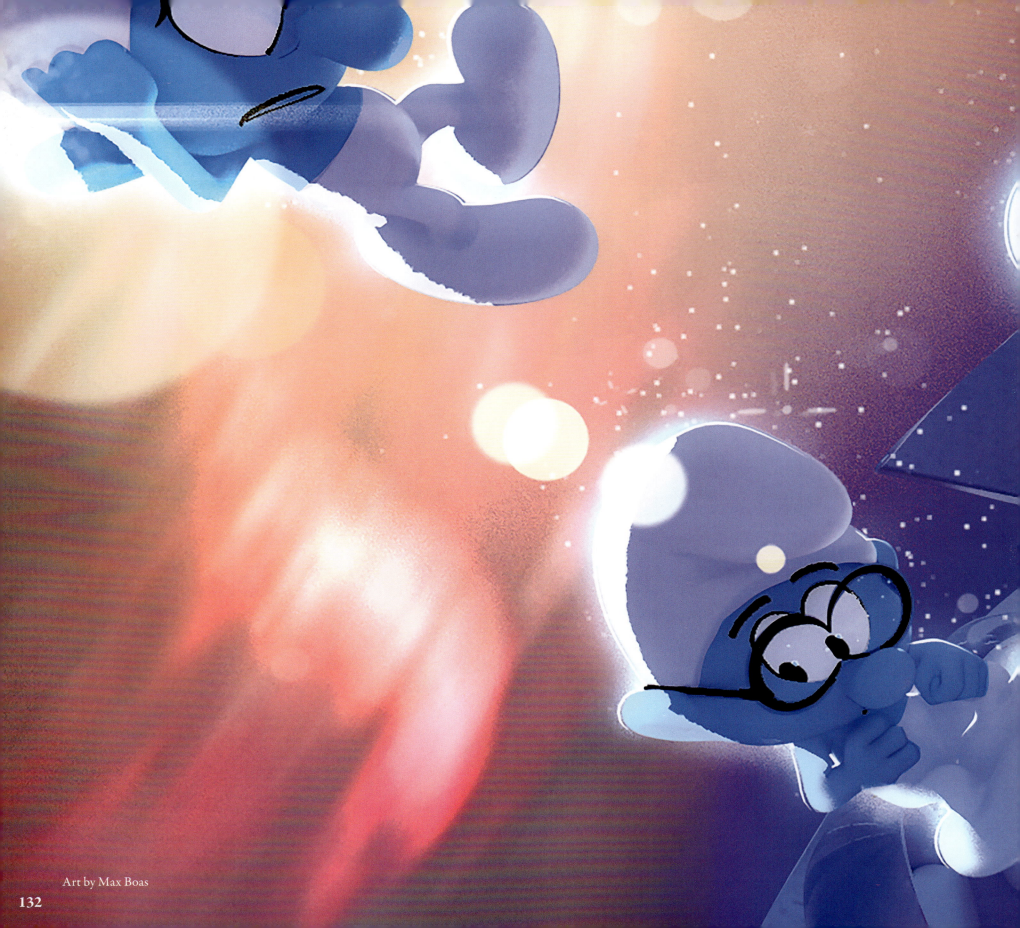

Art by Max Boas

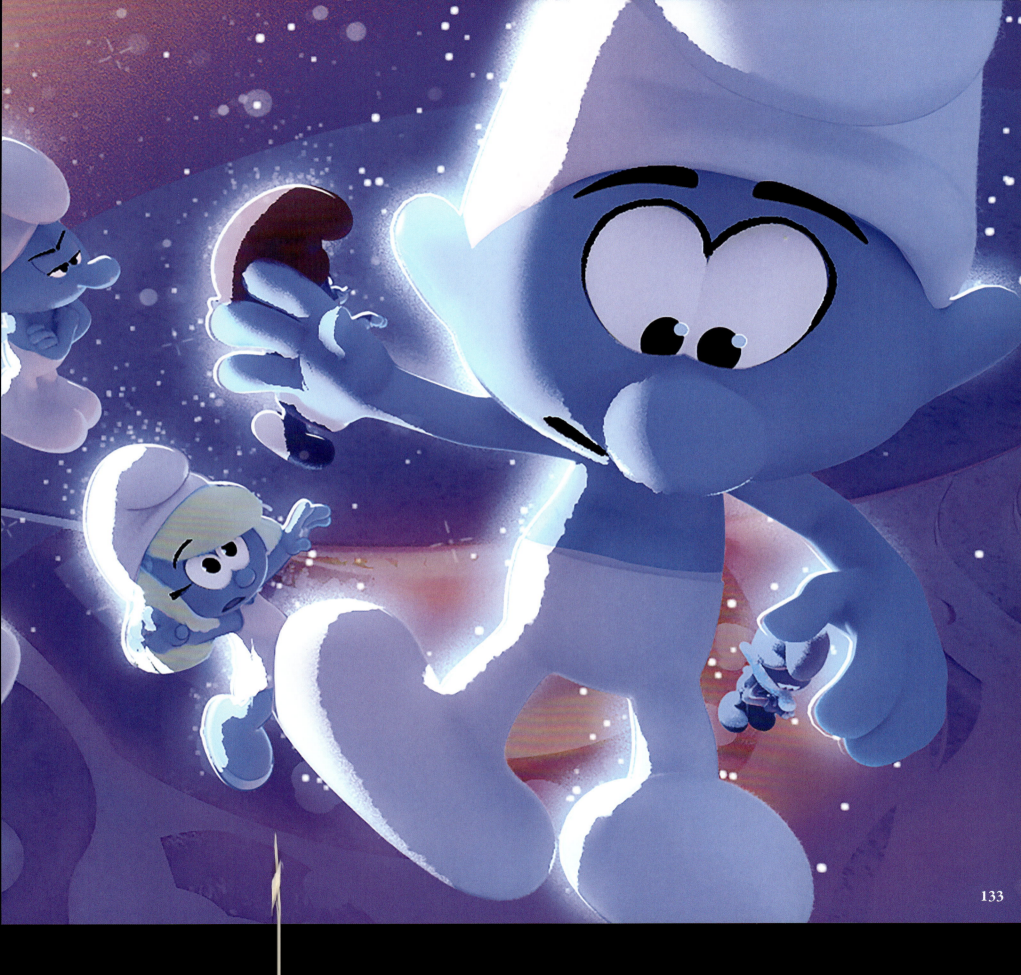

DISCO LOUNGE

Art by Angie Duran

Once Moxie establishes who the strange visitors are, she takes them to the INWS secret lair, located in a mirrored ball at a dance club, to meet the mysterious Ken.

Getting into the hideout marks a transition from the live-action Paris environment back into a purely animated world. Max Boas describes the scene: "The party's going on. The Smurfs aren't seen. They're hiding. They jump into the physical disco ball. There's a bright light, and using light as a transitional element, we're inside the disco ball and what does that look like?"

He explains, "We kind of play with this translucent, almost glass-like quality. You still feel like there's a light outside the ball, pushing the colors, [creating] a strong color palette."

"Lighting was a challenge," Margaret Wuller admits. "Lighting blue Smurfs in a blue environment. We started out heavily blue, and then through the course of lighting the actual [scene], we lifted the blue a lot because it's hard."

"Hard" in this case refers to the quality of light, which casts harsh and well-defined shadows. A subject or scene lit in this manner has a very abrupt transition between the highlights and the shadows.

"It's just hard," she continues, this time meaning the difficulty of the situation. "Hard to light blue characters in a blue environment."

What didn't seem too difficult was discovering the shape language of the lounge. "It's all based off mushroom shapes, just like Smurf Village, so, a lot of the same shape language, but because we're with Neighborhood Watch Smurfs, who are cool, edgy, cross-dimensional, we made it more '60s," says Wuller. The artists drew on the distinct, slick, retro-futuristic stylistic design that is present in art of that era.

The art team tried to evoke the natural habitat of the Smurfs in this flashy, human-made context and domain. "There are these shiny, kind of glassy, mushrooms," Boas says. "It's a party outside, and this is like a quiet space, like a spa, like an airport lounge."

In Wuller's words, "It's JFK Delta terminal"—New York City's elegant neofuturist airport structure, constructed during the late '50s and early '60s—"meets mushroom."

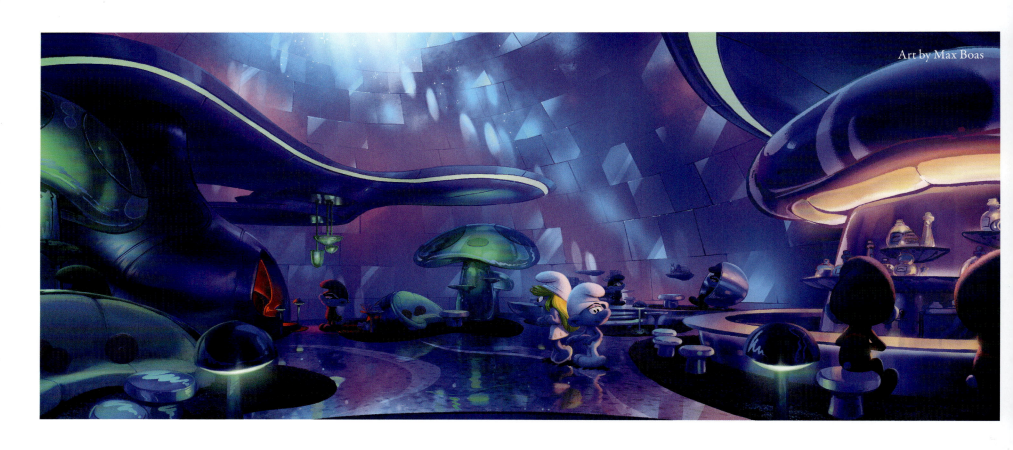
Art by Max Boas

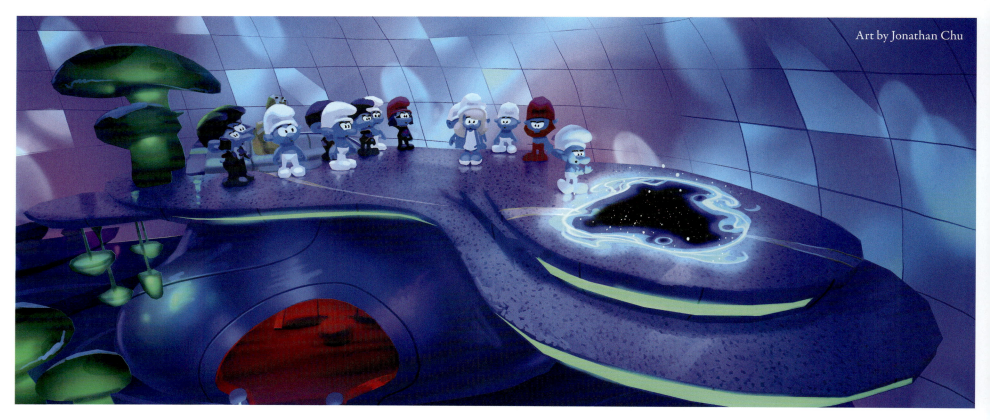
Art by Jonathan Chu

Disco lounge set dressing art
by Angie Duran

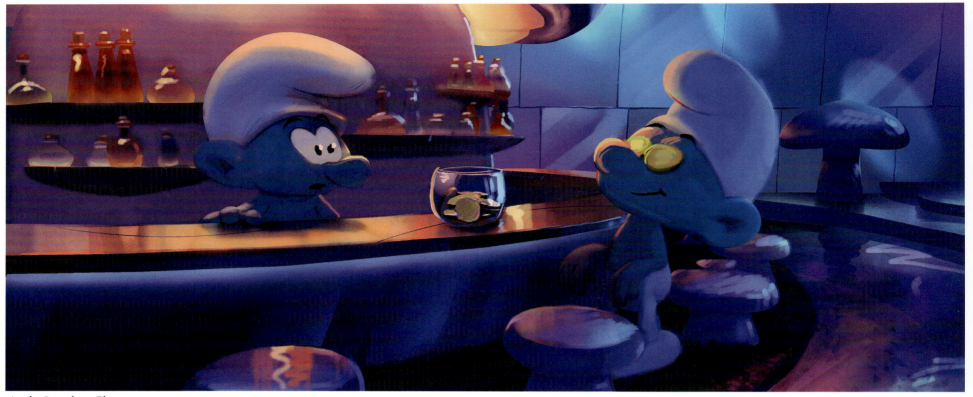
Art by Jonathan Chu

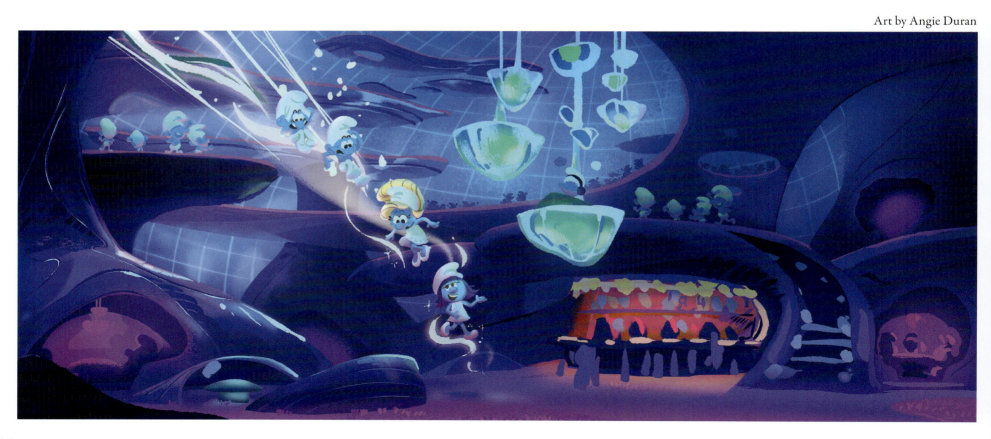
Art by Angie Duran

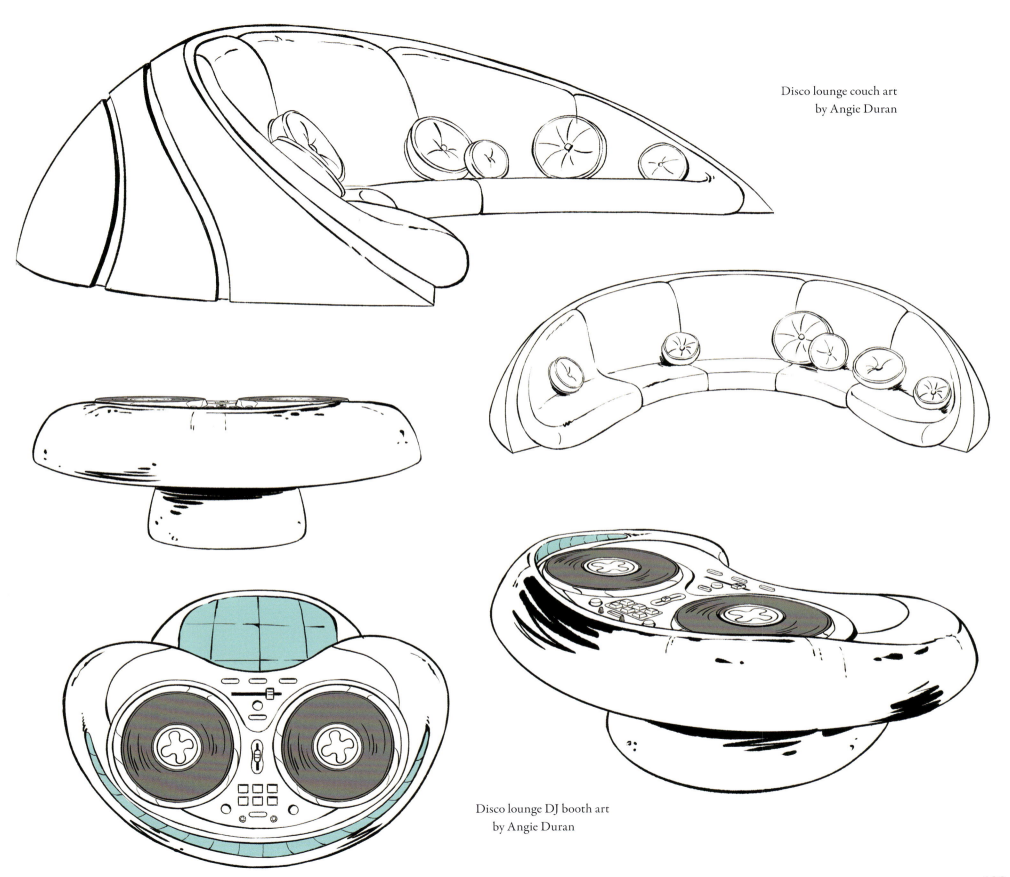

Disco lounge couch art
by Angie Duran

Disco lounge DJ booth art
by Angie Duran

139

KEN voiced by Nick Offerman

When Papa Smurf told his Smurfs to "Find Ken!" none of them expected who would emerge from the shadows of the VIP lounge at the International Neighborhood Watch Smurfs' secret lair. Except for having a reddish-brown beard, the savvy, surly supervisor of the INWS is a dead ringer for Papa, and with good reason: Ken is his long-lost brother.

Art by Gabby Zapata

Art by Gabby Zapata

"Papa is kind of a softy, as Chris [Miller] likes to say," says Max Boas. "Ken has kind of a more fighter mentality." The production designer pushed his team to express that in the character's design. "We kind of desaturated his red color palette. There's more staining. There're more marks that he's been through war. [We] gave him a little knife tattoo with his name on it."

They also emphasized his toughness by avoiding some of the curves characteristic of the Smurfs, which can soften the appearance. Boas recalls, "We had some exploration of what shape beard. We landed on this kind of a diamond shape overall to make him different from Papa."

The casting also helped emphasize the contrast between the two. Miller notes, "John [Goodman]'s got that folksy quality. Nick Offerman's kind of got that too, [but] in a much more sort of rugged way."

Character poses by Tristan Poulain

Art by Jonathan Chu

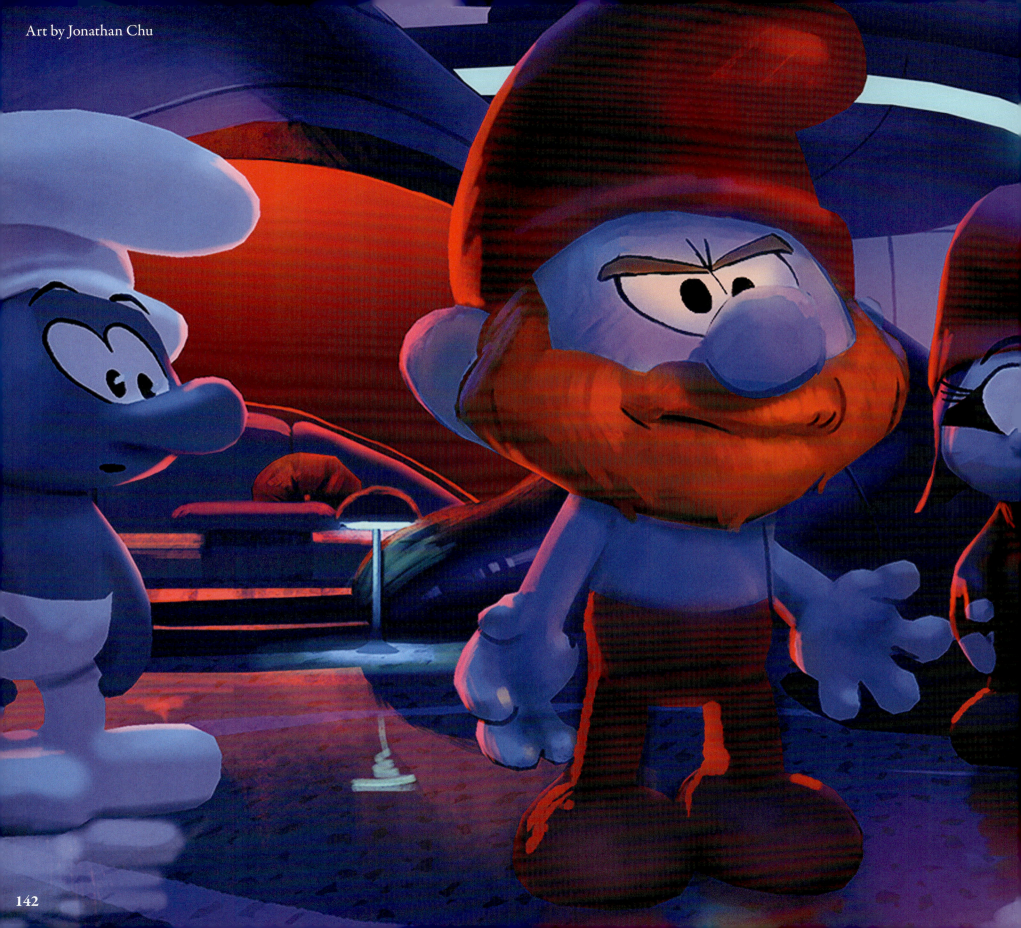

When asked to assist the Village Smurfs, the no-nonsense gnome is ready to save his sibling, revealing that he anticipated Papa's disappearance, and a potential rescue plan has been in place for over a century. However, he's unwilling to accept the help of No Name, Smurfette, and the rest. He tells them about Razamel, the Alliance of Evil Wizards, and an ancestry Smurfs share as warriors—all of which Papa has avoided for over a hundred years, leaving his charges unprepared for the fight ahead. Ken, through his leadership of INWS, has remained active in the wizard war and has the scars to show it.

Papa and Ken "had a falling out," explains Chris Miller, "and there's a lot of pain associated with [that]. Ken just thinks that Papa turned his back and walked away. There's a lot of pain and history to that relationship." This animosity fuels a heated exchange between Ken and Smurfette when they first speak to each other, which is a tour de force in the characters' use of the Smurf language and one of the more amusing moments in the film.

"It all sounds like a fairly depressing movie, [but], you know, it's steeped in comedy," promises Miller.

Matt Landon adds that the two characters "have this combination of great humor and gravitas. And, you know, they're having fun in the movie. I feel like that all totally comes through."

When Ken reluctantly relents to the Smurfs' pleas, he does so on account of Smurfette's pluckiness and the promise of No Name's magic, and his choice allows him to not only hold up his oath to protect all of creation but heal his relationship with his brother and start a new association with his extended family from beyond his "neighborhood." While he presents a gruff exterior, Ken has the same kind and faithful spirit that drives every Smurf.

The overhanging shadow, the real conflict behind the character, may be that in a movie where the main character, No Name, is searching for his role in life and, as a result, a proper monicker, how does one explain the rugged, funny, grave, folksy captain of an international, multidimensional spy team simply being named "Ken"?

Well, Miller—who admits he would self-identify as "Smart Aleck Smurf"— says, "It is just absurd. It's absurd, and it's sort of by design. Yeah, there's not a lot to dig out with that. It is a comedic, absurdist choice."

THE SNOOTERPOOTS

With Ken in tow (and finally leaving the laconic and sardonic Turtle behind) the Smurfs take another trip through one of No Name's vortexes, this time landing exactly where Papa Smurf isn't.

That leaves the options wide open as to their location, and this location just so happens to be a wide-open space that their new companion knows all too well. It's the Australian outback, which Ken recognizes as the home of a different race of magical imps, known as the Snooterpoots.

Character design by Tristan Poulain;
Color by Margaret Wuller

Character development by Tristan Poulain

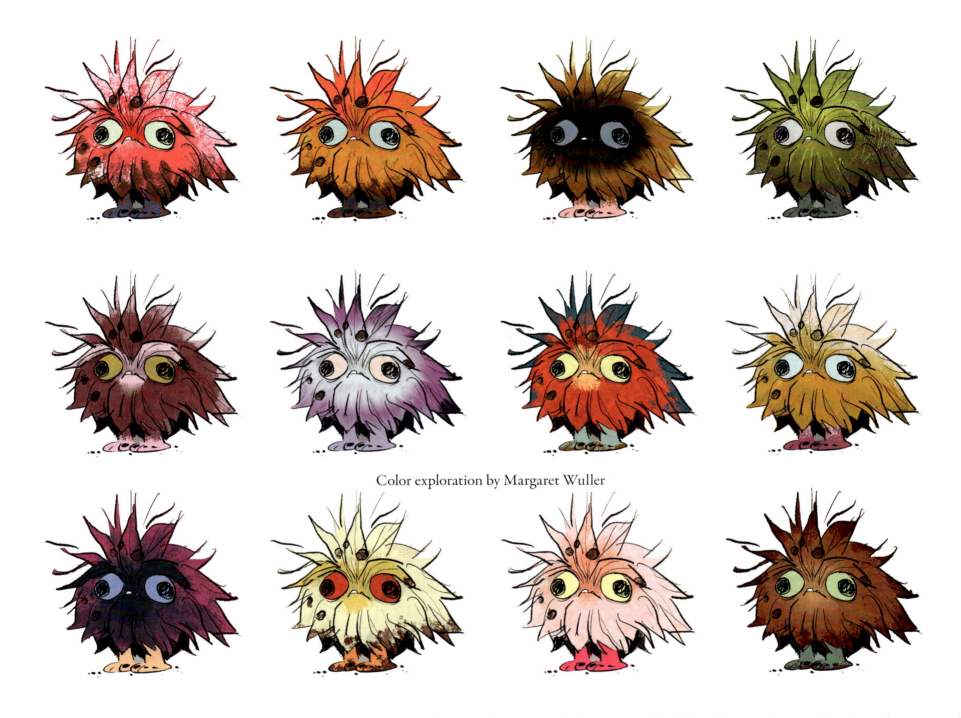

Color exploration by Margaret Wuller

This film marks the entry of these little googly-eyed furballs into the Smurfs canon, and their unique look has what can be considered a rather personal attachment to Chris Miller. In a moment she tried to keep off the record in regard to this book, Margaret Wuller pointed out that the characters' facial design might have had something to do with the director's own dog, a Brussels Griffon (a breed perhaps a bit too "on the (smushed) nose" to appear in a property that originated in Belgium).

Miller mostly fesses up to the semi-nepotistic inspiration, though. "I like something slightly walleyed, one tooth, that's plenty and I love it," he says, leaving it unclear whether he is alluding to his pooch or the Snooterpoot character models.

As for the creatures' personalities, Miller calls them "kind of grifters." He offers a simile to better explain: "It's like they work at that gas station in the middle of the desert, you know, the only gas station for hundreds and hundreds of miles and if you get stuck there, and your car is broken down, or you need a favor, you're going to have to pay to get out."

Matt Landon is a little more direct with his description of the miniature monsters and their role in the movie: "Snooterpoots are these crazy interdimensional traveling creatures and I guess they've been around forever. They're a source of help for our Smurfs when they get into trouble, but they're also very tricky creatures. As Ken says in the movie, they've got an agenda, which mostly revolves around picking people's pockets, or Smurfs' pockets." And, evidently, eating a lot of cake.

If the Snooterpoots can be considered Smurf-like (and they clearly can), their equivalent of the enchanted Village would be the salt-crystal caves they seclude themselves in beneath the dangerous, desolate plains of Oceania.

"We didn't want to give them houses—that didn't seem right," asserts Wuller. "They shouldn't be a perfect kind of Smurf partner. So, just as the Smurfs utilize the mushrooms, [the Snooterpoots] utilize the salt structure and they dig little holes, and they can pop out.

"We looked at a bunch of salt mines," she continues. "We didn't want this underground village to feel dark and dreary, so instead, it's a pink Himalayan sea salt–inspired cave system with bright crystals that illuminate."

Max Boas describes the evolution of the set's decoration from inception to final incarnation. "At one point, there was a lot of found objects, like they would steal hiking boots or wires and cables from a rest stop, and then they would be [decorating] with them," he recalls. "So, we had a lot of early designs that way. All that stuff kind of weeded itself out in the storytelling and what we landed on is kind of this magical element to the Snooterpoots that they're harnessing the power of crystals of the earth they live in [to open portals]."

Mobility within the cave was also given consideration. Wuller elaborates:

> We do have some wooden pegs stuck in the stalagtites, so that they could kind of climb up. But then we also created these ramp systems so that they could roll from one level to the next. Almost like those marble games, like a marble rollaway-inspired space, and that gave us these beautiful arcing shapes to play with. We wanted it to feel almost like an endless cave, and so you never really see the bottom.
>
> The whole cave system is filled with this atmosphere, this mist, which is unique to this location. [There is] this really thick humidity in there that's illuminated by a kind of a light source that we don't see an ambient light and that's what brings this lavender wash over everything. We didn't want anything looking [the same, but] we wanted them to feel roughly of the same universe as the Smurfs.

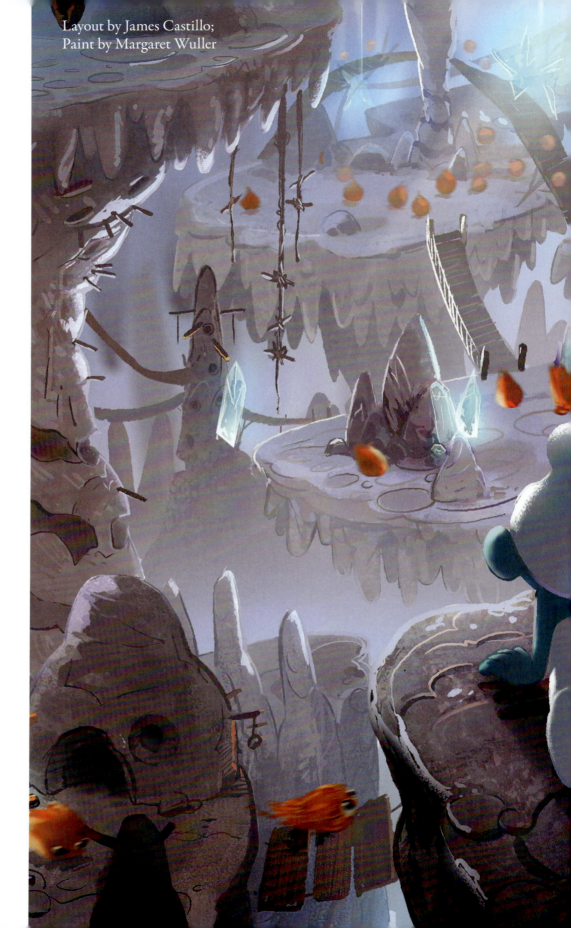

Layout by James Castillo;
Paint by Margaret Wuller

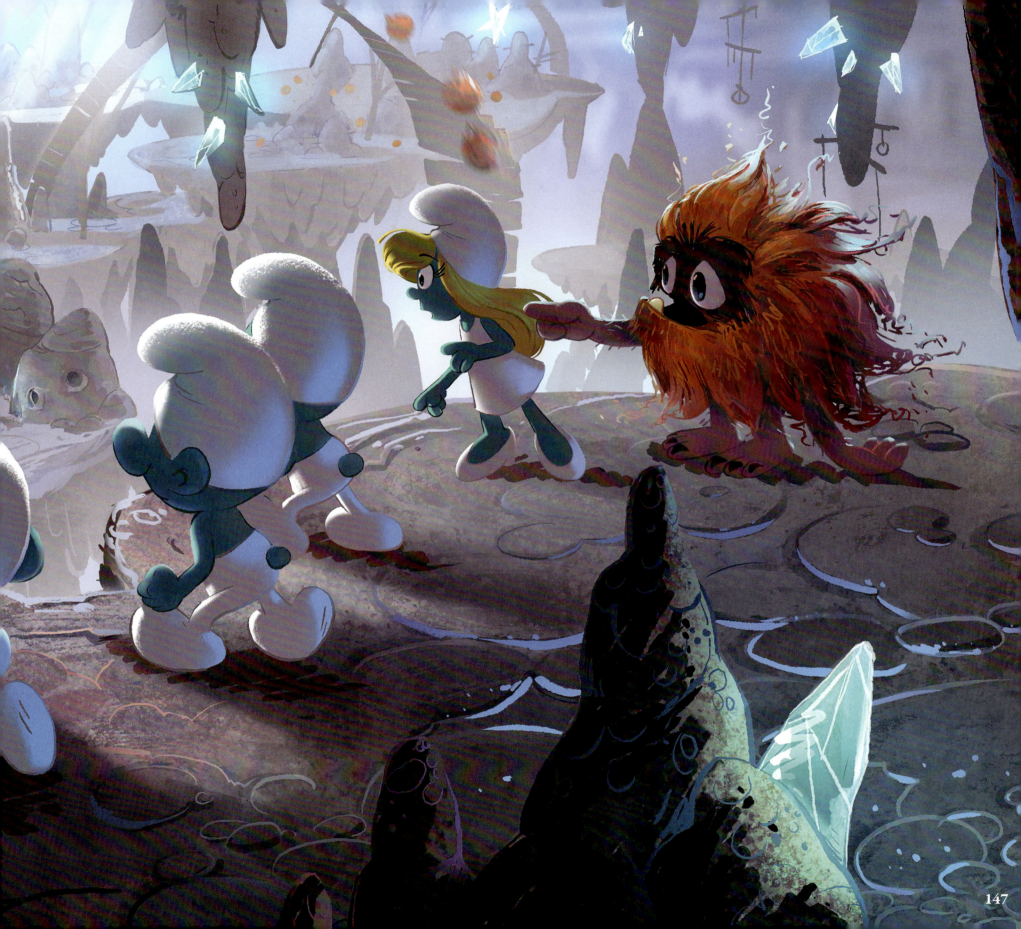

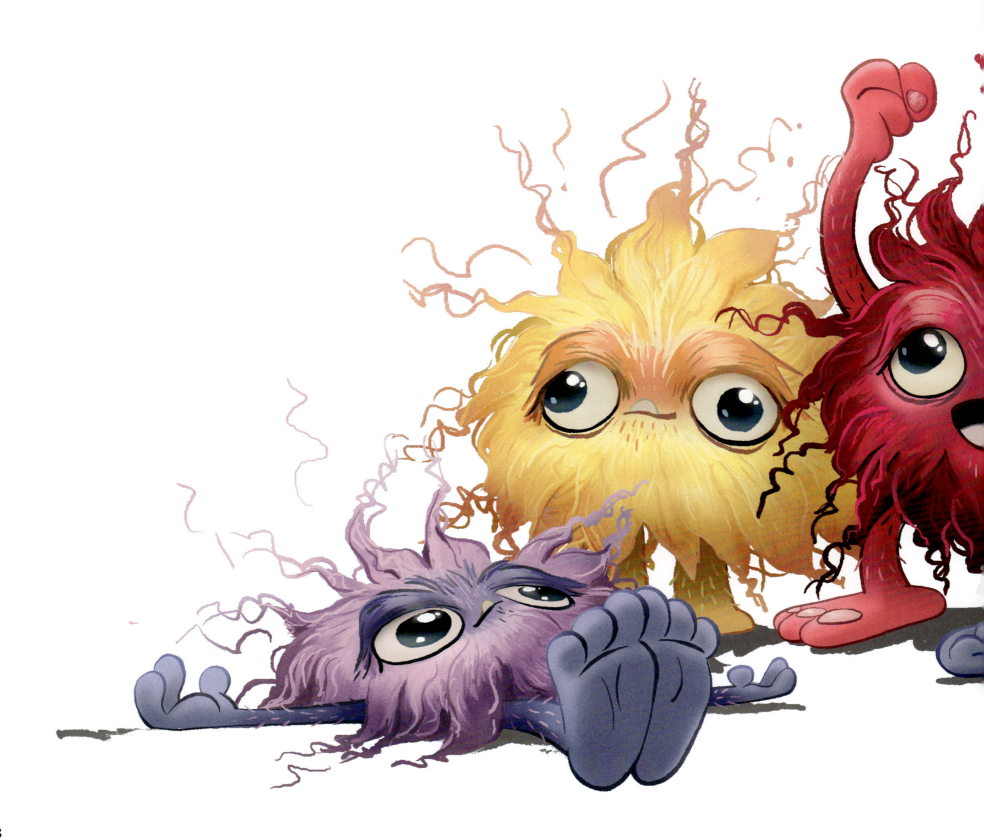

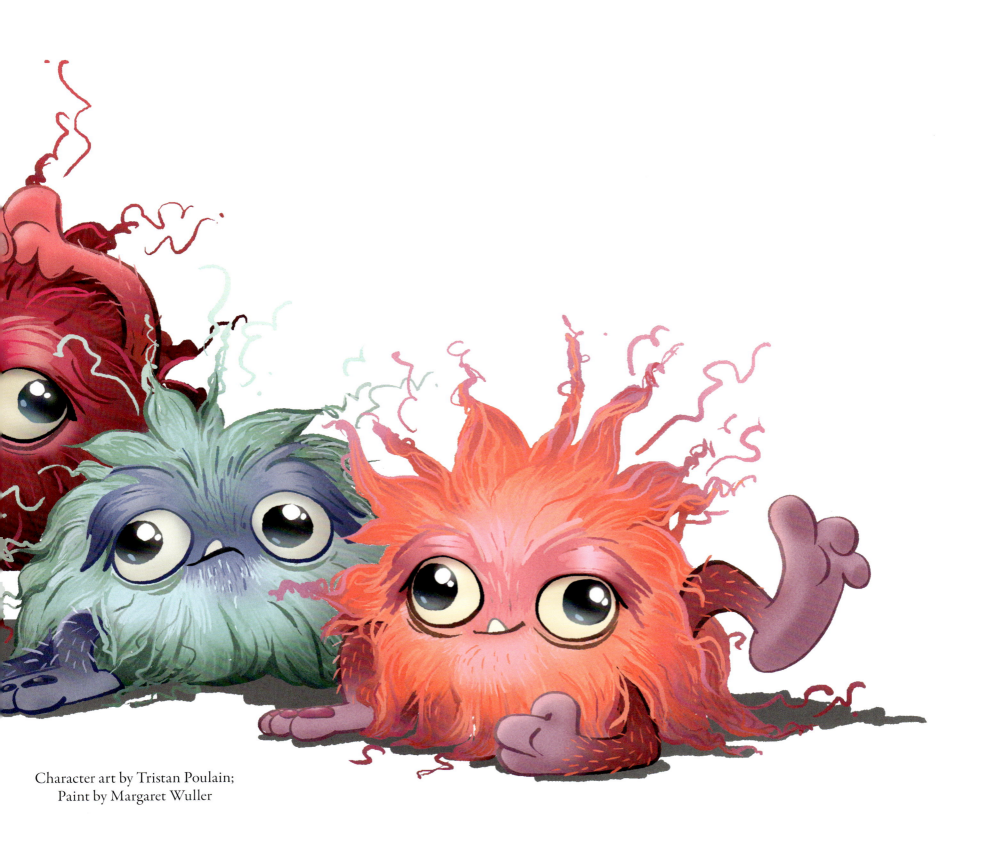

Character art by Tristan Poulain;
Paint by Margaret Wuller

MAMA POOT voiced by Natasha Lyonne

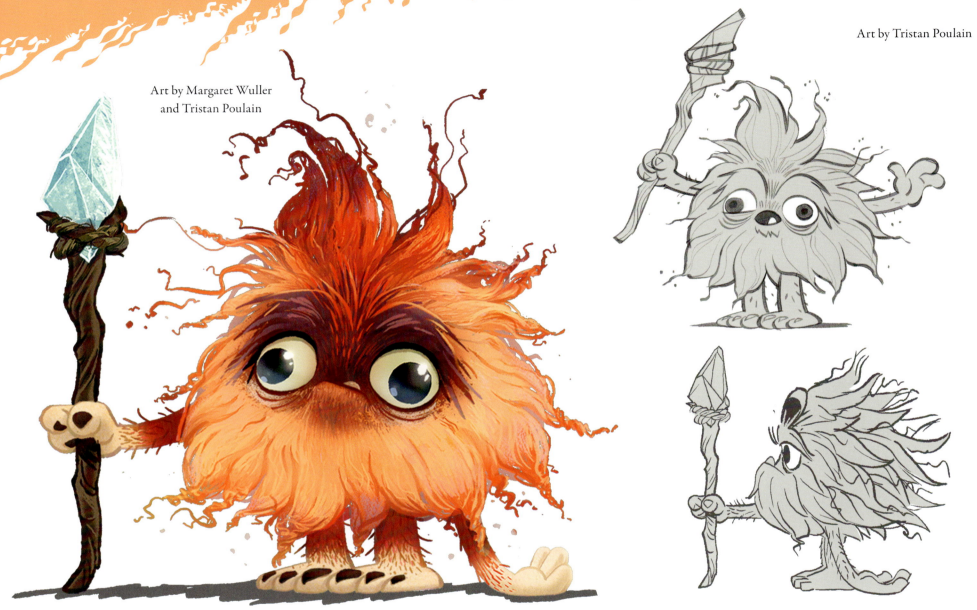

Art by Margaret Wuller and Tristan Poulain

Art by Tristan Poulain

As the Smurfs have their Papa, so the Snooterpoots have their Mama.

In likening her to le Grand Schtroumpf, Chris Miller notes, "She's maternal. She wants to keep her babies safe. That's why they live out in the middle of nowhere. She has magic power. She can access portals. She can help out, but she's kind of staying on the outside in order to protect her family."

And evidently, the two are acquainted.

"Mama Poot knows who Papa Smurf is," Miller tells us. "She knows who the Smurfs are. They're all sort of interconnected in this universe and [she has an] understanding of who the Alliance of Evil Wizards are, what [they're] after, and it's only bad things."

A Smurf she's clearly better acquainted with, as demonstrated in their interaction in the Poots' cave, is Papa's brother, Ken.

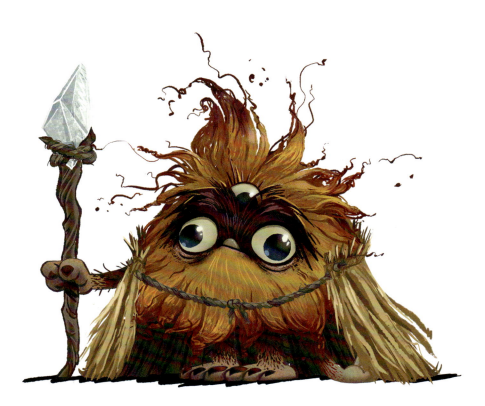

Art by Gabby Zapata

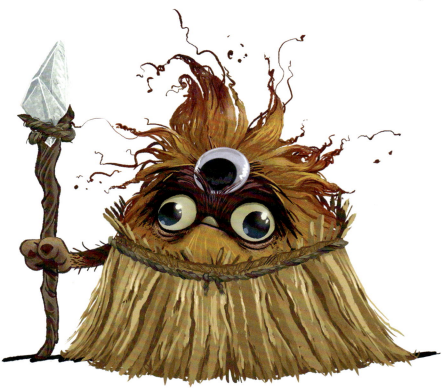
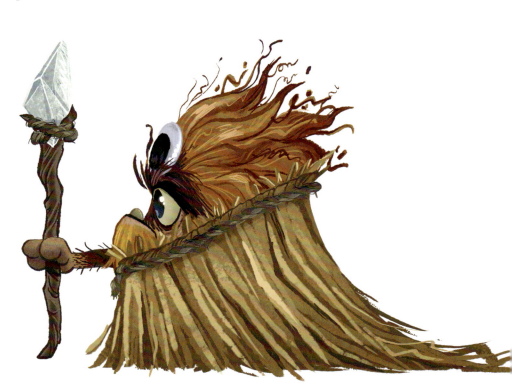

151

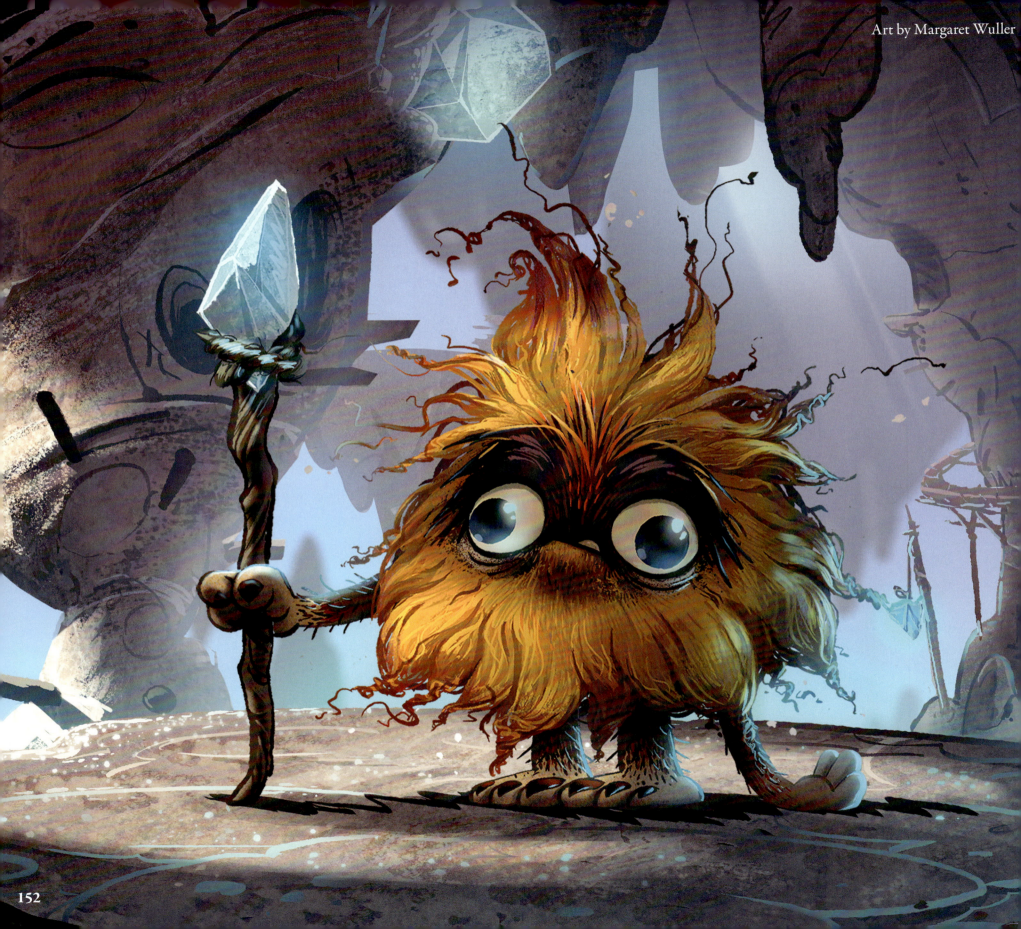

"There's definitely something that went on with Mama Poot and Ken," Miller states. "I'm not exactly sure, but they spent some time in Paris together. A little bit of tension there. There was a little bit of a falling out, but they definitely have a history that's more than professional."

Akin to Papa (or, for that matter, Ken), Mama Poot is the epitome of the group that she leads in both spirit and body. Like her "shaggy babies," she has something feral about her, and she's somewhat drawn to danger. She's a bit volatile, but she's always there to help—which is a volatile combination. On the physical front, Miller thought of the Snooterpoots as being like the Ewoks of *Star Wars*, again invoking images of 1980s action-fantasy, and recalls that he wanted Mama and her Poots to "move like Muppets."

"The way Chris envisioned these characters," Margaret Wuller adds, "is that they primarily had two feet, and they were often seen without arms. But then at certain moments, they could pop an arm out, and the arms could go, really, anywhere. So, we had many different shoulder joints for them. They could put their arms straight up, they could put them straight down, and they had a lot of mobility. It didn't have to be one specific pivot point, and that would free them up so that their movement could be more feral, and they could roll, they could climb, but they weren't supposed to be monkey like little fur balls that can pop out."

This physicality also gives them the ability to better conceal themselves in the face of danger, or to cloak themselves when they're pilfering their prey. At one point, Mama Poot was even going to be given an extra layer of camouflage, as she would need it for her solo trips to the surface. Max Boas says that she was going to be colored to resemble a tuft of grass, but "it became a little bit too brown and too neutral." So, he says, "We 'pulled her color out'"—meaning they brightened her up.

In fact, all of the Poots were given a color boost, with their final look reflecting a full rainbow of colors that accentuates their already fun and frantic design. "Their unpredictability should spill out into how they look," says Wuller, "and there was just so much more joy and candy[-colored] fun to be had when we diversified their colors."

Of Mama's vocal performer, both Miller and Landon offer nothing but bright praise. "Natasha Lyonne is great," says Miller. "She's a revelation."

Landon adds, "Natasha just attacked her character, at 100 percent, or 1,000 percent, and she's sort of amazing in that role."

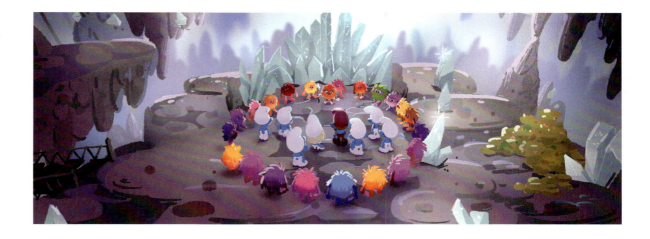

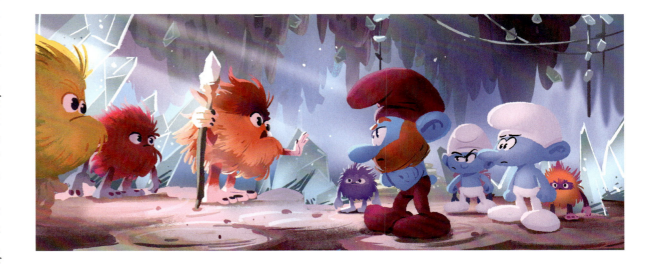

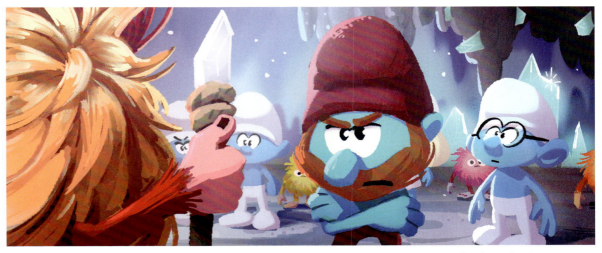

Color keys by Diana Ling

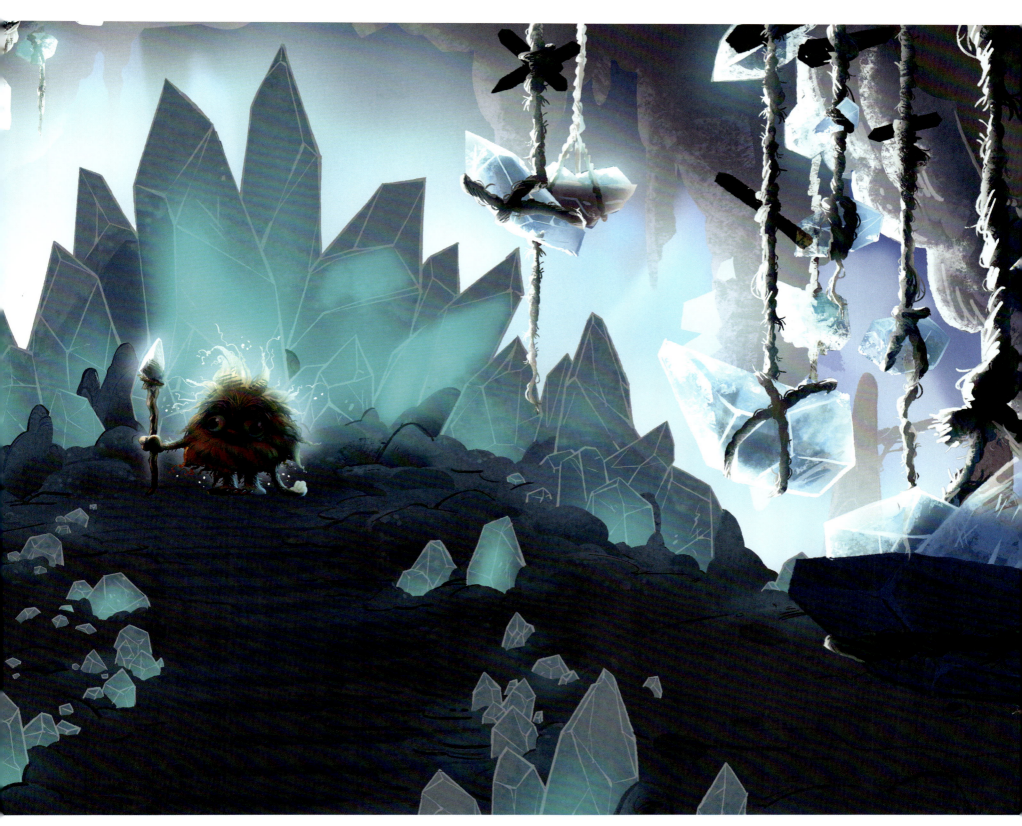

Art by Angie Duran

SCREAM BUGGY, SCREAM

When Razamel decimates the Snooterpoot hideout and captures all the inhabitants, Poot and Smurf alike, Mama Poot takes Smurfette and No Name on a hair-raising, white-knuckle ride across the Australian outback right out of a postapocalyptic road film.

Maniacally gripping the wheel of her jalopy, Mama Poot encourages her passengers to shriek as much and as loudly as they can, revealing that fear is the fuel of this "Scream Buggy" and when the tank is full of terror, the hot-wheeling heap has the power to speed through the multiverse.

Frights, camshaft, action! Next stop: Razamel's castle!

"There are so many different environments that the cast travels through," says Margaret Wuller, "and there was a lot of intention and making sure that each of these places feels unique in and of itself, but also complements the action that's going to happen there."

For the outback, that meant photographing the actual location and getting scans of the landscape in Australia, then sending that visual data to the production offices in North America, where the artists and technicians worked some of their own magic by creating a photorealistic yet story-friendly version of the terrain. "It looks like you're actually there," says Boas, "but it's 100 percent CG."

"The Mama Poot Scream Buggy sequence is just a really fun action-, music-driven scene," Chris Miller says. "Mama Poot [has created] this vehicle. It's like an old, rusted-out, I don't know—car? In the middle of nowhere. She makes it come to life. It's all driven by the fuel of your fears. It feels like anything can go wrong at any second."

Mama Poot deserves the credit Miller gives her for building the car within the context of the story, but Wuller is ready to dish the dirt on what really went into jiggering the jalopy for the film. "We spent a lot of time on [it]," she reveals, "pulling up references of authentic Australian cars. Even though it looks like it's live action and we built it all in CG [using] realistic textures and lighting to make it feel seamless to fit into the plate of the live action."

Through the magic of computer animation—not feathers or cave crystals, as the film would have the viewer believe—the Buggy "just keeps accelerating and accelerating," Boas tells us, pointing out where he and the team chose to observe their mandate of referencing the comics as much as possible. "We wanted to bring the Peyo action lines and his penmanship into the 'live-action' elements"—meaning the photorealistic CG. "So, some action lines are applied when the car goes super fast and takes off into another dimension."

Overall, the scene feels like another homage to the well-loved 1980s fantasy-action canon. "Definitely some pop [culture] references throughout," Boas admits. "*Mad Max*. There's some *Back to the Future* [in there], too."

"Watching and helping [the outback set piece] come together was interesting," says Wuller, "because it is a real place in Australia that was scanned and then rebuilt in the computer so that it looks exactly like the real place. But using it, actually rebuilding it, making sure that helped the action really, really interesting."

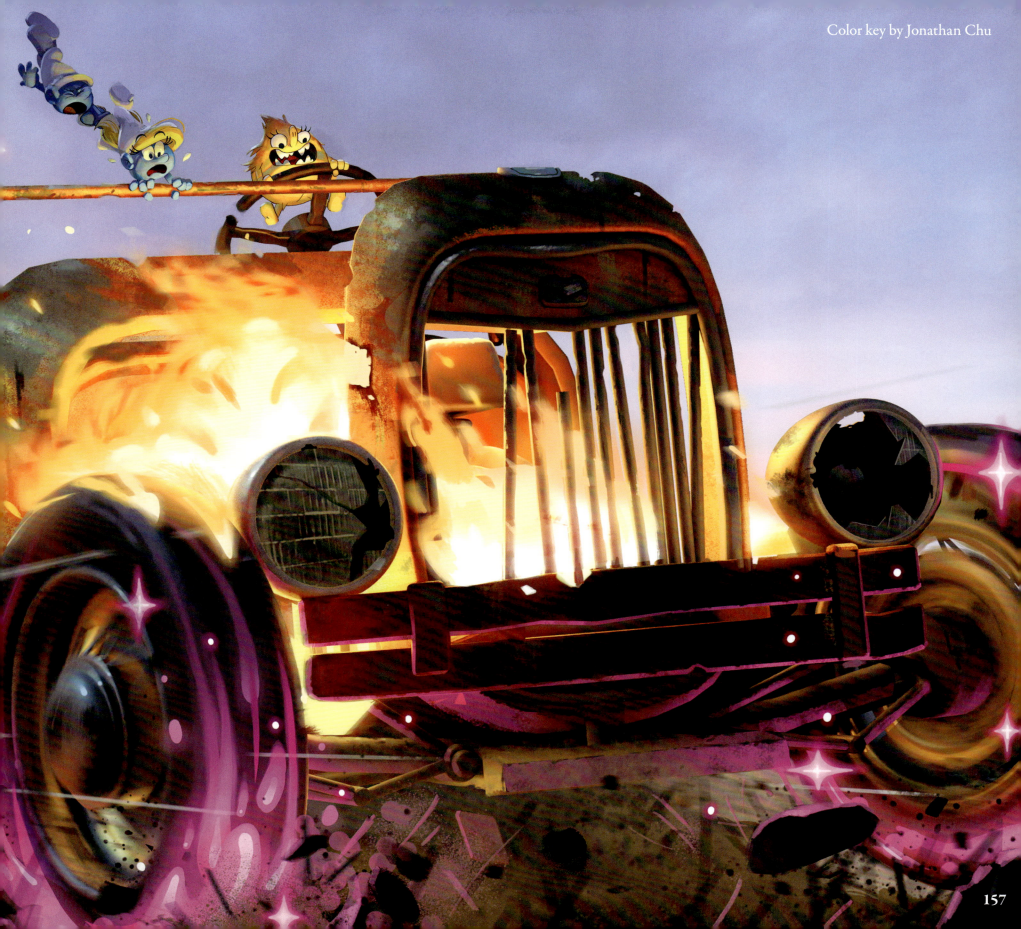

Color key by Jonathan Chu

STRAWBERRY MILK SLIDE

The Smurfs are no strangers to interdimensional travel, having done so in several TV episodes and films. However, they've arguably never done it with greater style than in 2025's *Smurfs*.

"The Smurfs leave Smurf Village," Chris Miller says, "and they go through this old-time kind of gramophone from, I don't know, the 1920s and it takes them through this portal that sends them across the universe."

"We knew we were going to be traveling through different dimensions and portals," recalls Max Boas, "so I started playing with outer space and thinking about what that look could be. I grew up with the Smurfs and thinking back to that time: Early fantasy video games, going to the arcade and seeing those graphics, that kind of 'retro' idea was an influence early on."

"The galaxy was heavily inspired by 1970s and '80s fantasy art," Margaret Wuller confirms, "with these sort of star patterns and the splatter paint effect, the look went hand in hand with the wizards' esthetic and the esthetic of the Smurfs."

As for developing the magic gnomes' means of intergalactic conveyance, Boas remembers his train of thought: "[Space] was always set up as a flowy place, which lent itself to soft, arcing shapes, which makes me think of water." That landed the team on the concept of a waterslide.

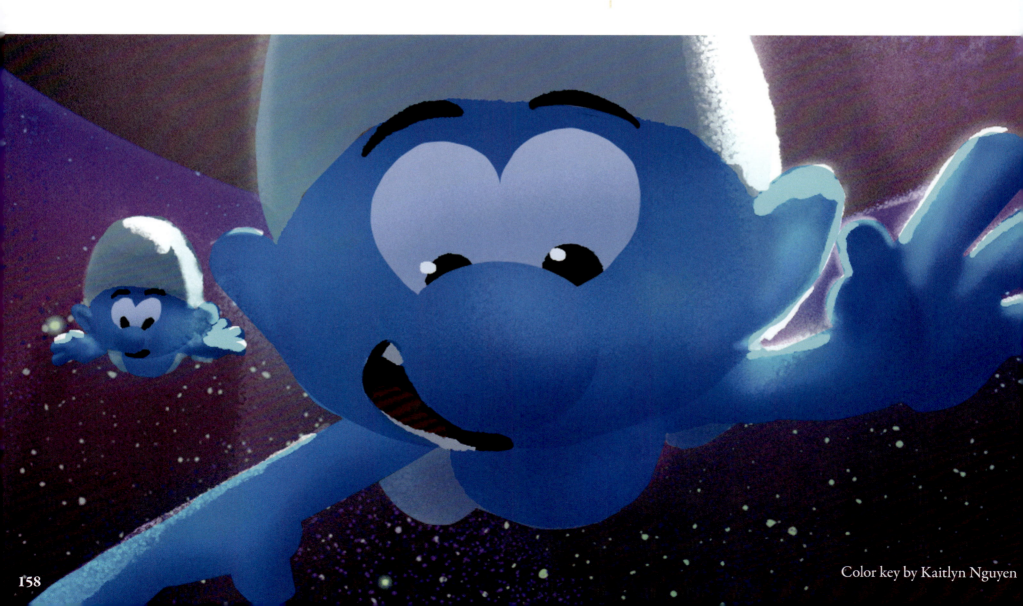

Color key by Kaitlyn Nguyen

Color key by Kaitlyn Nguyen

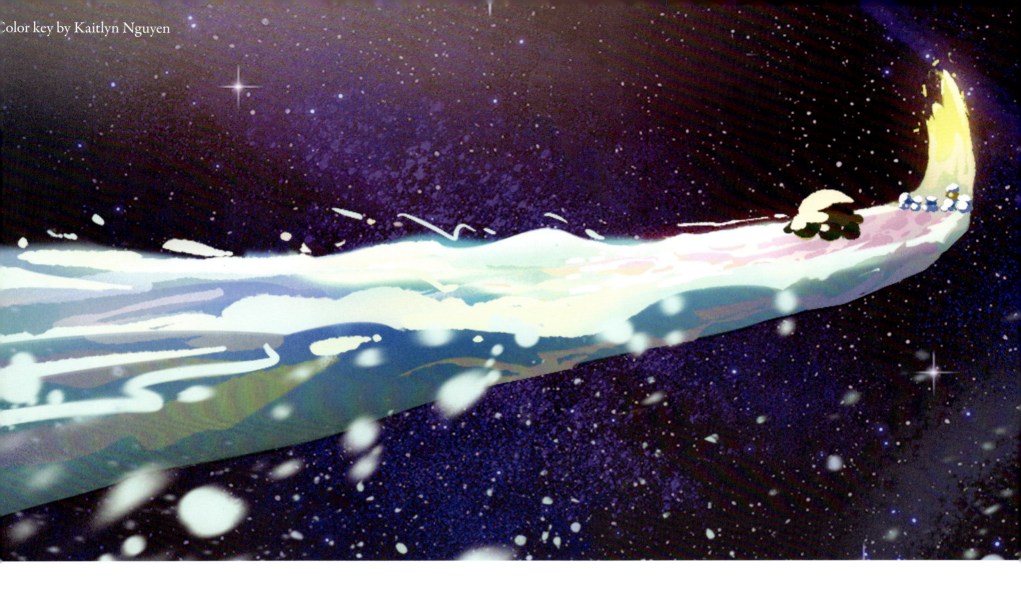

"We did the artwork," Wuller recalls. "Then it was given to [Paramount's production partner] Cinesite, [who] developed a water system, and put some pretty rigid restraints on it so it didn't look too real." The concept was volleyed back to Boas and Wuller's team, who colored it using an '80s-inspired color palette and applied a pearlescent sheen.

"There was an iridescent quality that started to show up," Boas says. Because of the pink color, he recalled, the team compared it to soap bubbles in a car wash and to strawberry milk. "It was a 'noodle slide' at one point," he says. "There's a lot of food references here."

The "Strawberry Milk Slide" continued to evolve at Paramount. According to Wuller, a 2D animator took a second pass on top of the 3D animation, adding "drops and lines flying off, so when it was all put together, it looked true to a Peyo water effect, with these 'Peyo squiggles.'"

"You know, watching Saturday-morning cartoons as a ten-year-old in the '80s, and even looking at '80s animation now, there's a handmade feeling," Boas says. "That's an inspiration for me." Wuller sums up the extremely positive experience: "This idea [that] they go through this sort of rainbow slide, like a roller-coaster ride, it's just full of joy. And, you know, developing that look for the strawberry milk was super fun."

"It's equal parts frightening and fun, you know?" Miller says, buttoning it all up. "We were always trying to strike that balance of—even when things were hyper dangerous, there was always an element of fun to what was going on."

159

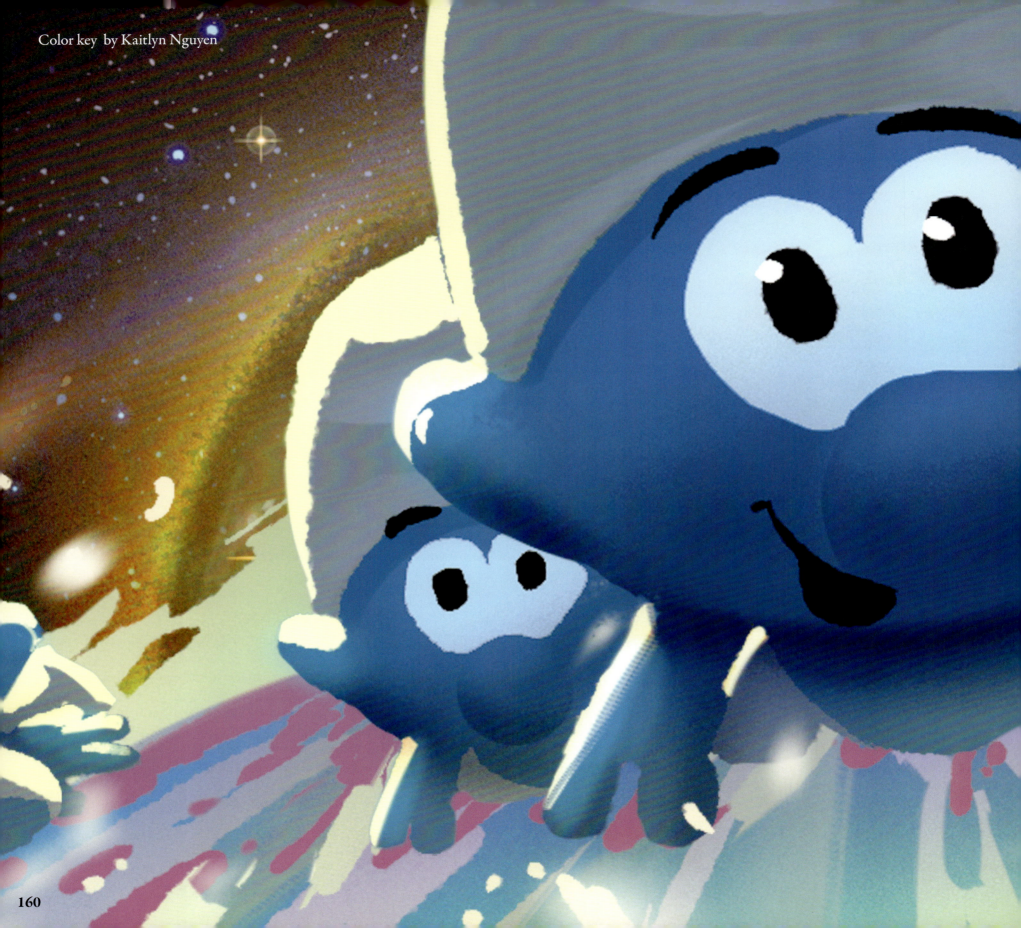

Color key by Kaitlyn Nguyen

161

THE GREATEST SMURF(S) EVER

MULTIDIMENSIONAL CONFLICT

Mama Poot lands No Name and Smurfette in Munich, Germany, the earthly seat of Razamel's castle, on their way to the story's epic showdown. There, a reunited Papa and Ken recount their history as magical guardians, battling the Alliance of Evil Wizards long ago to protect Jaunty Grimoire, a magic book whose possession would allow for complete domination over all realities.

In this battle of what is essentially a larger, time-spanning wizard war, Ken and Papa lost their friend and fellow "Guardineer of Good," Ron, who was beloved by all while still being lethal. It was in the wake of losing Ron that Papa Smurf made a choice to keep the Smurfs safe. He created a concealed world, Smurf Village, where the Smurfs would live happily, unaware of their true purpose while he also hid Jaunty for the next century.

Now, the Smurfs must channel their inner warriors to defeat Razamel. No Name and Smurfette must overcome their self-doubt to save their friends and the universe, and for the first time in history, Gargamel must fight his inner nature and team up with his azure archrivals to face off against his brother and the Alliance of Evil Wizards.

The battle takes them from the German Autobahn through scattered and sometimes silly dimensions before all of the heroes—Smurfs and Snooterpoots, new friends and old alike—land in Smurf Village to celebrate a hard-fought victory. Through No Name's journey of identity, the little Smurfs uncover their disregarded destiny and embrace their place in the larger world…as Guardineers of Good.

And in Razamel's former castle, their ancient enemy Gargamel returns to his villainous ways with vim and vigor.

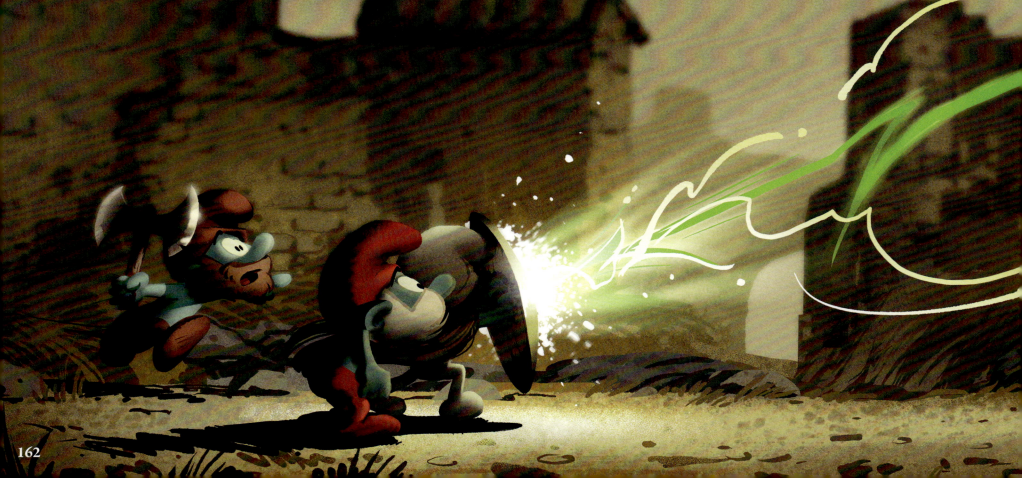

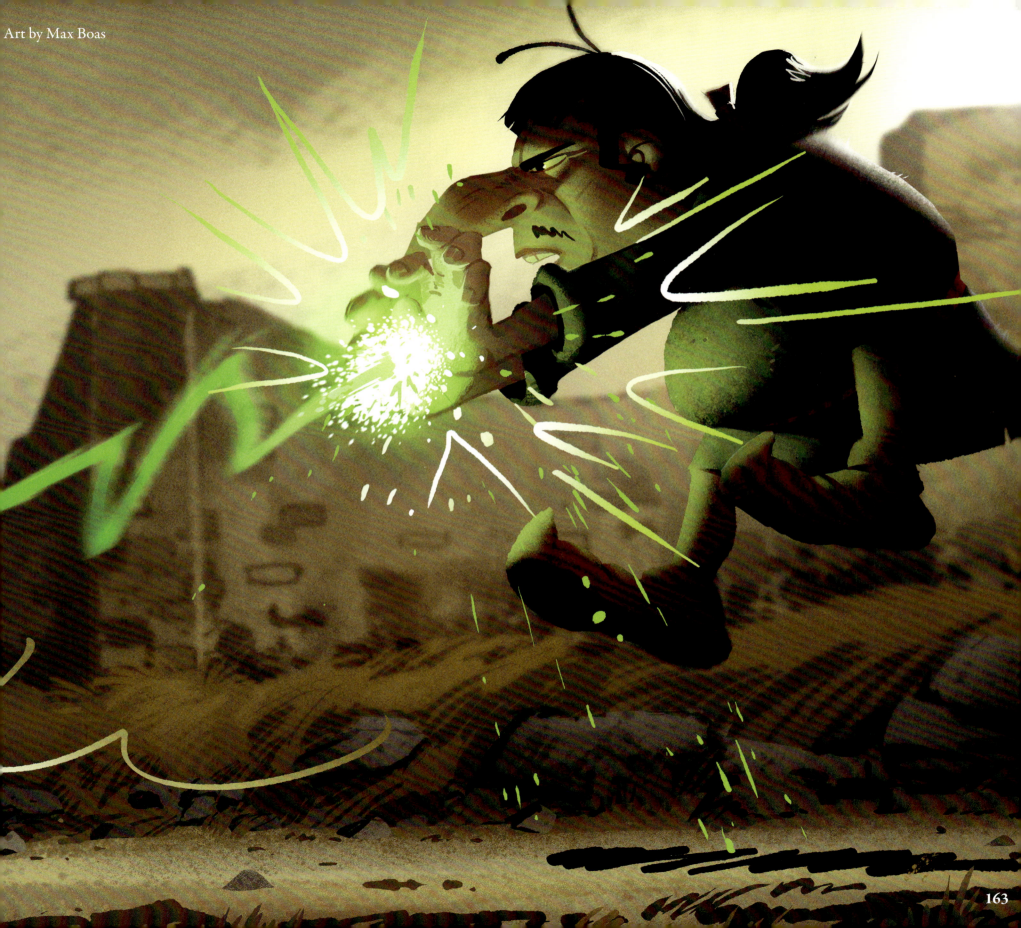
Art by Max Boas

RETURN TO RAZAMEL'S CASTLE

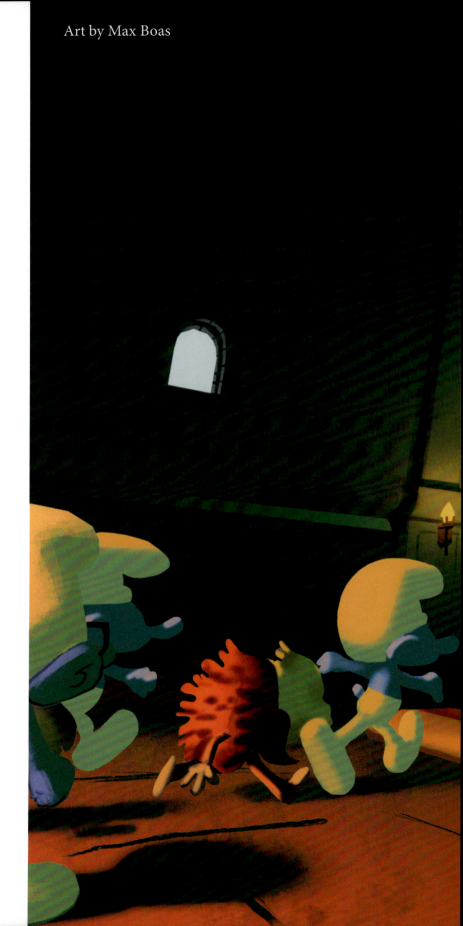

Art by Max Boas

The final act of *Smurfs* sees the entire cast converging, in one manner or another, on Razamel's lair, which allows the viewer to get a better sense of the multitude of mini environments present on this property that straddles the multiverse.

Outside, Smurfette and No Name stage a secret siege by hiding in a food delivery bag, allowing the viewer to get an even deeper sense of how the animated characters interact with the live-action dimension in the world of the film.

"It was really important to know that this movie was a hybrid film in the best possible way," declares Chris Miller. "The great challenge [was] taking these little woodland critters that live in a Belgian forest and then sending them out into the world and making it feel like 'Oh, they're part of this world. These cartoon characters integrate into a live-action world.'"

Miller's co-director Matt Landon elaborates: "We definitely wanted our Smurfs to feel like [animated] Smurfs from Smurf Village when they were in the real world. When they're around humans, we really didn't want to spend time explaining, 'Are they not seen by people?' It just seems complicated." So, they spent time deciding how they would handle the live-action material in a way that could hold those two realities together.

Max Boas illustrates by describing the delivery scene:

> The fast-food burger, it comes from [the] "outside." It's real. So, there's live-action Munich. We're in Germany, on the Autobahn, with an old medieval castle that we see as a live-action plate and then we go inside, [with] the handoff of that fast-food bag. The Smurf characters are inside. Does that mean [we] convert the burger into an animated burger? We played with that. We see the Smurfs with live-action hamburgers inside a bag that's CG, that, once inside, is placed on an "animated" table.
>
> This film is very collage-based in a way. It's mixed media. There's a lot of different styles throughout, and I think we've struck a nice balance between feature animation style, the live-action elements, and visual effects. It works unexpectedly.

Elsewhere in the castle, Gargamel, who has been portal-ed over from his prison in Smurf Village by Razamel, reconnects not only with his little brother but some of their shared history in what the screenplay refers to as the Solarium (an interesting term for such a dark environment).

A final stop on our return tour to Razamel's castle is the Squishadrome, where the collection of kidnapped heroes from Papa to the Poots, await their fate at the hands, or rather giant fist, of yet another cobbled together monolith of machinery—the Squishinator.

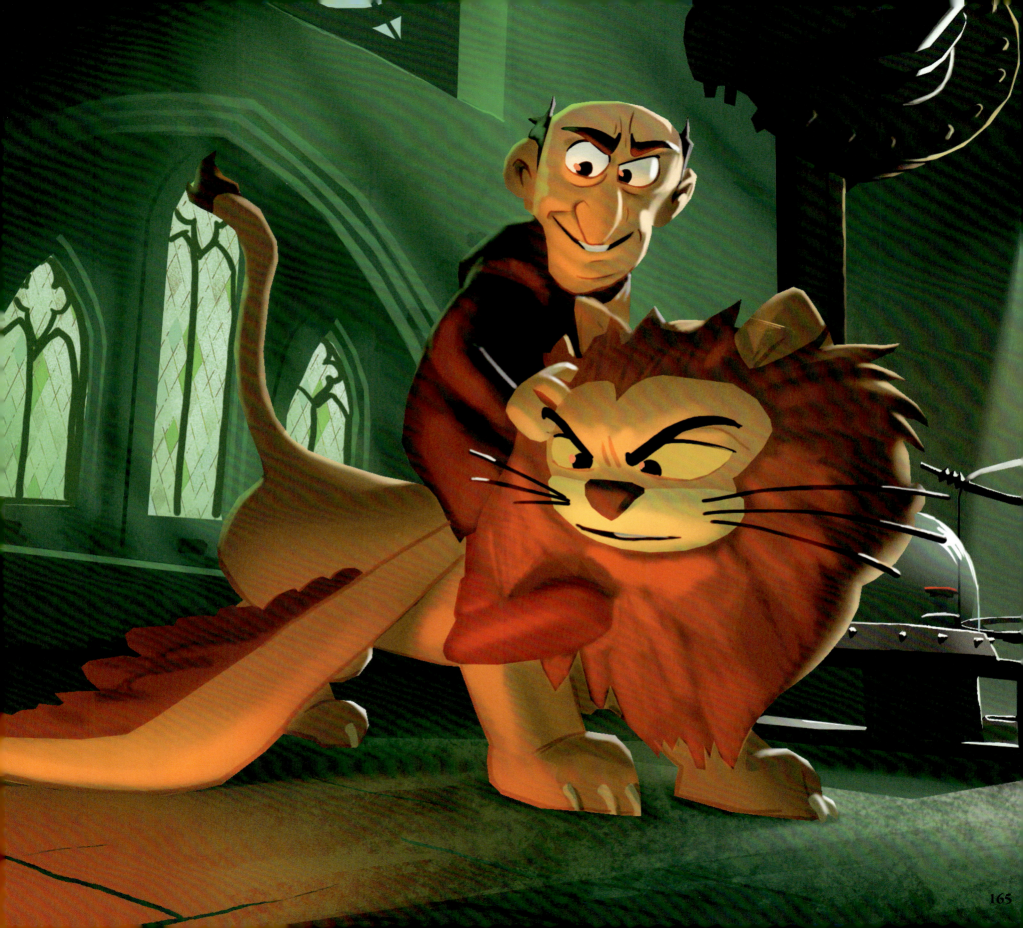

JAUNTY GRIMOIRE voiced by Amy Sedaris

Art by Tristan Poulain

Art by Gabby Zapata

There are a number of key themes that run through 2025's *Smurfs*: the search for identity, the importance of friends and family, the inherent undependability of non-Newtonian portals, the ability of good snacks to get you out of bad situations and while those play out differently across the vast array of characters, both good and evil, there is a common physical plot device that either instigates or furthers each of their stories, something which film scholars would call a MacGuffin. There are four of them actually—the magic books that maintain the balance of peace and power in the universe—but one in particular actually becomes one of the major players in the story, Jaunty Grimoire.

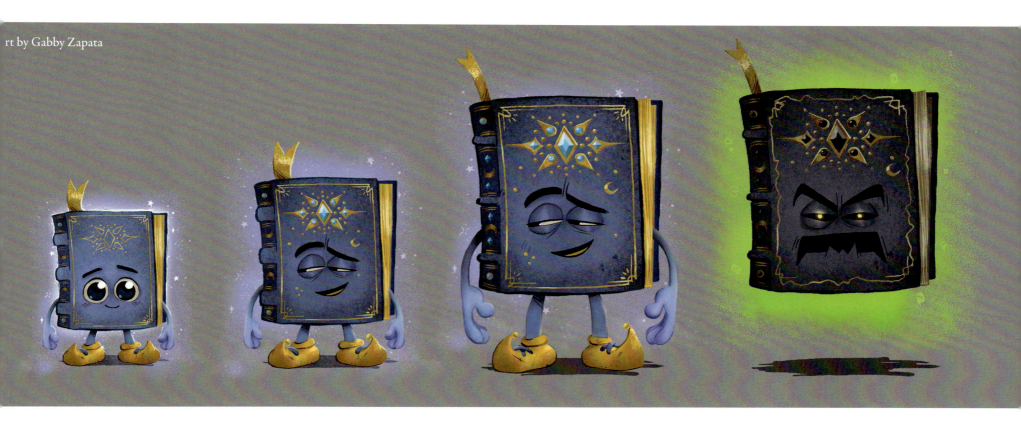

Art by Gabby Zapata

For those not familiar with the term *"grimoire"* it is an Old French word for a magician's book of spells.

The word "jaunty" is defined by Merriam-Webster as "sprightly in manner or appearance" (and if the word "sprightly" is at all a roadblock, that means traits marked by "lightness and vivacity"), so bringing it back to *Smurfs*, the character in the motion picture is certainly that.

Voiced by actress/author/comedian Amy Sedaris, Jaunty as described by Chris Miller is "effervescent and bouncy and, just nutty enough and wonderfully, off her rocker, like Amy is. And I mean that in the best possible way. Amy's brilliant."

Although created for the movie, it's established that Jaunty's place within the Smurfs canon dates back to the beginning of time itself.

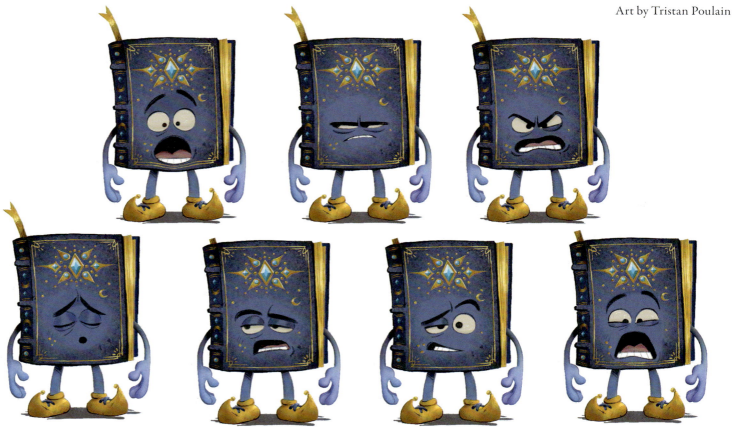

Art by Tristan Poulain

167

Art by Gabby Zapata

Art by Tristan Poulain

Jaunty witnessed the dawn of creation and survived the battle between Razamel and the original Guardineers of Good only to be forced into exile to avoid capture by the Alliance of Evil Wizards. Hidden for over a century in the forest surrounding Smurf Village, Jaunty managed to lay low until she felt compelled to answer No Name Smurf's wish for "a thing." She secretly hides under his hat "helping" to engineer his displays of magic, while aiding his journey to unlock the real magic inside of him.

In a display of truly bad timing, Jaunty chooses to reveal herself to No Name and everyone else in, of all places, the castle of her would-be capturer, Razamel. This sets the stage for the climactic all-out battle between the newly instituted and greatly expanded Guardineers of Good and the always evil Alliance over the fate of the universe.

According to Matt Landon, the filmmakers imagined Jaunty "had been left alone in the woods for 100 years, and [is] kind of neglected and starved for attention, and, you know, [we] ran with this idea that [Jaunty is] this very social creature [who] had been isolated for too long. Maybe has one or two screws that were starting to come a little bit loose and so she jumps at the chance to have any, any interaction with our Smurfs."

While that aspect of Jaunty appears in the final cut of the movie, there were several ideas that the team didn't "run with" over the course of development, one being that Jaunty was originally a "boy" book.

"I was the voice of Jaunty for 'a minute,'" revealed actor JP Karliak, before the part went to Sedaris and he moved on to play both Razamel and Gargamel.

And even before that, the art team explored "quite a number of options" regarding Jaunty's design, Margaret Wuller remembers one that appealed to the animators, but was ultimately sidelined:

"Using Jaunty as a flip book was a really cool idea initially, and we do use that for a moment in the movie, but then it just became too hard to maintain [her facial] animation, [it] would literally be her [interior] pages flipping back and forth. Loved it, but very difficult and the director eventually was like: 'Well, you know, that might be too distracting to have throughout the film.'

"So, there is one moment where we have Jaunty open up and you can see the pages, but that's in our introduction, and then the rest of the time Jaunty is a closed book."

While it's tough not to turn the page on Jaunty with a closing sentiment like that, there's still a wealth of the walking, talking book's backmatter worth referencing.

"Another thing with Jaunty is that her scale does change quite a bit," Wuller says "because she's supposed to be hiding under [No Name's] hat, but also be normal size. So, we had many different models in many different sizes."

While it might have seemed labor intensive to the design department at the time, that sliding scale would come in handy during a scene that involved a certain character's scalp.

"So, Jaunty is hiding under No Name's hat and we have a moment where we had to make her super tiny, and then the hat comes up, and all of a sudden, the shot has to cut really quick for Jaunty to pop out into full size because apparently, you do not show Smurf heads. They always need to have their hats. That was a really fun bit of learning [for the filmmakers], like, we couldn't show a Smurf without his hat for too long."

170

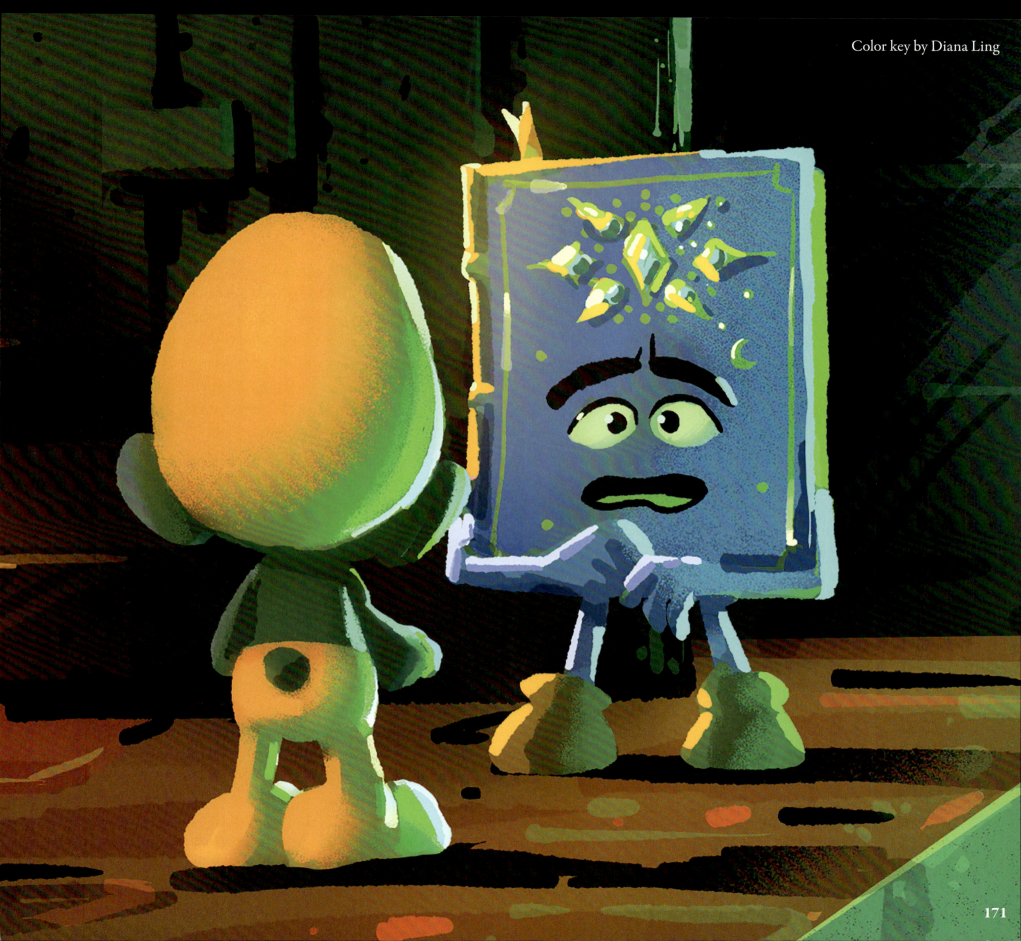

Color key by Diana Ling

TRANSFORMATIONS

In the confusion leading up to the even more disorienting final battle, there are flips and dramatic reversals that secure the evil Razamel in his sense of having the upper hand.

No Name's "magic" fizzles with an ill-fated "moonwalk," Smurfette falters in the face of her past as a tool of the bad guys, and Jaunty is converted to the dark side which brings Razamel within inches of his goal of acceptance by the other evil wizards—and more importantly complete domination of existence as all know it.

In his arrogance, he casts off his brother Gargamel before absconding with Jaunty to meet with the Alliance, resulting in a rather unexpected about face.

Even though it's to get revenge on his brother for his betrayal, Gargamel saves the Smurfs (and the Snooterpoots), and spirits them out of the Squishadrome—on the back of Azrael?!

With a simple command of "Engage wing spell!" Gargamel transmutes his sidekick into some manner of mythical griffin, or as the screenplay puts it: "...WHOOOOOF! Azrael GROWS GIANT WINGS."

The cat rears its "majestic head" back and roars, covering shocked onlookers in "majestic spittle," and declares in a human voice: "I'm majestic!" Before sweeping everyone to safety.

This moment is bound to elicit some cheers form fans of the oft put upon pussycat an equally long-standing but much more beloved antagonist than Gargamel—as it gives Azrael some agency and superpowers to boot.

Art by Tristan Poulain

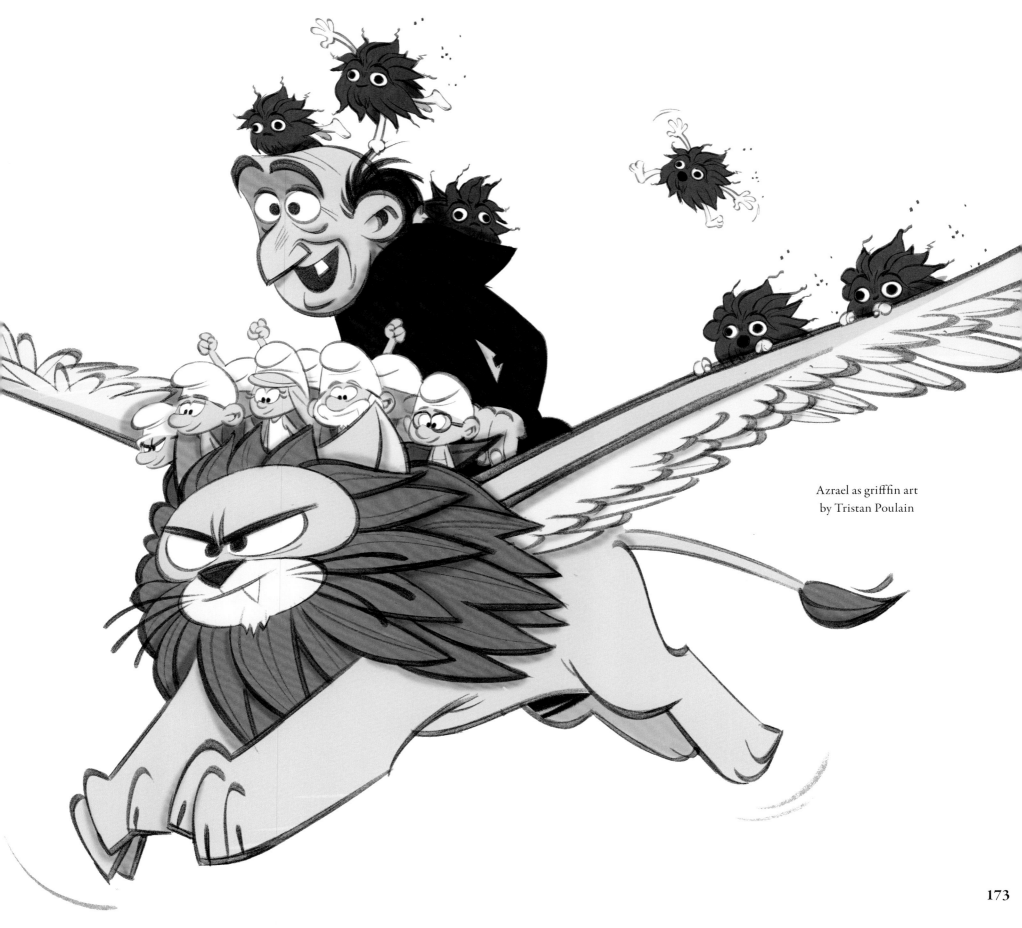

Azrael as grifffin art by Tristan Poulain

173

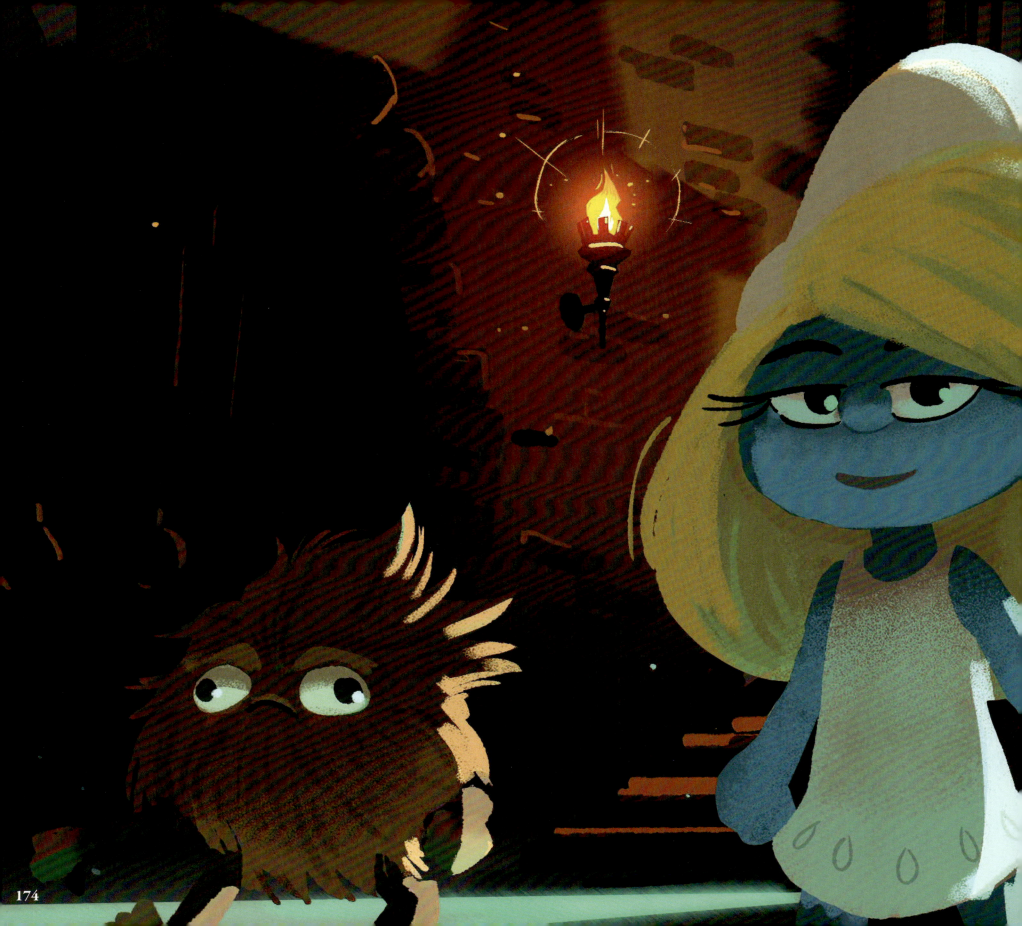

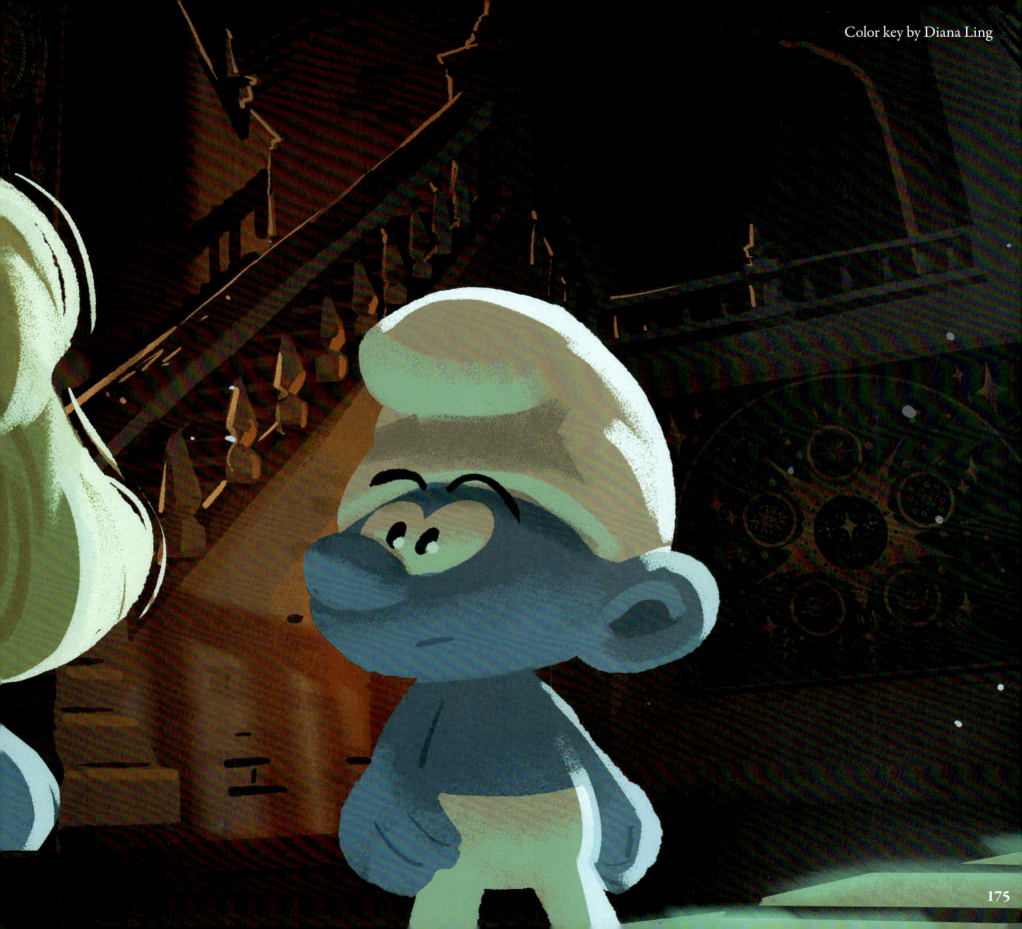
Color key by Diana Ling

RON voiced by Kurt Russell

When Papa Smurf and his brother Ken reunite after 106 years of not speaking, their thoughts drift to their mutual best friend who rounded out the original Guardineers of Good: Ron.

Remembered as a Smurf of tremendous courage and valor, and really great hair. Ron was beloved by everyone and everything he encountered. More importantly, he loved and respected everyone and everything no matter how small or insignificant they may have seemed to others. As a contrast to his staid and agreeable persona (and did we mention the really great hair?), Ron was also the most dangerous of the magical guardians, easily dispatching evildoers with what's described as a potent mix of "elegance and lethality."

Much to the shock and horror of young Papa and Ken, Ron was sucked into a vortex while saving baby Jaunty and was presumed "a goner" following a battle with Razamel. Although it was a heroic act of self-sacrifice on the part of Ron (who, after ensuring the book's safety, allowed himself to be pulled into the void by—you guessed it—his really great hair), Papa made losing Ron an excuse to hide from grand, universal battles of good and evil and seclude the rest of the Smurfs in the enchantment of Smurf Village.

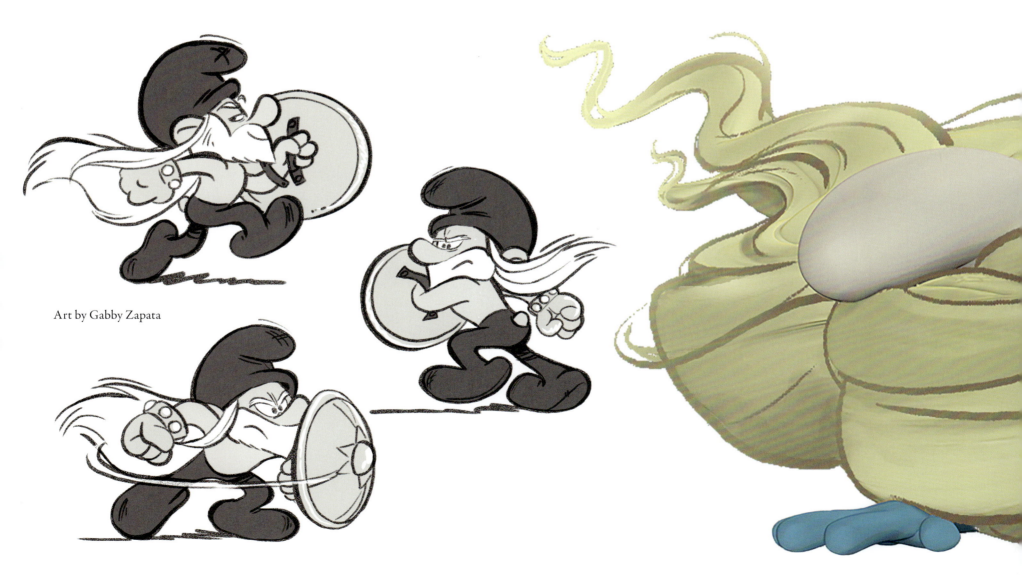

Art by Gabby Zapata

However, it's in memory of Ron that all the Smurfs choose to embrace their destiny as the Guardineers of Good to save Jaunty from the clutches of the Alliance of Evil Wizards and defeat Razamel, hopefully, once and for all.

Ron, whose voice is performed by action-movie legend Kurt Russell, is yet another character newly created for the Paramount film. Margaret Wuller describes his design as a "Viking-esque kind of warrior type," with Max Boas adding that his long, flowing hair, iron glove, and shield have "an '80s vibe." A spate of sword-and-sorcery films and television shows dominated the fantasy genre in the wake of 1982's mega-successful adaptation of Conan the Barbarian starring Russell's contemporary Arnold Schwarzenegger. While Ron's weapons of choice are reminiscent of those characters, they weren't an obvious decision for the *Smurfs* movie team, who came to them at the request of the licensor and the studio.

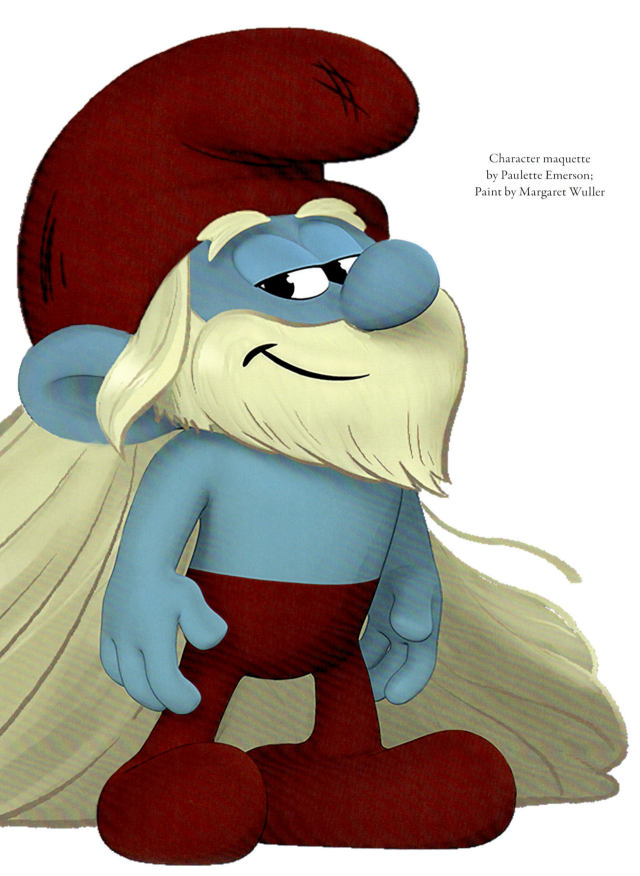

Character maquette by Paulette Emerson; Paint by Margaret Wuller

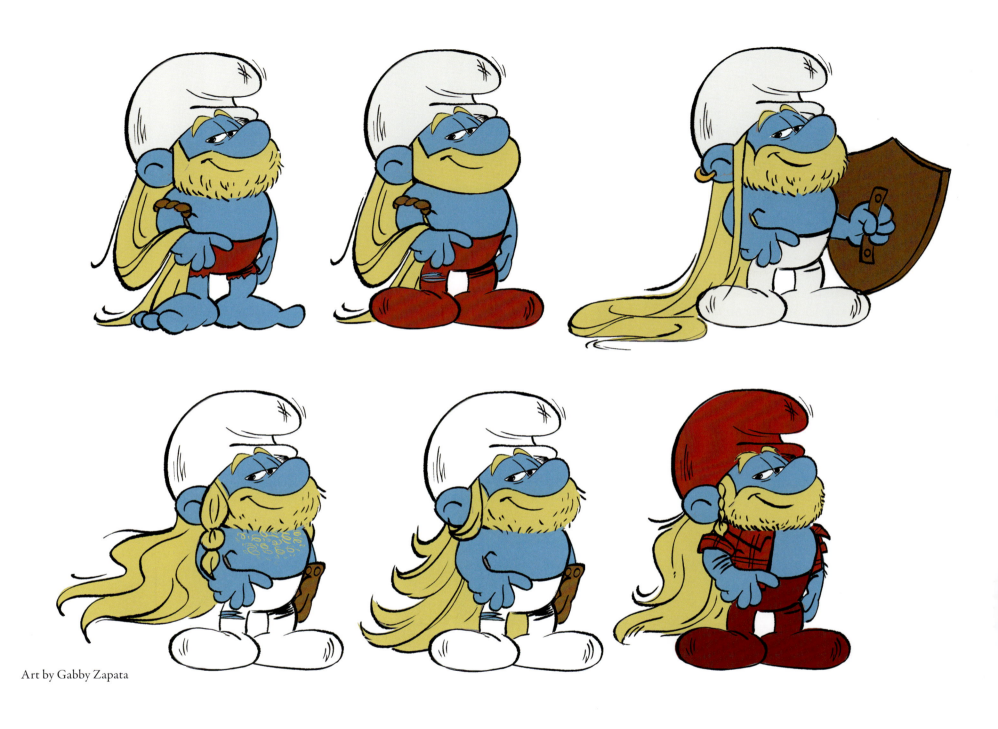

Art by Gabby Zapata

"It was very important for [Peyo's] estate and for the movie that [these Smurfs were] not violent," said Wuller. "So, how do you fight without being violent? And what kind of accessories can you have to show that you're a warrior without leaning into violence?" Producers informed her that in this film, Smurfs would not use swords. "And that was a hard line, too. So, we gave [Ron] a shield. We gave him this iron fist."

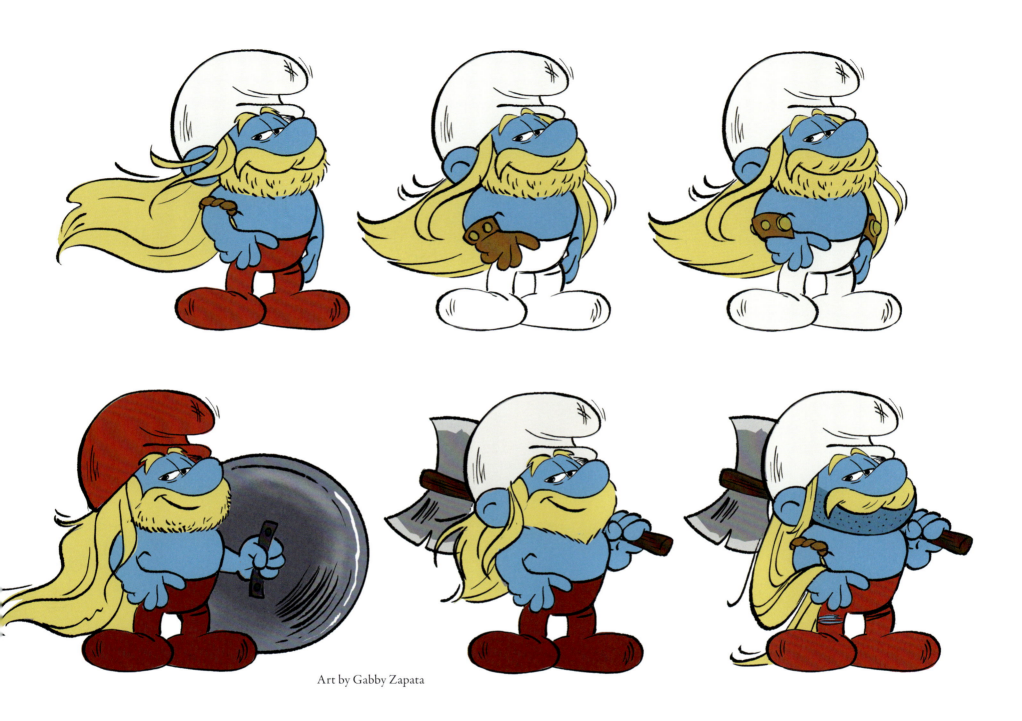

Art by Gabby Zapata

Although the choice of arms did influence the overall character, according to Chris Miller, the choice of actor did not (even if Russell did star as a comedic tough guy in 1992's *Captain Ron*). "The character design came before the Kurt Russell [casting]," Miller assures us. "They just, actually, joined hands beautifully. [Russell]'s a legend. What I wanted was a legendary figure, mythical and powerful and heroic. And, you know, he's the kind of guy that's going to run into any fire. You know, the guy from *Backdraft*"—the 1991 film that starred Russell as a firefighter.

179

PLUNGE INTO THE ABYSS

The historic final battle of the Smurfs' wizard war with Razamel and the Alliance of Evil Wizards gave Chris Miller and his team the opportunity to direct a major melee that was intended to be enjoyed on the large screens of multiplexes everywhere but could also be studied and explored on the smaller screens of a home theater environment. With that in mind, they threw everything they could into the mix, allowing all their visual influences and personal animation fandoms to serve as a moving backdrop to the fight for the fate of the cosmos in the Inter-Dimensional Abyss.

Matt Landon sets the scene(s): "Our Smurfs [exist] in one dimension, [and] all these other dimensions and universes exist out there. So we thought it was only natural that as they were battling our bad guys and trying to rescue Papa and save these books, that they would have to encounter some of those other dimensions. We were really just looking for the most fun things we could take advantage of in terms of different animation styles that would represent these other universes."

"In terms of inspiration for the multiverse styles," Miller says, "I was drawn to my own childhood nostalgia. Old-school anime and low-rent 8-bit video games. Old-timey Claymation and anything and everything that would help make it fun and weird."

"Yes, this is an animated movie," says Margaret Wuller. "It can be 'animated.' We can cheat things. We can limit things. We can blow things up. Everything's possible." The art director declares, "Coming up with these concepts was a highlight of the movie."

Color key by Diana Ling

THE MOST BORING CONFERENCE ROOM EVER

The sequence starts quietly enough, in what the script describes as a mundane shared commercial space with "bummer office vibes."

"It's supposed to be the most boring conference room in the universe," Margaret Wuller explains, "and this is where the wizards meet. It's all based off the 1970s," she says of the drab tones and stuffy, fluorescent-lit atmosphere adorned with banal outdated items like paper calendars and a chunky landline phone. "Through the course of the story, the walls get blown off. The only thing that remains through the end portion of the movie is the floor, because the conference room gets completely disassembled."

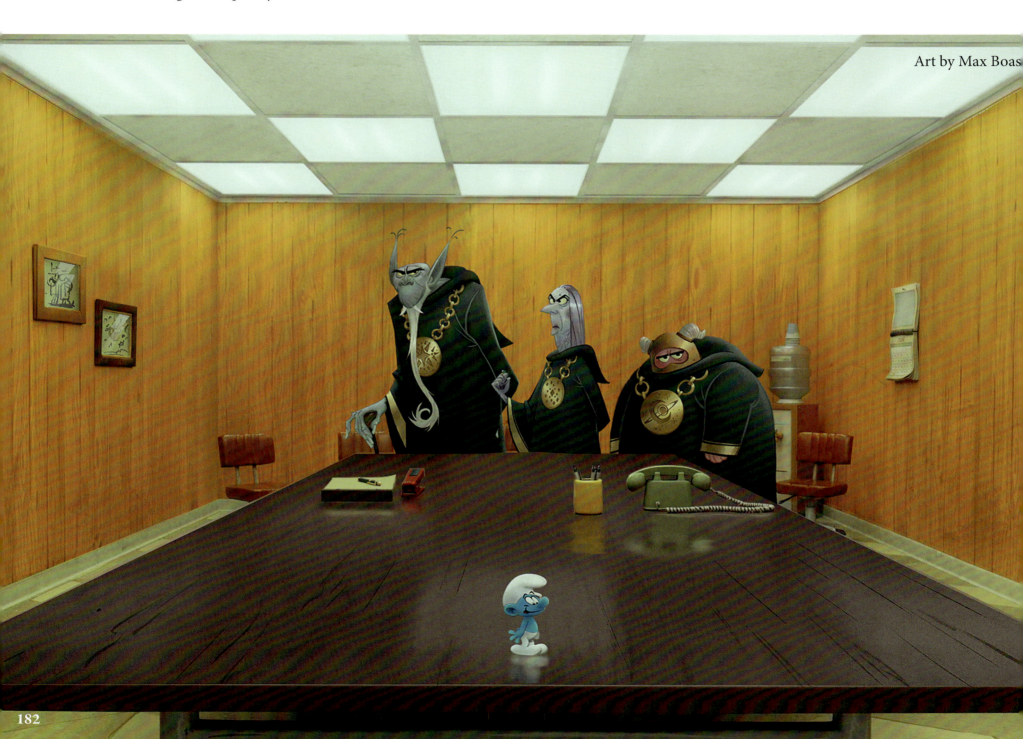

Art by Max Boas

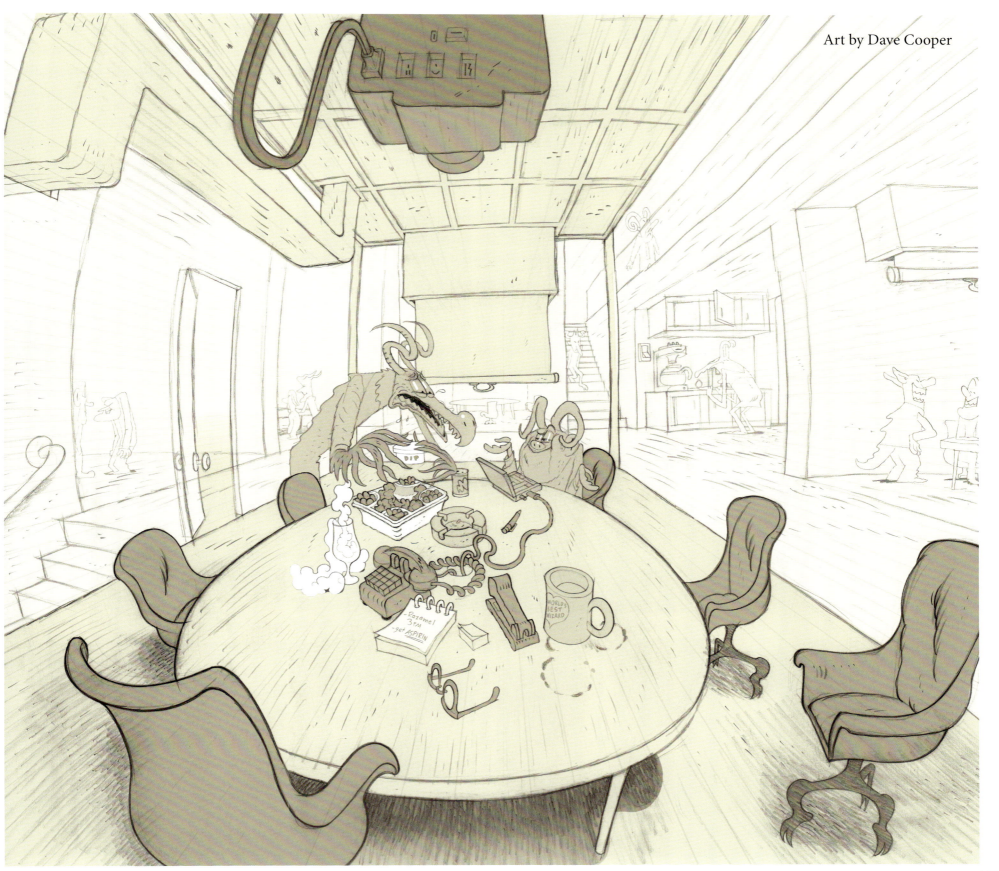

Art by Dave Cooper

THE CAUSEWAY OF DOOM

After suitably wrecking the conference room, Razamel, Jaunty, No Name, and Smurfette drift across a void before truly beginning their trek through the fractured fantasy spaces.

However, the void itself presented some visual opportunities for the team. Muller explains: "They're on this sort of ground plane floating in space and knowing that you don't really have any set pieces, we put some planets in the background and tried really hard to have a distinct lighting direction. [To] know where the sun is, so that you don't get too confused as to where you are. So, in one way, it was really helpful because you could do all of this wonderful action and be larger than life, [as] you don't have walls to contend with, but at the same time, you need just a couple little pieces of set dressing here and there, so you know where you are in the world, you don't get too disoriented."

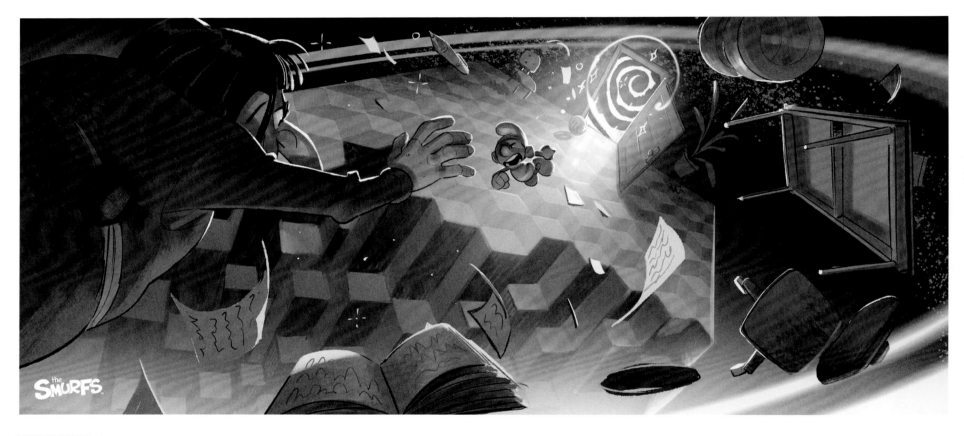

Concept art by James Castillo

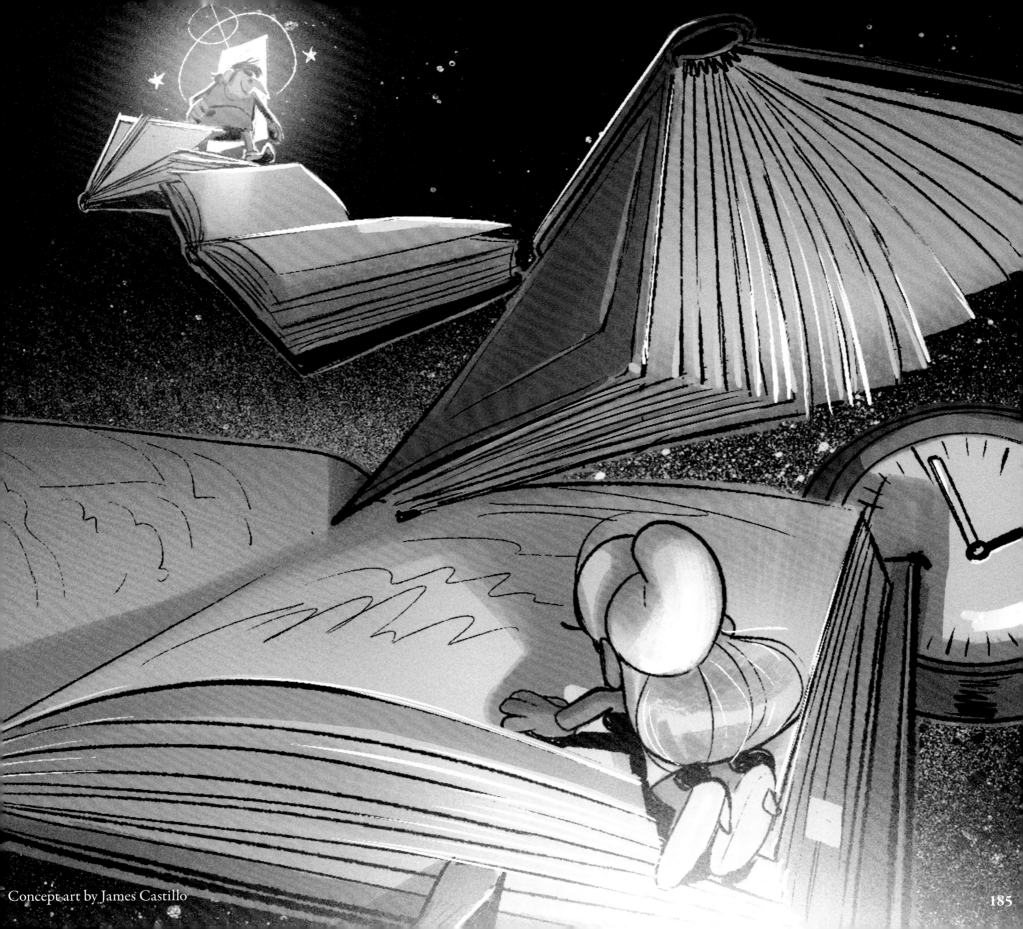

Concept art by James Castillo

STOP-MOTION DIMENSION...

The first major stopover on their voyage is a stop-motion environment animated in what's commonly referred to as "Claymation" after the pliable material that was used to bring the characters to life in the early days of the medium. Artists would sculpt the "actors" and then move each piece of the sculpture a fraction of an inch at a time, stopping to take a single photo along the way. Ultimately, when the pictures were projected in sequence, it would create the illusion of life.

"I'm definitely partial to the Claymation [universe]," admits Matt Landon. "I loved Gumby when I was a kid, [and] I just love seeing our Smurfs as these lumpy clay creatures."

The sequence was subcontracted to Screen Novelties, a Los Angeles–based company that specializes in stop motion and has worked on getting other cartoon icons, such as SpongeBob SquarePants and Fred Flintstone, "physical," so to speak. However, the *Smurfs* team did come to them with some previsualization in tow.

"We had this great concept piece—not representative of what the Claymation moment actually looks like, but I think it might be in the trailer," describes Margaret Wuller. It features a "1979 or '80 Schleich Smurf figurine, a real one that I was gifted by my German in-laws and Razamel was painted in to make him look like he was a figure."

Concept art by Kaitlyn Nguyen

...AND BEYOND...

Other pit stops on the path to narrative resolution include the 8-Bit Dimension, which Miller calls "an old ColecoVision/Atari section," the Japanese-language-dubbed Anime Dimension, the Microscopic Dimension inhabited by lonely tardigrades, and finally the Surreal Dimension in the landscape of No Name's mind, where he and Smurfette manage to resolve their respective inner conflicts, save Jaunty, and defeat Razamel once and for all.

One world that didn't make the final cut was the Graffiti Dimension, which would have had flat, spray-painted representations of the Smurfs and Razamel pursuing each other across the walls of an urban landscape.

"There's so much great Smurfs street art out there. I've seen a lot of beautiful melting Smurfs across L.A.," says Chris Miller.

As Margaret Wuller points out, like the Smurfs themselves, this is an international phenomenon. "Vacationing in Italy, there was Smurf graffiti everywhere," she says. "Our character designer is from France, and he was living in Paris at the time we were doing the initial designs, and he kept on walking around and snapping graffiti of Smurfs."

She recalls of the deleted sequence, "We had taken all this reference and made street art versions of them animating across a brick wall, integrating and reacting to a phone booth and they'd turn the corner and just wrap around like a sticker. It was really a wonderful sequence. Unfortunately, it got cut, but it's okay—that made the movie tighter, better."

GRAFFITI DIMENSION

Concept art by Margaret Wuller

MICROSCOPIC DIMENSION

Art by Margaret Wuller

ANIME DIMENSION

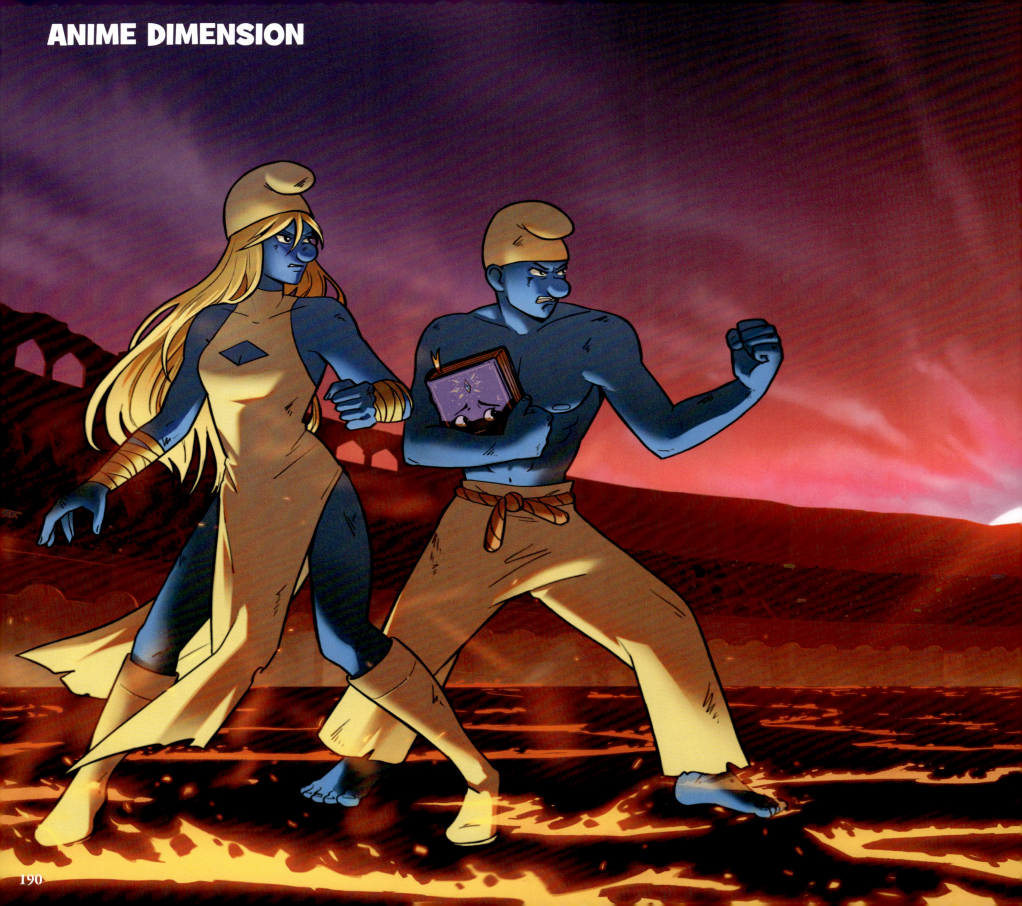

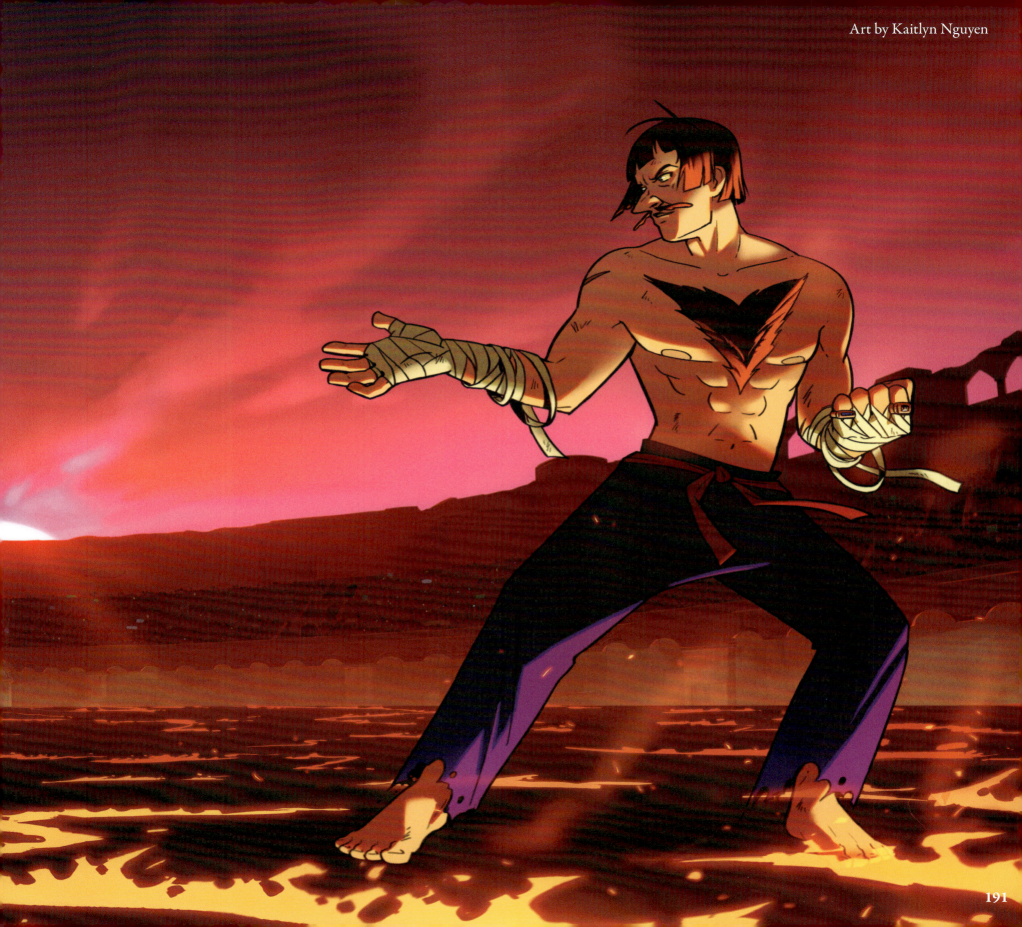
Art by Kaitlyn Nguyen

ALL'S SMURF THAT ENDS SMURF

The *Smurfs* screenplay ends with the Smurfs "back home celebrating with balloons and pies and presents." So, too, does this trip through the art and craft of the movie made from that script.

However, instead of a montage of "Smurfy play and partying," we deem it more appropriate to end with a selection of reflections on the overall experience from the artists and craftspeople who took time out of their Smurf-filled schedules to contribute to this making-of book.

∗∗∗

"I am overwhelmed with gratitude at being a small part of such a beloved brand," says producer Ryan Harris. "The Smurfs [were] such a huge part of my childhood. I also love how this film shines a light on the importance of community, as what brings me joy when I produce a film is working closely with the crew and director while ensuring their vision is executed in alignment with the studio."

Art by Kaitlyn Nguyen

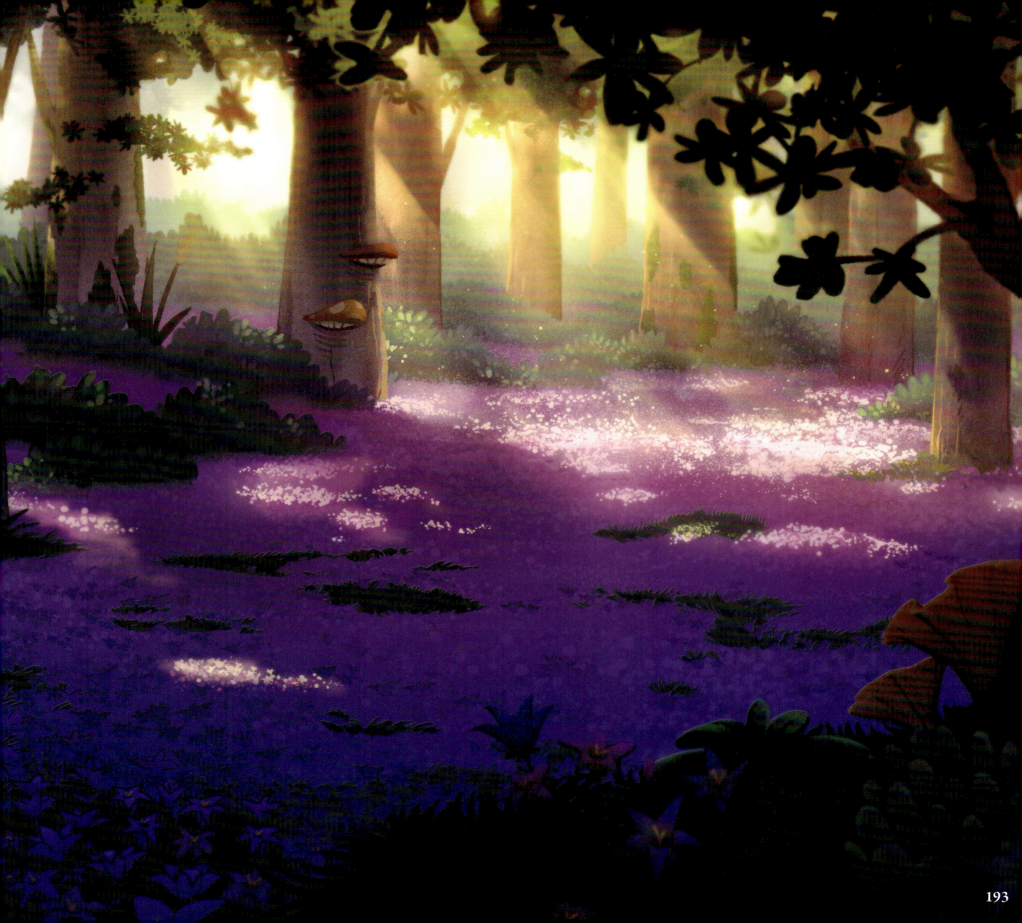

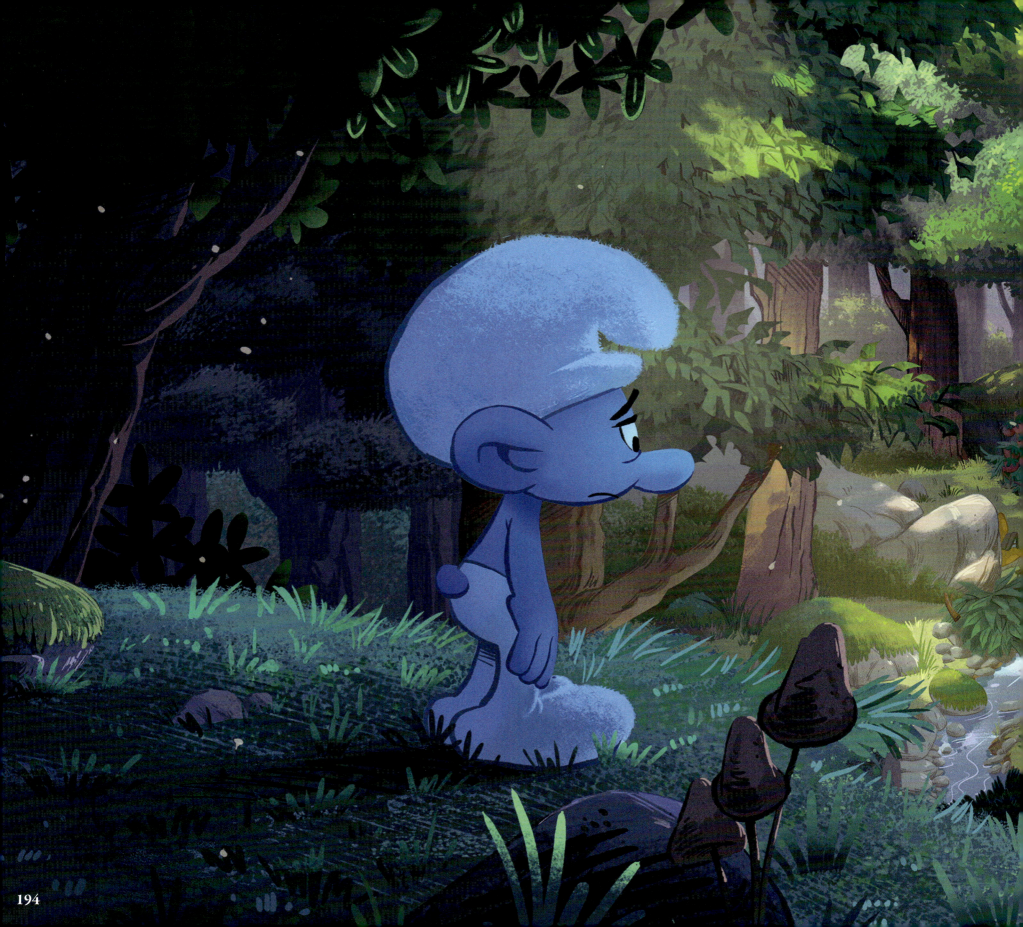

"If you had told me at five years old that I was going to be the art director of a Smurfs movie, I would have…" Margaret Wuller starts before thinking better of her answer out of respect to her family, who have, perhaps, gotten more joy out of the project than she has. "My in-laws are from Germany. My husband's from Germany and so they were more thrilled than anyone I know. They just automatically started singing the ["Smurf Song"], and then they showed me all the videos of people celebrating the Smurfs [there]. It's wild. I knew it was big [in America], but honestly, before I worked on this movie, I didn't realize how big it was. I didn't realize that the European fan base. They love it."

"I'm a fan," says voice actor JP Karliak. "I was a kid glued to the TV watching, specifically, those performances [in the Hanna-Barbera show]. So, I have a certain bar that I set for myself, and also that childlike joy of 'Holy &$@%! I get to do this!' There is a humbling aspect to it and there is some pressure. But I've learned, if you're finding that it works [for you], then it's going to work for somebody else. And I would so much rather put my authentic stamp on it and be a handful of people's very favorite version of the character than try to adhere to somebody else's standard of what it's supposed to be and miss the mark entirely. It's too hard. Make it something that you yourself enjoy and there will be people who will be on board with you."

Art by Diana Ling

Production designer Max Boas thinks it was "awesome" to be able to contribute to the legacy of the property. "I think what this film does is [continue] the groundwork that there's a magical quality about the Smurfs, that they are powerful when they unite. When they come together, they can fight danger or evil wizards across the universe, they can go anywhere. I think that's really exciting."

If there were only one Smurf-sized kernel of information that director Chris Miller took from the film, it would be to "trust the emotional core of your movie and take your time in delivering that to the audience. Those choices are what make a movie truly memorable."

And making memorable movies is something that he truly loves doing. "It's the joy of collaboration, the joy of working with hundreds and hundreds of people and creating a collective consciousness and making something that will last forever," he says.

Concept art by James Castillo

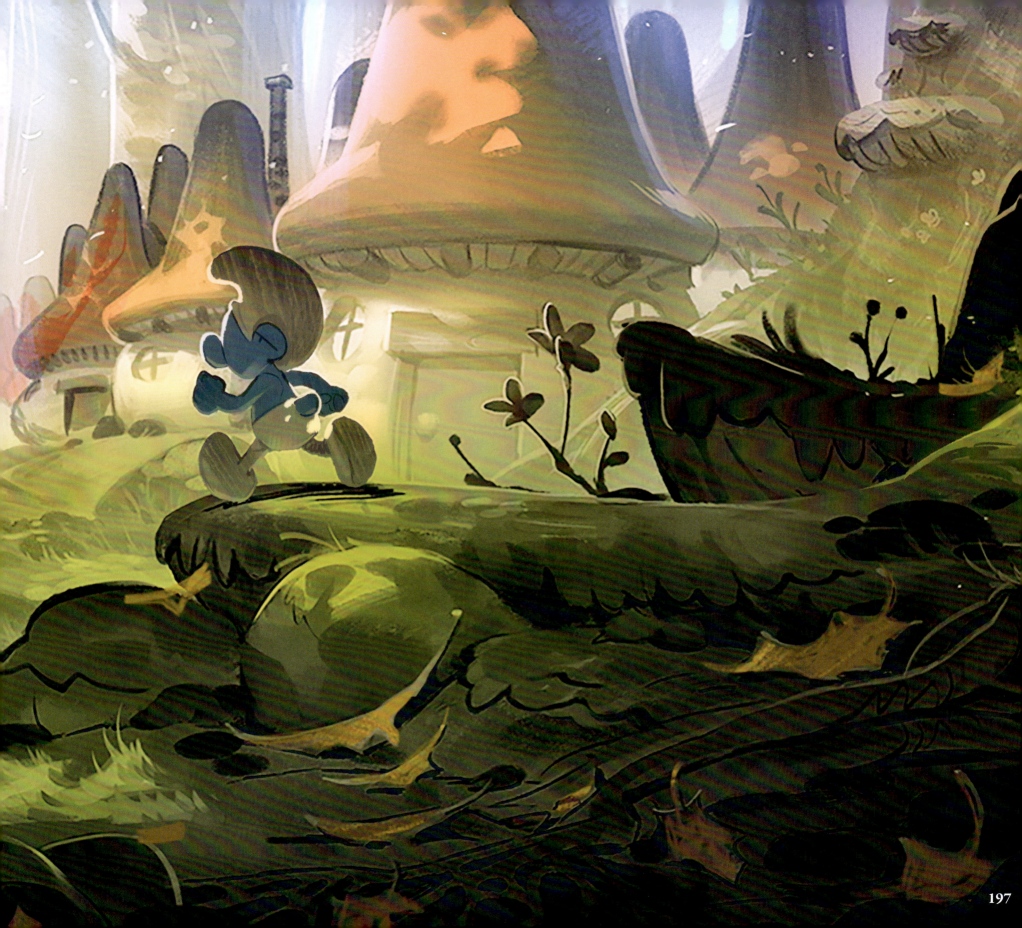

BIBLIOGRAPHY

D'Alessandro, Anthony. "Rihanna Shows up at CinemaCon, Reveals That She's Playing Smurfette in Paramount 'The Smurfs Movie.'" *Deadline*, April 27, 2023. https://deadline.com/2023/04/rihanna-smurfs-movie-cinemacon-1235339477/.

Grierson, Tim. "Pam Brady on 'South Park,' 'Smurfs' and Her New Ramy Youssef Animated Comedy." *Cracked*, April 16, 2025. https://www.cracked.com/article_46220_pam-brady-on-south-park-smurfs-and-her-new-ramy-youssef-animated-comedy.html.

Merriam Webster. "Brand Definition & Meaning." Dictionary. Last updated May 19, 2025. https://www.merriam-webster.com/dictionary/brand.

Merriam Webster. "Jaunty Definition and Meaning." Merriam Webster Dictionary. Last updated April 12, 2025. https://www.merriam-webster.com/dictionary/jaunty.

Merriam Webster. "Sprightly Definition and Meaning." Merriam Webster Dictionary. Last updated April 15, 2025. https://www.merriam-webster.com/dictionary/sprightly.

Miller, Chris, dir. *Smurfs*. Script by: Pam Brady. (Paramount Pictures, 2025), Script

Murray, Matt. "The Smurfette Question." In *The Smurfs Anthology #2*. Papercutz, 2013.

Murray, Matt. *The World of Smurfs: A Celebration of Tiny Blue Proportions*. Harry N. Abrams, 2011.

"Peyo à Le Première Personne Du Singulier." *Le Journal de Spirou* no. 2434, December 6, 1984.

Rose, Cynthia. "Behind the Blue: The Story of Peyo," *The Comics Journal*, August 28, 2018. https://www.tcj.com/behind-the-blue-the-story-of-peyo/.

Rose, Cynthia. "The Belgians Who Changed Comics," *The Comics Journal*, September 11, 2015. https://https://www.tcj.com/the-belgians-who-changed-comics/.

Schuddeboom, Bas, and Kjell Knudde. "Peyo." Lambiek Comiclopedia, Last updated April 13, 2025. https://www.lambiek.net/artists/p/peyo.htm.

Schuddeboom, Bas. "Eddy Paape." Lambiek Comiclopedia, Last updated March 16, 2025. https://www.lambiek.net/artists/p/paape.htm.

Schuddeboom, Bas. "Jijé." Lambiek Comiclopedia, Last updated September 25, 2024. https://www.lambiek.net/artists/j/jije.htm.

ABOUT THE AUTHOR

Matt. Murray is an award-winning comic book writer and editor whose projects include Stan Lee's *God Woke* (2016), Clive Barker's *Hellraiser Anthology I and II* (2017), and the 2023 relaunch of *Conan the Barbarian* and the Robert E. Howard literary properties. His earliest work in Smurfology dates back to 2006 and has since included roles as an author, translator, historian, lecturer, curator, and documentary "talking head." He has been a consulting editor on *The Smurfs* comics since 2008, helping to oversee the translation, restoration, and publication of decades of material, a substantial portion of which had not been previously available to English-speaking audiences.

The author wishes to thank: Stephan G. & Noreen C. Murray; "Da Boys" & All Other Murrays Great and Small; Allan Dorison, Alan Mechem, Attila Juhas, Jennifer Babcock, Kevin Bonser, Aron Fromm, David McCallum, Mark Alan Miller II, and WRT&S; Adam Wallenta and Papercutz Graphic Novels; the staff and administration of the NCC Fab Lab and Center for Innovation & Entrepreneurship; Alonzo Simon and IDW; Fabienne Gilles, Louise Busseniers, and Peyo Company; Veronique Culliford, Max Boas, Margaret Wuller, JP Karliak, and anyone who made this experience as "smurfy" as possible for everyone involved.
As always in these matters, an extra thanks goes to Jim Salicrup for being a mentor, entertainer, and friend, who opened the door to twenty years of "adventures in four colors!"

Art by: Attila Juhas, AJ Design
© 2025 Thingers of Stuff, LLC

Color key by Katilyn Nguyen

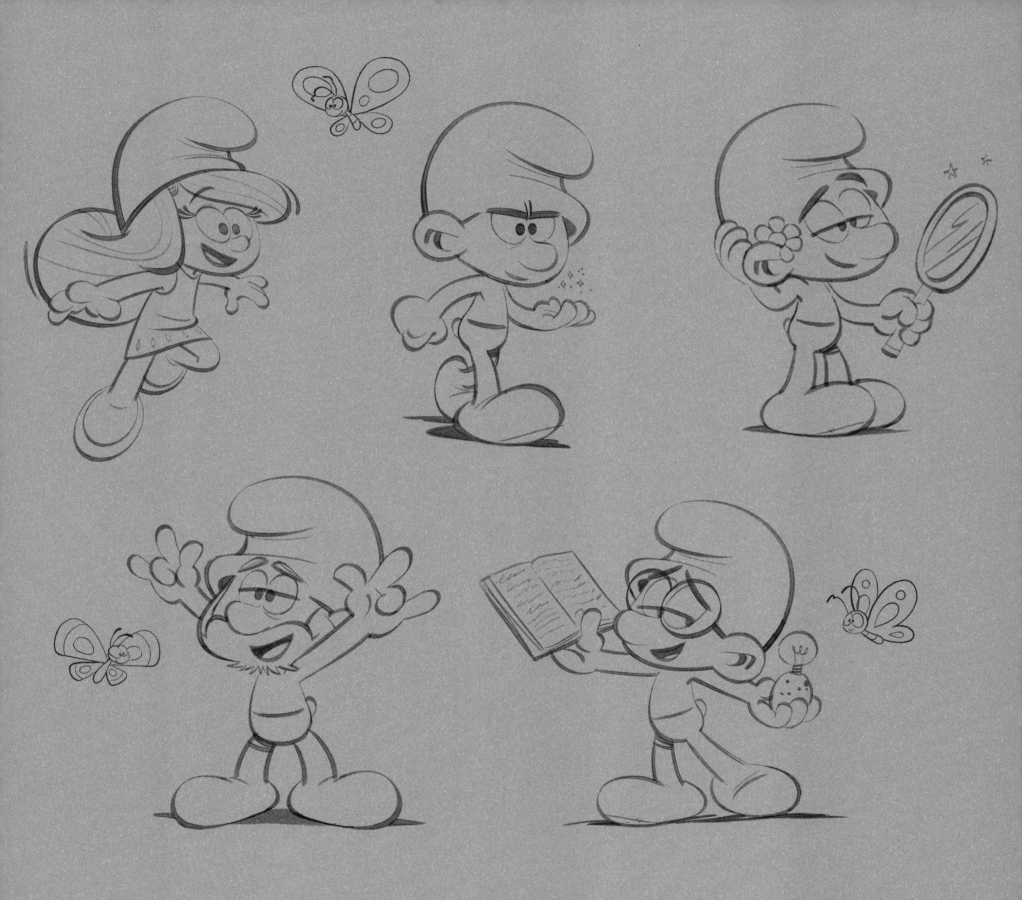

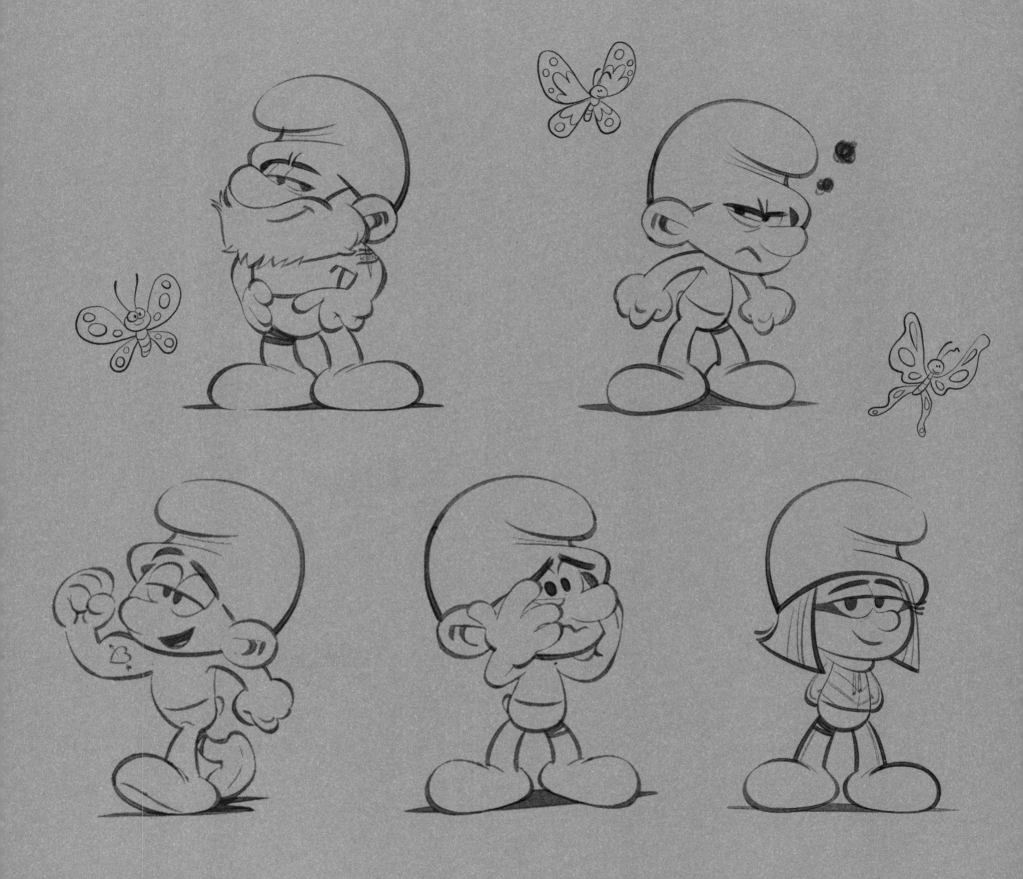